I WAS VERMEER

The Legend of
the Forger Who
Swindled the Nazis

Frank Wynne

BLOOMSBURY

First published in Great Britain in 2006

Grateful acknowledgement is made to copyright holders for all copyright material reproduced in this book. For a detailed listing see the Picture Credits.

Every reasonable effort has been made to contact copyright holders of material reproduced in this book, but if any have inadvertently been overlooked the publishers would be glad to hear from them and to make good in future editions any errors or omissions brought to their attention.

Bloomsbury Publishing Plc
36 Soho Square
London W1D 3QY

A CIP catalogue record for this book
is available from the British Library.

ISBN 0 7475 6680 1
ISBN 13 9780747566809

10 9 8 7 6 5 4 3 2 1

Typeset by Hewer Text UK Ltd, Edinburgh
Printed in Great Britain by Clays Ltd, St Ives plc

The paper this book is printed on is certified by the © 1996 Forest Stewardship Council A.C. (FSC). It is ancient-forest friendly. The printer holds FSC chain of custody SGS-COC-2061

For my mother, for her love and her
unfailing, often bemused, support.
To the memory of Ric Shepheard: filmmaker,
fraudster, friend, for his brilliance and inspiration.

La vie étant ce qu'elle est, on rêve de vengeance.

Paul Gauguin

ACKNOWLEDGEMENTS

I would like to offer my heartfelt thanks to: my agent, the incomparable David Miller, for his friendship and his unshakeable faith; Rosemary Davidson, Amanda Katz and Bill Swainson for their help and support on this book; Machiel Brautigam for introducing me to Geert Jan Jansen, who offered me a first-hand insight into the mind of the forger, Roland Burke for his help when my rudimentary German failed me; and to my friend and Dutch uncle Ravi Mirchandani.

CONTENTS

INTRODUCTION

The best way to learn about fakes
is to get in touch with a forger.

Thomas Hoving, *False Impressions:*
The Hunt for Big-Time Art Fakes

I am sitting in Het Molenpad, one of the oldest and most
*gezellig** of Amsterdam's 'brown cafés'. The few tables on the
pavement overlook the sweeping curve of the Prinsengracht, all
the more beautiful on this early summer morning as dappled
green sunlight spills through the leaves on to the still waters of
the canal. I sip my beer and wait to meet my first convicted
forger.

Forgery is a booming industry – though not perhaps one a
career-guidance counsellor will recommend to your gifted
child. The former director of the Metropolitan Museum of
Art, Thomas Hoving, estimates that 60 per cent of all the
works offered to him during his sixteen-year tenure were 'not
what they appeared to be'; the *New York Times* has suggested
that 40 per cent of all major works offered for sale are
forgeries. This is not a recent development: as long ago

* The great untranslatable Dutch concept which encompasses welcoming,
cosy, friendly and good fun.

as 1940, *Newsweek* alleged that 'of the 2,500 authentic works painted by Jean-Baptiste Camille Corot, 7,800 are in American collections alone'.

Forgery is art's shadow-self, the vice without which virtue is impossible. For as long as mankind has coveted objects for their history, their beauty, their proximity to genius, the forger has been there with a mocking smirk ready to satisfy the demand. Art is the business of selling fetishes, sacred relics once touched by genius: what the forger offers the gullible buyer is not art, it is 'authenticity', something John Groom argues 'is the abiding perversion of our times. It is indulged as a vice, worshipped as a fetish, embraced as a virtue. [. . .] Everything it touches turns to gold – or at least is burnished with a scrape of lustre – and in that sense it is the mark of genius, the Midas touch, the apotheosis of capitalism.'

For an artist with a little talent and few scruples, forgery offers not only riches, but a clandestine celebrity. To know that one's paintings hang in the Louvre, the Met, the Tate – even if no one else can ever know – is the finest revenge. Once in a gallery, there is little chance that the forger will be unmasked: as Théodore Rousseau pointed out, 'We should all realise that we can only talk about the bad forgeries, the ones that have been detected; the good ones are still hanging on the walls.'

Forgery, said Orson Welles, 'is as old as the Eden tree'. By the time the ancient Greeks arrived to begin the looting of Egypt which would continue for two thousand years, Phoenician and Sumerian forgers skilled in the making of 'ancient Egyptian' artefacts were waiting for them. In Rome, when Caesar Augustus commanded Virgil to create an epic to rival those of Homer and the empire struggled to forge for itself a history that might rival the Greeks, the statues of the greatest of Greek sculptors of the fourth and fifth centuries BC – Phidias,

Praxiteles and Lysippus – changed hands for exorbitant sums. But the statues which graced the homes and private temples of senators and wealthy merchants were forgeries carved in sweatshops outside Rome. Pasiteles, one of the most gifted forgers of his generation, even wrote a sensational exposé of his forgeries. The manuscript, sadly, has been lost, but the myth of its existence may one day tempt a skilled forger to invent it.

In Renaissance Italy, at the height of perhaps the greatest flowering of human endeavour, the young Michelangelo, in an attempt to impress his patron Lorenzo de Medici, forged Roman sculptures and buried them in the gardens of the Medici palace, later arranging for these 'ancient' artefacts to be discovered. According to Vasari in his *Lives of the Artists*

> He also copied drawings done by various old masters so closely that they were not recognised as copies, for by staining and ageing them with smoke and various materials, he soiled them so that they seemed old and could not be distinguished from the originals . . .

Michelangelo would borrow works of art in order to copy them, but he returned the copies, keeping the originals for himself.

Forgery can lay claim to being the second-oldest profession, and so it seems somehow appropriate to be waiting for a forger here in the stilly, greeny summer of Amsterdam's genteel western canal belt, barely half a mile from where lissom women in picture windows practise the oldest profession: both, after all, know something about faking it.

Geert Jan Jansen arrives, a short, stocky man with a shock of white hair pushed back from his balding pate. In my finest

Dutch I order two beers, and the barman inevitably answers in perfect English. The casual incredulity the Dutch reserve for those of us foolish enough to try to learn their language is matched only by their conviction that we have no hope of mastering it.

Soft-spoken and gracious, Geert Jan Jansen makes an improbable master criminal, and yet he admits to having forged thousands of paintings, drawings and watercolours by a Picasso, Matisse, Dufy, Miró, Jean Cocteau and Karel Appel. I look down, but the only question I have pencilled on my notepad is 'why?'.

The why of forgery is thornier than the how. To art critics, the forger is a mediocre artist seeking revenge; to the media, a conman interested only in money; to the apologist, he is the equal of the masters he has forged; to the public he is often a folk hero. Where the common thief or the mugger is despised, it is difficult not to admire the forger, not to feel a surge of joy at the thought of a critic waxing lyrical over the glories of a seventeenth-century masterpiece on which the paint has barely dried. 'Even when forgeries are badly done, they highlight the capacious self-delusion that must have been necessary for anyone to be fooled,' writes Cullen Murphy; 'When they are superb, they represent a triumph of the human spirit.'

For Geert Jan Jansen, the 'why' was simple. Having studied art history, he worked for the fashionable Amsterdam gallery Mokum. Later, he set up his own galleries, Jacob and Raam. His fellow-dealers were fulsome in their praise of his impressive feeling for art. 'But when I was running my galleries, my best customers were the bailiffs – I couldn't make enough money to survive and I didn't want to lose the shop.' Jansen began modestly, transforming humble posters with a pencilled number and the simple flourish of the artist's signature and

selling them as limited-edition lithographs. With the proceeds, he could fill his gallery with the paintings he truly admired. It was only a matter of time before he was tempted to go beyond forging signatures, to faking the paintings themselves.

'My first forgery was a Karel Appel. I sold it to a famous Dutch architect and later I heard him boast to another dealer that he'd seen the painting on an easel in Appel's studio. I thought: if everything goes this easily . . .' His second forgery, also an Appel, he offered to a London gallery. Since he had scant documentation for the work, the auction house decided to verify the painting before sale and sent a photograph to Appel himself, who stated categorically that it was genuine. *Child with Toy* set a record price for a work by the artist.

'I took no pleasure in the deception itself. Personally, I'm against forgery . . .'

I splutter nervously, but his face is deadly serious. Then, I see a shard of a smile, an 'emotional leak', a manifestation of what psychologist Paul Ekman calls 'duping delight': the pleasure of lying for its own sake.

'. . . unless it's well done. Let's be honest: people don't buy a painting because they think it's beautiful, they buy it for the signature, they buy it to have a Warhol to hang on their wall. It's like the traffic in sacred relics in the Middle Ages: if you took all the splinters of the one true cross, you could build a fleet of ships.

'No – for me, the excitement was in mastering an artist's style, and I've mastered the entire alphabet of twentieth-century artists: Appel, Chagall, de Kooning, Matisse, Picasso. But I discovered that there was a real thrill in the "magic wand effect" – you scribble the right artist's signature in the right place and suddenly doors open. Even I find it crazy to think I've created genuine Picassos. But every time I look in the *catalogue raisonné* of his work, there they are.'

Works of art are rarely authenticated simply by provenance – the chain of documents which trace a work from the artist's studio to its current owner. For old masters (anything painted before 1850), such documentation has rarely survived and even in the case of modern art, provenance will not exist for works given as gifts, or kept in the artist's private collection. In the twenty-first century, most works of art are still authenticated by experts, whose years of study have given them invaluable insights into an artist's mindset. 'All experts operate largely on bluff. They don't want their cover blown – they don't want us to know how often, and how easily, they have been duped,' according to Cliff Irving, biographer of Elmyr de Hory, the forger who was, to quote Robert Anton Wilson, 'Jailed For Committing Masterpieces'. Wilson himself is less gracious: 'Experts do not always know shit from shinola.'

Geert Jan's career as a forger was not cut short by an expert's eye, but by a simple misspelling. In 1994, introducing himself as Jan van den Bergen, he offers three paintings to the prestigious Munich auctioneers Karl & Faber: an ink drawing by Chagall, a Karel Appel and an Asger Jorn gouache. The experts in residence have no qualms about the authenticity of the art, but on one of the documents establishing the provenance of the Chagall, someone has typed 'environs' where it should read 'environ'. The gallery contacts the Chagall Committee in Paris, who decide that the Chagall drawing is an exceedingly good forgery. While the auction house would be content to return the works to 'Jan van den Bergen' with an apology, one of their number is suspicious enough to contact the Art and Antiques squad of the German state criminal police. It takes several months running down mail drops and anonymous postboxes to trace Jan van den Bergen, whom police have identified as Geert Jan Jansen, to his farm in the

village of La Chaux, south of Poitiers, where French police find 1,600 works by Picasso, Matisse, Dufy, Miró, Cocteau and Karel Appel. Jansen was immediately arrested and jailed.

'I was pretty well treated compared to the other prisoners.' Geert Jan smiles; 'As soon as I got there, the board of governors asked me to dash off a couple of Picassos. And I got on well with the warders. When the prosecution was forced to drop most of the forgery charges because none of my victims would come forward, one of them came to give me the news and said: "Obviously you only had satisfied customers." '

Despite the vast cache of forgeries found by the police, the case against Geert Jan took six years to come to trial, principally because none of the forger's victims was prepared to give evidence. At first, French authorities called on art dealers and collectors worried that they might have bought one of Jansen's forgeries to come forward. When not a single person did so, the Procureur de la République threatened to charge the buyers as accessories after the fact if they refused to press charges. Still, no one responded. Even those the authorities managed to trace were un-cooperative: one declared that he loved the painting and did not care whether or not it was genuine; an art dealer who had bought a Joseph Beuys, insisted that he was certain it was genuine. 'There are a lot of forgeries in circulation,' Geert Jan says. 'Art dealers know that, but they're hypocrites – they don't tell the buyers: if a dealer thinks he's bought a forgery, he salts it away for a year or two and then sells it at auction.'

In 2000, the French authorities finally succeeded in mounting a case against Jansen. In this, they were more successful than the Dutch attorney general, who ten years earlier, faced with the fact that he had no complainant to press charges, offered Geert Jan immunity from prosecution if he would undertake not to produce forgeries 'for three years'. At his

trial Geert Jan's most unlikely ally was Rudy Fuchs, the director-general of the Municipal Museum in Amsterdam. In a written statement, Fuchs argued that the paintings confiscated by French police should not be destroyed, since he considered many of them to be genuine. Of the thirteen charges originally preferred, Geert Jan Jansen was found guilty on only two counts. Despite the state prosecutor's plea for leniency, recommending a five-month suspended sentence, the magistrates' decision was six years' imprisonment (five of them suspended); his girlfriend received five months as an accessory.

I ask Geert Jan what he intends to do now. 'At the moment, I am suing the French government for the return of my paintings.'

'Do you think there's any chance that they'll give the paintings back?' I ask.

'I hope so.' He smiles. 'At least one Chagall and one Picasso *are* genuine. Besides, they have to return any painting they cannot prove is a forgery and their experts can't seem to agree on which ones are fake.'

He is philosophical about the possibility that the paintings will not be returned since he estimates that the haul represents barely 5 per cent of the forgeries he has created in twenty years. In the meantime, he regularly leafs through *catalogues raisonnés* of twentieth-century artists to see how many of his works are still numbered among their masterpieces. There seems little chance now that any of these will be exposed as a forgery. As he explained: 'Most forgeries just get sold from one person to another and in the process they become more genuine: the more often they're sold, the longer they hang on a gallery wall, the more genuine they are.'

As I pedal my rickety standard-issue Dutch bike back towards my apartment, dodging cars and pedestrians along the canal

banks, I realise he is probably right. After all, it was not an expert's instinct which exposed him in the first place, but a spelling mistake on a document spotted by a meticulous intern. On the Keizersgracht, I stop in front of number 321, now occupied by the Guild of Dutch Architects. I stare up at the magnificent five-storey *voorhuis*, imperious in its time-honoured Amsterdam livery of red brick and white. As I lean on my bicycle, one of the never-ending procession of tourist barges that ply the canals pauses briefly – as it did on my first day here, when I took the tour. I listen as the tour guide, mangling a dozen different languages in the same jaunty tone, explains that this was once the residence of the most famous forger in history, a man whose paintings hung in the Rijksmuseum, the man who swindled Hermann Göring: Han van Meegeren.

PROLOGUE
AMSTERDAM, 7 JULY 1945

Death is Nature's remedy for all things,
and why not Legislation's? Accordingly,
the forger was put to Death . . .

Charles Dickens, *A Tale of Two Cities*

'When a man knows that he is to die in a fortnight,' Doctor Johnson opined, 'it concentrates his mind wonderfully.' And yet Han van Meegeren was having trouble concentrating. The bewildered, ailing artist huddled in his dank Amsterdam prison cell, terrified at the knowledge that, if convicted, the death sentence was a foregone conclusion.

His nightmare had begun six weeks earlier when the two officers of the Dutch Field Service knocked on the door of the magnificent Keizersgracht house on a chill May morning. At fifty-six, van Meegeren was an imposing figure: he was tall and wiry, a hank of white-grey hair like hoarfrost was slicked back from his widow's peak, a neat, faintly Fascist moustache was trimmed and waxed. He looked a full ten years older than his true age, his high cheekbones jutted over sunken jowls, his heavy-lidded eyes had bags in which the worries of the world might be stored but his long aquiline nose conveyed a certain

hauteur. Usually he exuded a wry, sardonic charm, favouring tailored suits in dark blue serge or casual jackets over cashmere sweaters or flamboyant shirts, but when he answered the door that morning, van Meegeren was still padding around in slippers and a worn bathrobe, his face gaunt, his hair wild, looking slightly mad. He chatted easily and glibly with the officers in spite of his fear. The senior man, Joop Piller, asked if they might come inside. They needed to speak to him about a painting. As he ushered the officers into his opulent studio, Han offered them a drink and was surprised when they accepted. If he was playing for time, the officers hardly noticed. Han was relieved to see that they were suitably awed by the lavishly appointed room. Piller strolled through the vast wood-panelled drawing-room, admiring Han's small but perfect collection of old masters.

As Han busied himself with the glasses of *jenever*, his visitors talked amongst themselves. A cursory investigation had told them that he was an eccentric, a sometime painter and occasional art dealer, living with his ex-wife, the actress Joanna Oelermans. They knew, too, that Han was rich, though the source of his wealth was mysterious. Neighbours said that he had won the French national lottery – some said he had won it twice.

Han returned with the Bols and a box of fine Havana cigars and sat, waiting for them to speak. He had been waiting half his life for this moment, for a knock on the door, a tap on the shoulder, a voice from the heavens which would acclaim him as a genius or expose him as a fraud.

'Maître,' one of the officers began.

The honorific surprised van Meegeren. In Dutch, 'Maître' is a title routinely bestowed on lawyers, but accorded otherwise only to great artists. It was a title he had long coveted, a mark of deference.

'Maître, we are members of the Dutch Field Service working with the Allied Art Commission. It is our job to trace and repatriate items looted by the Nazi occupying forces. Works of art, jewellery, gold, furs – even the factory supplies stolen from warehouses and shipyards. We have been asked to speak to you about a painting which our colleagues recently discovered in Austria. They say it is an important painting, a national treasure. A Vermeer.' At these words Han must surely have relaxed. He lit a cigar and passed the box around, sipped his Bols and doubtless smiled. Whatever the officers knew, it was clearly not what he most feared.

'Some days ago, we were contacted by colleagues in Austria who have found a cache of paintings stolen for the collection of Reichsmarschall Hermann Göring in an abandoned salt mine at Alt-Aussee. Major Anderson has also recovered a number of paintings from the castle at Zell am Zee, where Mijnheer Göring's wife is staying.'

In *Salt Mines and Castles*, Thomas Carr Howe described the find:

> Frau Göring's nurse handed over a canvas measuring about thirty inches square. She said Göring had given it to her the last time she saw him. As he placed the package in her hands he had said, 'Guard this carefully. It is of great value. If you should ever be in need, you can sell it, and you will not want for anything the rest of your life.' The package contained Göring's Vermeer.

Han nodded and refilled his glass, thinking quickly.

'The painting is a religious work,' the officer continued, '*Christ with the Woman Taken in Adultery*. Our colleagues could find no mention of such a painting in the catalogue of

Vermeer's work, but it is clearly a Vermeer and bears a striking resemblance to his masterpiece, *The Supper at Emmaus*, in the Boijmans Museum in Rotterdam.'

'Yes, yes . . . I remember the painting.' Han put down his cigar and leaned conspiratorially towards the officers. 'As I'm sure you know, aside from being an artist in my own right, I am an occasional art dealer, though I cannot always bear to part with such treasures.' He gestured to the paintings that towered over them.

'The Reich kept very detailed documentation,' the officer interrupted, 'so we know that Göring's adviser Walter Hofer bought the painting through a member of the Nazi occupying forces in Amsterdam, a banker named Alois Miedl. His records indicate that the painting was purchased from you.'

'I sold the painting, certainly,' Han blustered, 'but I did not sell it to anyone named Miedl – I don't even know the man. In any case, I have always been adamant that no painting should ever go to a German agent. No, I believe I offered the painting to the respected Dutch art dealer Rienstra van Strijvesand.'

'Of course, of course.' The junior officer nodded eagerly. 'We were not accusing you of anything, Maître. We have already traced the painting to van Strijvesand, so there is no reason to suppose you would have known that it was sold to the enemy. We simply need to know how you came by the painting so that the commission might restore it to its rightful owner.'

'It was part of the estate of a lady of Dutch origin. The family had moved to Italy many years ago, and when they later fell on hard times she asked if I would sell a number of paintings which her grandmother had brought with her, though only on the strict condition that I did not reveal the family's identity. Embarrassed by their reduced circumstances, you understand.'

His panic over, Han felt entitled to become a little testy now. 'Since they retained me to act for them strictly on the basis that I preserve their anonymity, I can tell you only that they left Holland some sixty years ago, and the painting was among their effects. Since the death of her father, Mavroeke – the lady I represent – has been compelled to sell some of her family's heirlooms. I can tell you no more than that.'

Han's indignation and integrity sounded heartfelt, his voice quavered with concern for this once-proud Dutch family, and his protestation that his source must remain confidential seemed genuine. In fact, the story was one he had invented a decade earlier for an altogether different occasion and he had told it so often now, he almost believed it himself. No one had ever questioned it. Nor did they now. The senior officer closed his notebook and the men finished their drinks and cigars in companionable silence. They shook his hand warmly on the doorstep, thanked him again for the Bols and the cigars and walked back towards their office on the Herengracht.

Han was surprised and irritated when the following morning he opened his door to find the same officers – slightly abashed – inquiring if they might ask him one or two more questions. Han brusquely waved them in, his previous courtesy exhausted.

'I'm afraid, Maître, we must insist on seeing the painting's document of sale. It's simply that, well . . . as I'm sure you know, it has been illegal to export works of art from Italy for many years.'

'Of course I know.' Han was peremptory; 'This is precisely the reason why I cannot reveal the identity of the family. If the *fascisti* were to discover that Mavroeke had smuggled the painting out – who knows what might happen to her?'

'Indeed, indeed . . . but for that very reason we need to be

sure that the painting was not looted or confiscated by the *fascisti* and sold to the Nazis.'

'Are you suggesting that I have acted as a go-between for Mussolini and Hitler?' Han snorted a derisive laugh. 'The very suggestion is monstrous!'

'Even so, we must insist on verifying that the documentation is in order.'

Han fumed on behalf of the unfortunate if imaginary family whom he had so gallantly aided. He had a duty of honour, he insisted, to respect the confidentiality of his clients. Unmoved, the officers insisted that if he could not produce documentary evidence to prove that he had obtained the painting legitimately from its owners, together with any supporting papers to confirm their ownership, they would reluctantly be forced to place him under arrest. Since such documentation had never existed, Han could only refuse.

'Then I am sorry, Mijnheer van Meegeren,' Joop Piller stood and laid a hand on Han's shoulder, 'I must arrest you on suspicion of collaborating with the enemy, to wit knowingly selling a national treasure to Reichsmarschall Hermann Göring. I'm afraid you will have to come with us to the station.'

Dazed and disoriented, Han may have asked for a moment so that he could talk to Joanna, his ex-wife, who still lived in his Keizersgracht home. But neither she nor his influential friends could help: within twenty-four hours Han was charged with treason and incarcerated.

Now, six weeks later, van Meegeren was still languishing in prison and refusing to co-operate with his interrogators. Joanna visited him regularly, and must surely have tried to persuade him to explain himself. She alone knew that Han did not sell a Vermeer to Hermann Göring, and that he could prove his innocence if he would only speak. Meanwhile the

reputation of this little-known painter, art dealer and land-owner was dragged through the tabloid press.

In the bright, postwar weeks after the Allied liberation, the Dutch were pitiless in their pursuit of those who had colla-borated with the Nazis. With liberation came a smouldering anger; a hunger for justice.

If the occupation had taken its toll on the Netherlands, freedom when it came had been slow in arriving. Six months earlier, on 'Mad Tuesday' – *Dolle Dinsdag* – as Allied forces marched across the southern border of the Netherlands it seemed that the war was over and the Dutch people celebrated in the streets. From her exile in London, Queen Wilhelmina called for a general strike in order to prevent German troops from reaching the front. In retaliation, the German authorities halted all shipments of food and essential supplies to the western provinces and began a savage, systematic looting of cattle, machinery, food and clothing. When the advancing Allies were halted at Arnhem, after the disastrous failure of Operation Market-Garden, there followed what the Dutch still call the 'Hunger Winter'. Deprived of supplies by the occupy-ing forces, 20,000 civilians died of starvation or hypothermia. 'It was horrific,' a Dutch journalist wrote at the time. 'The whole day was spent eating, eating, talking about eating. It began as soon as we got up. Should we eat this piece of bread now or save it until later.' By the time the Allied forces arrived, there was no bread, the hastily erected soup kitchens had long since closed, even the tulip bulbs had been eaten by the starving populace.

It was hardly surprising, then, that the people of Amsterdam read in stunned disbelief the newspaper accounts of how van Meegeren – the newspapers referred to him as a 'Dutch Nazi artist' – had lived the life of a millionaire while his compatriots

starved. The press described lavish parties at van Meegeren's opulent Keizersgracht home where the guests gorged themselves on black market food and wine. It was rumoured that there had been exhibitions of van Meegeren's paintings in Germany during the war. Han quickly came to symbolise the traitor within and the papers bayed for his blood.

Han was hardly an innocent – he was a liar, a swindler and an adulterer. In addition to his crimes, he had amassed a gratifying catalogue of vices: he was an alcoholic, a morphine addict, and regularly consorted with local prostitutes. To this, it might be added that his mental health was tenuous, he was a veteran hypochondriac and in all probability suffered from paranoid delusions. But of the charges against him Han van Meegeren was innocent: he had never sold a Dutch national treasure to the Nazis, a fact he could have proved at any time with four simple words. And still he said nothing. For the inveterate fabulist, the truth which might set him free was a long time coming.

There seems to be only one plausible explanation for Han's continued silence. He was wrestling with immortality. For six weeks, sweating, sleepless, shaking and delusional from the enforced withdrawal from alcohol, cigarettes and morphine, Han worried about his artistic legacy. As John Groom has it, 'Death stalks the forger, either literally as capital punishment or culturally as censorship.' This was Han's dilemma: if he told the truth, his life would be spared, but his paintings – *The Supper at Emmaus*, the most celebrated and admired painting in the Boijmans Gallery, *The Last Supper* in the collection of D.G. van Beuningen, *The Footwashing* in the Rijksmuseum, and half a dozen others cherished by public and private collectors as priceless treasures – would be derided and, in accordance with Dutch law, destroyed. If he said nothing,

though he were dead, his work would live on. Through the haze of panic, sickness, fear and frustration, he wrestled for six weeks with his decision, trying to mouth the words that would transform him from a Nazi sympathiser to a national hero: 'I am a forger.'

A PORTRAIT OF THE FORGER
AS A YOUNG ARTIST

1

THE LION TAMER

Every child is an artist.
The problem is how to remain
an artist once he grows up.

Pablo Picasso

Han van Meegeren was born to be a painter; unfortunately, he was fifty years too late.

With due solemnity on 19 August 1839, Paul Delaroche, one of the most popular and respected French painters of the nineteenth century, solemnly reported: 'After today, painting is dead.' Paradoxically, he made this statement while working on a twenty-seven-metre painting for the École des Beaux Arts depicting the history of art. The death knell came in response to the most spectacular event in the history of figurative art: the gift to the world by the French government of a dazzling new patent: the daguerreotype.

Across Europe, the new technology of painting in light dubbed 'photography' was greeted with excitement and awe. Exhibitions were held in the great cities of Europe celebrating this magical process which could freeze time and create a perfect likeness. Viewing an early daguerreotype, the

elderly J.M.W. Turner is said to have remarked that he was glad he had had his day.

Though Louis Daguerre's process was too expensive and cumbersome to supplant painting immediately, the fear that painting was dead was real and palpable. At the 1860 Paris Exhibition, Charles Baudelaire denounced photography as 'the refuge of failed painters with too little talent'. 'It is obvious,' the poet railed, 'that this industry has become art's most mortal enemy. If photography is allowed to supplement art in some of its functions, it will soon have supplanted or corrupted it altogether, thanks to the stupidity of the multitude which is its natural ally.' While many artists dubbed photography the *foe-to-graphic-art*, others were more sanguine: when asked by Queen Victoria whether photography was a threat to the painter, her miniaturist Alfred Chalon quipped dryly, 'No, Ma'am: the photograph cannot flatter.'

In fact, photography, far from destroying painting, was a major factor in its evolution. The traditional subject matter of the artist had been circumscribed by history, religion and mythology, photography, however, insinuated itself into every area of human experience, chronicling the lives of labourers and factory workers, capturing chance unposed moments, forever changing what was appropriate for observation. As photography struggled to mimic fine art, using soft focus and multiple exposures to ape romantic realism, artists began radical reconsideration of their subject and techniques, abandoning realism as the acme of artistic achievement in favour of strange and unfinished 'impressionistic' sketches.

By 1889, when Han was born, though realism was indeed in steep decline, painting was thriving. It was in 1889 that Gauguin turned away from Impressionism towards something less naturalistic, which he called 'synthetism'; that Georges

Seurat made his pointillist sketch of Gustave Eiffel's new Tower as men laboured to complete this iron folly for the Exposition Universelle. This was the year in which an unknown Dutch painter voluntarily admitted himself to the asylum of St Paul in Arles where he painted the stone bench and the swirls of cypresses in the hospital gardens; the year in which the young Henri Matisse, a court clerk who had never set foot in an art gallery, enrolled in a painting class in his native Saint Quentin. And it was in 1889 that Picasso, barely eight years old, painted what is considered to be his first work: *Le Picador*. Something almost magical was happening in Western art, some spark of madness, of genius, was at large, fuelling argument and controversy in Paris and London. Nothing of this had made its way to Deventer.

Han van Meegeren was born in the historic Hanseatic city of Deventer which then, as now, offered a comforting glimpse of the glories of Holland, a thousand years of history frozen in stone. From a distance, it seemed little changed from the city that appears in the riverscapes of Salomon van Ruisdael. Ringed about by a landscape of windmills, thatched houses, ancient forests and paddocks where sheep may safely graze, it was a bucolic idyll. Han came to loathe it. From his earliest years he had a taste for the high life, in later years a penchant for low life; Deventer offered neither. Its quaint medieval streets bristled with bourgeois common sense, but a short stroll to the outskirts of the soft centre reveals the hard industrial shell: nineteenth-century chemical plants, textile factories and machine shops, as dark and satanic as any Blake imagined, girdle it with their staunch Dutch work-ethic.

Henricus van Meegeren and his wife Augusta Louise christened their third child Henricus Antonius van Meegeren fol-

lowing the Dutch custom of giving their children Latinate names, but since the Dutch can rarely resist a diminutive, Henricus was shortened to Han, which became Hantje – 'Little Han' – to distinguish him from his father.

Henricus senior was the epitome of doughty, hard-headed pragmatism. A teacher at the Rijksweek school, he held degrees in both English and mathematics from Delft University and was the author of a handful of dry textbooks. In the family home, an elegant three-storey house with bay windows and a mansard-roof, Henricus governed his five children as he did his pupils. He was a good man: upstanding and honourable, without a whit of imagination. A zealous Catholic, he marched the family five miles in crocodile formation every Sunday to the church where Henricus's brother was parish priest. The children, Hermann, Han, Joanna, Louise and Gusstje, were forbidden to play with Protestant children. Han and his siblings quickly learned that to deviate from the future their father had mapped out would lead to heartbreak and disappointment. Henricus senior had already decided that Hermann, his eldest son, would enter the priesthood; Han, who was an able student, would follow in his father's footsteps as a teacher. The girls, he presumed, could hope only to marry someone of breeding and education, a man with a profession.

As a boy, Han drew lions. By the time he was eight, the margins of his schoolbooks had become rolling plains and circus rings where prides of great cats fought and played. His mother had taken him to see them. Augusta Louise nurtured in her son the same creative spark she had once felt in herself until marriage had snuffed it out. She took Han through the intricate tangle of medieval streets where Erasmus had dawdled as a schoolboy. She told him about Ter Borch, a great artist and Deventer's most famous son. She took him to see the gabled houses overlooking

the Ijssel, to St Lebuinuskerk and the Bergkerk, but Han always begged her to take him to De Waag, the medieval Weigh House which dominated the town square with its curious octagonal tower and turrets at each corner. Han would sit with his sketchbook and stare at the carved lions. Two of the beasts sat upright on pillars which flanked the great double staircase, others seemed to slink along the stone balustrades, crouched, menacing, waiting to pounce. Sometimes, on his way home from school, he would come just to stare.

The drawings were his secret. He spent all of his pocket money on pencils and paper. *Pappa*, he intuitively suspected, would not approve. He was ten years old when his father, livid that Han's schoolwork seemed to be suffering, stumbled on the sketchpads. He ripped the drawings to shreds before the bewildered boy's eyes.

'I will not have a son of mine idling and dreaming his life away,' Henricus spluttered with all the contempt he could muster. 'What possible use do you think drawing will be to you when you become a man?'

Han shuffled his feet.

'None! You will concentrate your energies on your studies.'

As punishment, his father had him write out a hundred times:

Ik weet niets, ik ben niets, ik kan niets
Ik weet niets, ik ben niets, ik kan niets
Ik weet niets, ik ben niets, ik kan niets
I know nothing, I am nothing, I am capable of nothing.

Augusta Louise replaced her son's sketchpad. She bought him crayons and pencils and encouraged his imagination. As best she could, she defended her children's dreams against the

thunderous pragmatism of his father. Each of the children developed their defences. Joanna, Han's eldest sister, was devious and manipulative, constantly turning her father's anger on her siblings. Hermann accepted his father's will with a meek stoicism. Gussje, the youngest, tried her best to remain the baby of the house, cosseted and spoiled. Han channelled his frustration into practical jokes. It was he who inveigled a reluctant Hermann to break into the sacristy of their uncle's church where the brothers got blissfully, riotously drunk on communion wine. Their crime went undetected until the following Sunday when, before church, their uncle realised the wine was missing. Han, eyes downcast, but with a flicker of a smile, confessed. Hermann was shamefaced.

It was a more daring prank that made Han a legend among the children of Deventer. Passing the local police station as he walked home from school one afternoon, he noticed the keys dangling in the lock, tinkling in the chill wind. The sleepy town was hardly a maelstrom of crime and calamity and the police were inside chatting and playing cards. Han crept up and silently locked the door. Slipping the key from the lock, he ran and tossed it into the canal. Then he crouched in a nearby garden and watched. Han knew, as everyone in the town did, that there was no other door. It was some minutes before one of the policemen tried to venture out on his rounds. Finding the door stuck, he cursed and swore and called his fellow-officers to help. A small crowd gathered, drawn by the commotion. For half an hour, the police hammered and yelled before an officer climbed out of a ground-floor window to find the door locked and the key missing. One by one, the embarrassed policemen emerged from the window. When a locksmith could not be found, they were forced to make a crude battering ram and break the door down.

News of the prank flitted around the playground, but no one knew the culprit. For Han, his triumph would not be complete until he was acknowledged; he boasted to his schoolmates. Word filtered back to Henricus, who marched his twelve-year-old son to the police station where Han confessed, a model of feigned contrition.

For all his bravura, he was a lonely child. He was awkward, gangling and fond of reading: philosophy, literature and history. He had little interest in sport and abhorred the rough-housing of other boys. When not compelled to be in school at prayer, he spent his time alone, sketching creatures from the vast bestiary of his imagination on the tablet his mother had given him. Time and again, he would give the fiercest lion in the pride the sullen, glowering features of his father and Hantje and pencil himself – a stick-figure with a chair and a whip – into the corner of the page, as if his father might be tamed.

2

THE ALCHEMY OF PAINTING

When my daughter was about seven years old,
she asked me what I did at work. I told her that
my job was to teach people how to draw.
She stared back at me, incredulous, and said,
'You mean they forget?'

Howard Ikemoto

'These,' Bartus Korteling gestured to the wooden bench, 'these
are your tools.' Han glanced up at his teacher, perplexed, then
at his friend Willem who smiled, half-embarrassed by his
father's theatrical gesture.

Han had met Willem Korteling on his first day at the Hogere
Burger School. Wim, too, liked to draw and to paint, and
within weeks they were inseparable. Han would later admit
that he was jealous of Wim, whose father, Bartus Korteling,
was not only an art teacher, but a professional artist. When
Wim boasted that he would grow up to be a painter too, Han
believed him.

Han looked around, confused by Korteling's cryptic remark.
He stared at the wooden bench in the centre of the studio, but
could see no paints, no palette, nothing he recognised. On the

bench was a large slab of scuffed glass. Beside it, plump and stately, gleamed a heavy glass pestle like an exclamation mark carved in ice. Laid out along the bench were small heaps of clay, dull irregular stones and hunks of metal ore.

'But . . .' Han stammered, 'but where are the paints?'

'Precisely,' beamed Korteling. 'If you are to be an artist, you must understand the tools of your craft, you must know how to make your paints.' Korteling smiled now at the boys. 'Colour is not something that can simply be squeezed from one of these *buizen* the English have devised. It is something to be crafted, something you can make and control as did the great artists of the Dutch Golden Age. Rembrandt van Rijn did not buy his paints, nor Pieter Claesz, nor the Master of Delft, Jan Vermeer. They worked with stone and clay, with the grinding board and muller.' He picked up the glass pestle; 'They understood how the intensity of colour fades once paint has been mixed, how it dries to become unworkable, how it blanches in the light.'

He glanced at his new pupil. Han, a frail, slim boy, looked younger than his twelve years, but his eyes were large and expressive. The boy glanced around the studio. The light which poured in through the high windows illuminated several canvases stacked by the walls. On the easel sat a half-finished oil painting of a still life so real it seemed as though Han could reach in and touch the silver jug.

'Do you know the paintings of Johannes Vermeer van Delft?' Bartus asked.

Han nodded – though he knew little about artists, he had heard the name.

'Have you been to the new Rijksmuseum? Have you seen *The Milkmaid*?'

Han shook his head. He had seen few paintings and had never been to Amsterdam, though he had heard of Pierre

Cuypers's complex of gardens and galleries which had opened a mere four years before he was born, whose soaring gothic towers incorporated fragments of historic buildings from all over the Netherlands.

'*The Milkmaid* is perhaps the masterwork of the greatest Dutch master, and yet it was painted with perhaps ten colours – no more than a dozen. Vermeer's skill was in combining few colours, mixing little and using layers of lakes and varnishes to build up the illusion of life.'

Korteling ran his finger along the bench, picking up the various ores, sifting the clays through his fingers.

'Massicot, prepared from lead and tin, gave Vermeer his radiant yellow, ochres raw and burned for browns and reds gave warmth to his shadows.'

He picked up a shard of animal bone.

'Bone black, made of the charred turnings of ivory. Green earth ground from celadonite. And this . . .'

Korteling held up a piece of jagged blue stone shot through with a filigree of gold.

'Ultramarine, the costliest of colours, is ground from this stone. It is called lapis lazuli, worshipped by the ancient Egyptians and found only in rare mines of the Orient. Artists throughout history have used it sparingly because of its expense, but Vermeer preferred it over azurite and used it not only as a jewel but for the everyday raiment of the poor and dispossessed. This is the colour of his genius.'

Han stood spellbound, listening to the man recite names that seemed magical, trying to understand what strange alchemy might transform these dull lumps of clay and stone into the brilliant colours he had seen in Korteling's paintings; wondering how they might transform his own childish sketches into wonders.

Bartus Korteling was an autodidact whose training in art was limited to a number of night-school classes at the age of forty. Now, he was a moderately successful painter who had exhibited and even sold some of his work, achievements which Han found romantic and thrilling. As a painter and a teacher, Korteling was a traditionalist, in awe of the painters of the Dutch Golden Age; he had little time for contemporary artists, except for the romantic realism of Johan Jongkind and Jozef Israëls. Korteling was impressed by the facility of Han's draughtsmanship, the intensity of his passion, his dawning realisation that art was an important part of Dutch history. Han already declared, with as much wistfulness as determination, that some day he would be a great artist.

Over the weeks and months, Han and Willem spent hours learning the arcane knowledge of the seventeenth century from Bartus. Korteling taught them how to prime the glass mortar using a paste of carborundum grit and water to provide sufficient traction or 'tooth'. Only then could they begin to prepare pigments. Korteling taught the boys how ores and metals were heated and clays roasted, how lead could be oxidised in jars of weak vinegar and the white powder collected to make a dazzling pigment. Han and Willem spent their after-school hours grinding pigments, watching as the stone or ore yielded up its colour, adding alum or clay as a base to 'lakes' – paints which did not have enough bulk to be used directly. They learned how to roast cobalt ore to produce an oxide, melt it with quartz and potash, then pour the melt into cold water where it disintegrated into blue powder which was ground to make a pigment that could be used as a substitute for costly ultramarine. Bartus taught them that some pigments had to be ground for as much as an hour or more; others if ground too much would lose their brilliance and intensity. Every

afternoon as he walked home, Han repeated this new rainbow like an incantation: vermilion, madder, carmine, weld, azurite, smalt.

What the boys were learning belonged to a tradition that had all but disappeared. Since 1842, when Winsor and Newton had patented the re-sealable paint tube, artists had increasingly bought their paints premixed. Industrial rollers ground pigments to a finer, more consistent powder and new colours like zinc white and cobalt blue, made possible by industrial chemistry, had replaced poisonous lead white and expensive ultramarine. Korteling admitted to his pupils that artists now bought their basic raw materials from chemists and artists' suppliers but, he insisted, the ability to make his own paints was one of the great skills of a true artist. As Han would later discover, it is a tool invaluable to the forger.

In Han, Bartus Korteling quickly recognised an impressive talent. The boy was inquisitive and learned quickly but he was jealous and competitive, constantly vying with Willem. Han's sketches were technically dazzling, but Korteling noticed that there was something superficial about his technique. Han always seemed to have half an eye on Willem's work and if he was not consciously copying it, he was certainly using it as a model for his own.

'You must begin to look beyond the surface,' Bartus chided him, 'you are a fine draughtsman, but you are too dazzled by your own technique.'

'But I simply draw what I see . . .' The boy was stung by even the mildest criticism.

'And you have a keen eye and a confident brush, but you must not allow technique to be your master. To draw, even to draw well, is not enough – you cannot compete with the camera for sheer mechanical accuracy: nor should you. To

be great, an artist must paint not simply surface light but what is inside, what he sees within his subject.'

'But how will I know if I am great?'

'Hard work, discipline and a respect for your subject. It is something you can feel, something you can sense in the portrait of even the most unworthy of Rembrandt's subjects.'

Han tried to think like an artist, tried to see beyond the everyday to what was within. When he was fifteen, he brought a pastel drawing to Korteling which he thought captured everything his teacher had taught him. Like Turner's *Rain, Steam and Speed*, his subject was a steam train; it came hurtling from a tunnel across a summer meadow of wildflowers and grasses in a fury of energy and power. The pastel was crude, almost impressionistic: smoke erupting from the chimney, an angry glitter of sparks spraying from rails which glowed white-hot. This was technology at its crudest set against the raw simplicity of nature. Korteling, aware that Han was keenly sensitive to criticism, was kind.

'It is a powerful piece – it has . . . energy, passion, perhaps some originality: but it is crude. You must control your passion.'

Han's smile faded, and he looked down at his drawing, embarrassed now by its childish rawness.

'You've allowed yourself to move away from perspective, to draw things as a child might . . .' Korteling went on.

'You said I should paint what I feel . . .'

'Indeed, indeed – but it must be tempered with intellect, you must be master of your emotions and not they of you. I've no doubt you are tempted by these new artists, by the superficial dazzle of these "Impressionists", but it is a passing fashion.'

Han did not argue. Korteling was his only ally and over the years the teacher had become a friend and mentor whose

support and encouragement went some way to compensate for his father's scorn and contempt. It was in Korteling's books of monographs and reproductions of the masters of the Dutch Golden Age, that Han found the space to dream that the spark of talent within him might grow into something.

As adolescence began to course through his shy and awkward body, Han, who had never summoned the courage to speak to a girl, discovered he could create his own. His classmates, who had always teased him about his art, suddenly noticed that every sketch he drew seemed to be a nude. Han always pictured these girls from behind, lavishing much care and attention on the curve and heft of their buttocks. When one boy asked to 'borrow' some of Han's drawings, Han hesitated. Though Korteling had always impressed upon him that the nude was an entirely respectable subject in art, Han was in no doubt that what his friend intended to do with them was far from respectable.

'I–I don't think so . . .' Han mumbled.

'OK, then – I'll buy them from you.'

Han was stunned. It had never occurred to him that anyone might want to *buy* his work.

'I'll give you five florins.'

Though he worried that his friend's parents might not approve, the sheer pleasure of being offered money for his work outweighed his fear and Han sold the sketches. Suddenly his love of art, for which he had always been teased and bullied, was in constant demand. His finest hour was one he would never tire of telling to his own children.

'One day one of the seniors came up to me – Walter, his name was, he was tall with ginger hair and was a fine footballer. He was one of the most popular boys in school.

He'd never even spoken to me before. He had seen some of my drawings and offered me a week's pocket money if I would draw some sketches of his girlfriend and leave them unsigned. He wanted to take the credit for the drawings himself.

'I thought it was amusing, but I was flattered that he wanted to pretend to have my gift to impress his girlfriend. So I sketched her – she was a pretty girl with a freckled face. I had kissed her once at a Christmas party.

'After he had shown her the drawings, I even thought about telling her that I was the artist – but I never did.'

Thirty years later, still proud of his role as Cyrano, Han would say, 'You know, she married Walter in the end.'

Han's own first love was a pretty girl named Thea who worked in a restaurant overlooking the Ijssel and lived on a barge on the river. Han watched her from afar, sketched her and showed the result to her. She was impressed; she even let him kiss her once or twice. Han asked if she would come and sit for him on Sundays so that he could paint her portrait. She should wear her blue and white dress, he suggested, with her hair loose over her shoulders. He prepared his materials, bought a small canvas, and even managed to steal some lapis lazuli from Korteling's studio to make ultramarine. Han was more in love with the portrait than with Thea. She sat for him only once, quickly bored by the monotony of holding a pose. Han tried to complete it from memory but failed. Twenty years later he would still speak of the *Girl in a Blue Dress* as his first rejection.

One day during their final year at the Hogere Burger School, Wim asked Han where he was going to study art. 'Maybe we could study together. My father says I should study in Delft, maybe you could go there too.' Han was touched that Wim

had assumed that they would both be students of art. In fact, Han had given his future little thought. He knew that everything had already been decided. Henricus had always insisted that Han would study mathematics and qualify as a teacher.

'I don't know – I mean, I'd like to. I'll have to talk to my father.'

Han did not even know how to begin such a conversation. His brother Hermann had already left home for a seminary, browbeaten into studying for the priesthood. It was folly to think of talking to his father about studying art. Henricus had made no secret of his distaste for Han's vain, frivolous pastime, and had been as good as his word, destroying Han's paintings and sketches whenever he happened on them.

In the spring of 1907, Han steeled himself and told his father that he wished to study art. Henricus, marshalling his most thunderous glare and spluttering bombast, refused even to consider the idea. Han tried to stand his ground but withered in the face of his father's fury. It was only when his mother interceded that Henricus – uncharacteristically – suggested a compromise: while there was no question of Han studying fine art, Henricus agreed that the boy might put this idle talent for drawing to good use and study architecture, a profession which just met Henricus's threshold of respectability. He would finance his son's studies only if Han would commit to finishing the six-year course in five. Han eagerly agreed. It was Bartus who suggested that the boys could still study together. Han could take architecture at the Technische Hogeschool – the Institute of Technology in the cradle of the Dutch Golden Age: Delft.

3

THE VIEW OF DELFT

So departed this Phoenix to our sorrow in the
midst and at the height of his powers, but
happily arose from out his fire, Vermeer
who in masterly fashion treads his path.

Arnold Bon, *The Phoenix*, 1667

Looking north from the Hooikade across the Schie, the river-
scape sweeps from Kethelstraat in the west, along the medieval
city wall to the magnificent Schiedam Gate. Across the canal
stands the Nieuwe Kerk framed by clouds and further east the
Rotterdam Gate, its great barbican crowned with octagonal
towers stretching out towards a double drawbridge which
leads to the shipyards. The city seems silent, prosperous and
peaceful, glowing in the haze of early morning. Wealthy
burgers gossip on the quays as the glassine river flows almost
imperceptibly.

Stepping back from the painting in the hushed halls of the
Mauritshuis, Han felt a wave of sadness. When he had
dreamed of Delft, this was how it rose in his imagination.
He had pored over the monochrome reproduction in Korte-
ling's catalogue many times. Now, here it was: Vermeer's *View*

of Delft. It was a view he should be able to see himself every day. The Hooikade was a minute's walk from the Institute of Technology on the confluence of canals known as de Kolke. He had stood there often, looking north as Vermeer had done, but the world the master had captured, the brickwork, the gates, the towers and the bridges, had disappeared.

The great barbican which dominates the painting's eastern skyline was demolished soon after Vermeer painted it and the medieval city walls had long since crumbled, but much of the glory of Delft had held out until it fell to the industrialists of the nineteenth century. The Kethel Gate and the magnificent red-brick and limestone Schiedam Gate were torn down in 1834 and two years later, the Rotterdam Gate was reduced to rubble. Of Vermeer's numinous cityscape, only the spires of the Nieuwe Kerk and the Oude Kerk remained.

Han stared at the painting, rapt. This was his first visit to the Mauritshuis, his first glimpse of the artist he would come to love above all others. It was appropriate that his first love was the *View of Delft*, the painting which, according to his biographer John Nash, rescued Vermeer from oblivion.

On Wednesday 16 May 1696, almost twenty years after Vermeer's death, the property of Jacob Dissius, including the largest collection of Vermeer's work ever offered for sale, was auctioned. Lot number thirteen, *The Town of Delft in perspective, to be seen from the South*, sold for the princely sum of 200 guilders. Thereafter, the painting – and Vermeer – all but disappeared. In the century and a half that followed, Vermeer's name was mentioned only in passing by art historians as one of the 'pupils and imitators' of Gabriel Metsu or Pieter de Hooch. It was not until May 1822 that the *View of Delft – This most capital and famous painting of the master –* reappeared, to be bought by the Dutch state for 2,900 guilders and presented to

the newly opened Mauritshuis. It would take a further thirty years before the painting and its artist were 'discovered' by Théophile Thoré, the eminent French critic whose obsession with the man he called 'the Sphinx of Delft' would single-handedly secure for Vermeer a place among the masters of the Dutch Golden Age.

Thoré, a respected and influential cultural commentator, was critical of neoclassicism and the romantic tradition of Géricault and Delacroix, favouring instead the new realism of Courbet and Millet. He was an early admirer of the Impressionists. In part Thoré's taste was political: he was a radical who had been elected a member of the *Assemblée Nationale* after the revolution of 1848, but was forced to flee France after his involvement in an abortive coup d'état. What he admired in Dutch seventeenth-century art was precisely what he had praised in the work of Courbet and Millet: an unassuming realism, with none of the trappings of romanticism, of allegory or history. He did not believe in *art for art's sake*, the popular catchphrase of the times, but, as he put it, *art for man's sake*.

'. . . having become, of necessity, an exile,' he wrote later, 'and, by instinct, a cosmopolitan, living in turn in England, Germany, Belgium and Holland, I was able to explore the museums of Europe, collect traditions, read, in all languages, books on art, and attempt to untangle somewhat the still confused history of the Northern schools, especially the Dutch school, of Rembrandt and his circle – and my "Sphinx" van der Meer.'

From the moment in 1849 when Thoré stood and gazed at the *View of Delft*, as Han did now, he became obsessed with the work of this forgotten master. 'The obsession caused me considerable expense. To see one picture by van der Meer, I travelled hundreds of miles: to obtain the photograph of

another van der Meer, I was madly extravagant.' For almost
twenty years he lived in exile, travelling under an alias and
researching Vermeer's life and work. Despite his limited
means, he bought several paintings by Vermeer. In 1866,
under his pseudonym Willem Bürger he published a dazzling
three-part study of the work of Johannes Vermeer van Delft in
the *Gazette des Beaux-Arts*. It was the first step in elevating
Vermeer to the ranks of the great Dutch masters of the Golden
Age.

It was a painstaking task. Vermeer signed barely half of his
paintings, and by the nineteenth century many of his works
had come to be attributed to other – more famous and more
valuable – artists. George III accidentally acquired a Vermeer
he was told was a Frans van Mieris, the Emperor of Austria
bought *The Allegory of Painting* as a genuine Pieter de Hooch,
and *A Woman Reading a Letter* spent a brief, glorious period
as a Rembrandt before becoming a de Hooch in 1826. Thoré/
Bürger proved a perceptive but quixotic critic. Though he
correctly recognised Vermeer's hand in these paintings, he
mistakenly included works by Mieris, Jan Vermeer of Haar-
lem, and Jacob Vrel. In fact, Thoré/Bürger's favourite Vermeer,
A Rustic Cottage, reproduced on the first page of his article, is
now attributed to Derk van der Laan. Thoré/Bürger began to
see Vermeer's hand in everything. Eventually, the founder of
Gazette des Beaux-Arts, Charles Blanc, protested in exaspera-
tion: 'Nowadays, Mr Bürger sees Delft just about everywhere;
although until now we have benefited from his mania; leave
him alone!'

In the summer of 1907, when Han made his first pilgrimage
to The Hague, Vermeer was still all but unknown. The pioneer-
ing work of Théophile Thoré, and recent discoveries by Abra-
ham Bredius, the director of the Mauritshuis, were only then

being distilled into the first *catalogue raisonné* of the master's work by Cornelis Hofstede de Groot, the deputy-director of the Mauritshuis. De Groot's monograph, published in the autumn of 1907, slashed the seventy-three paintings Thoré/Bürger had attributed to Vermeer to barely fifty. Of these, four were then in the Mauritshuis: alongside the *View of Delft* hung *A Lady Standing at the Virginal* and *Woman with Pearl Necklace*, both of which had been bequeathed to the museum by Thoré/Bürger. Next to them hung *Diana and her Companions*, which was then on loan to the museum. Han found himself inexplicably drawn to the artist. It was not merely that Vermeer's work encapsulated all of the virtues of the Dutch Golden Age which Korteling had instilled in him. Vermeer's long sojourn in obscurity appealed to van Meegeren. Here, he thought, was a kindred spirit: an artist reviled and rejected by his own, his genius only belatedly and grudgingly recognised by his countrymen. For even at the tender age of eighteen, Han did not aspire to be an artist, he aspired to genius.

In his first year at university, Han was diligent in his studies but he spent as much time as possible in The Hague, haunting the halls of the Boijmans and the Mauritshuis, sometimes travelling to Amsterdam to spend whole days wandering the galleries of the Rijksmuseum. His passion for fine art crept into his architectural assignments: his professors were bemused to see front elevations adorned with classical statues, casements ornamented with flourishing window-boxes, dogs sleeping in the gardens, once even an anatomical study of a horse's head in the margin. When not attending classes, Han spent his time with Wim, quizzing his friend as if attempting to take an art degree by proxy. His free time he spent mastering the styles of the artists he admired, practising the techniques of Rubens and Rembrandt, constantly circling back to Vermeer, utterly

unaware that at that very moment Pablo Picasso was adding the final electrifying brushstrokes to *Les Demoiselles d'Avignon*, the painting that would unleash cubism on a startled public and change the face of art once more. Seventy-five years later, the critic Robert Hughes would write: 'With its hacked contours, staring interrogatory eyes, and general feeling of instability, *Les Demoiselles* is still a disturbing painting after three-quarters of a century, a refutation of the idea that the surprise of art, like the surprise of fashion, must necessarily wear off.' The twentieth century had arrived just as Han was struggling to absorb the seventeenth.

At university, Han reinvented himself. The precocious adolescent became a dandy, the scrawny boy who had hated sports joined the boat club where he proved an able oarsman and developed an impressive physique. He cultivated vice, becoming an accomplished smoker and an incorrigible drinker. From the imperious heights of the Delft Institute of Technology, Han looked out upon a new world, far from the narrow strictures of his father. To his new friends, he introduced himself as an artist. At night he and Wim would go drinking with their companions and Han would hold forth on art and culture, offer opinions on contemporary artists and styles he barely knew and regurgitate half-digested philosophy with wit and passion and the infallibility that for centuries has been issued to first-year students. Walking home as dawn broke over the canals, euphoric and inebriated, his friend Wim later related, Han would stop at every street corner and announce himself: 'Henricus van Meegeren: genius!'

It came as a shock to Han when, returning to Deventer for the holidays, he found his brother Hermann there. After almost

two miserable years studying at the seminary at Culemborg, Hermann had finally admitted that he had no vocation and had run away. Hermann was reticent about the reasons for his loss of faith, but Han had the impression that his brother had been involved in a homosexual affair. His father was incensed, implacable. There could be no question of wasting the years of religious instruction, to say nothing of the esteem which a son in the priesthood would confer on the family. Han argued with his brother, urging him to stand up to their father's benighted authoritarianism. When Hermann fell to pieces, Han took up his brother's case, but Henricus was immovable. He contacted the local bishop, who arrived some hours later and dragged the recalcitrant sheep back to the fold.

Han would not see his brother again. After returning to the seminary, Hermann's health began to fail. He had always been a sickly child and his father thought the boy's illness wilful. The abbot may have concurred, for it seems that no doctor was called to treat Hermann, nor, when his illness worsened was he admitted to a hospital. Before he could be ordained, Hermann was dead.

4

A SHADOW OF DIVINE PERFECTION

Art is either plagiarism or revolution.

Paul Gauguin

Her name was Anna. She was Eurasian, alien, exotic, like Vairaumati sprung from one of the brazen, burnished Tahitian portraits by Gauguin. Her skin was sensuous and tawny, her eyes were pale almonds, her hair shone like a hank of coal-black silk. Han sketched her on a summer afternoon at the boat club, her willowy limbs trailing in the iridescent water, sunlight pooling around her bare feet like beads of spilt mercury.

For almost a year, he watched this dreamlike wraith. He did not speak to her, he hardly dared look at her. Despite the urbane personality he had assiduously cultivated since arriving in Delft, Han was excruciatingly shy in the company of women. Even now, in his fourth year in the town, at the age of twenty-two, he was still a virgin.

Han was jubilant and nervous at discovering she was studying Fine Art. He begged his friend Wim to find out who she was. Her story was as enchanting as her dusky skin. Her name, Wim told him, was Anna de Voogt and she had been born on the island of Sumatra in the Dutch East Indies. Though her mother

was not of noble birth, news of her startling beauty reached the son and heir of an Indonesian prince who wooed her and asked for her hand in marriage. But Anna's mother was captivated by the lure of the West and rebuffed the prince to marry Heer de Voogt, an official with the Dutch East India Company. If her mother dreamed of being swept away to Europe, she was disappointed. Before Anna was five years old, her father was re-posted to Java and her parents divorced. Anna was sent 'home' to the Netherlands where she was raised by her grandmother in Rijswijk, a small village on the outskirts of The Hague.

Wim arranged an introduction, and Han stammered the lines he had been rehearsing for almost a week: 'I have a bone to pick with you. I am an artist and you are the one girl I am unable to draw!'

Anna laughed, flattered by Han's self-conscious bluster and impressed that this gangling youth could so confidently introduce himself as an artist. They chatted easily, sitting on the riverbank. Anna asked Han about his studies and he shame-facedly admitted that his father had forced him to study architecture.

'But I am an artist,' he said, 'I can show you my work.'

To her surprise, Anna discovered in his work a confidence, a sureness of line and an eye for detail which impressed her. They were soon inseparable. She loved him because under his wild free-thinking he was sensitive and shy. He loved her from the moment she asked the simple, innocuous question: 'Why on earth are you studying architecture? You're already an artist.'

He painted her at every opportunity, but the painting she most loved was the first: a strange exotic scene conjured out of his imagination. He knew nothing of Indonesia, but invented the flowers and the vegetation that framed a scene of her olive-

skinned body, naked, emerging from the sea. When Han, worried that someone would recognise the model, suggested that he burn it, Anna laughed at him.

'Don't be so prudish, Han, this is the best thing you have ever done.'

Han blushed charmingly: he was besotted. Anna was intelligent, mysterious, stunningly beautiful, but most of all she believed in him as an artist. By her side he felt as if he no longer needed to pretend: her affection, her admiration, her awe were unconditional. Within six months, he had asked her to marry him. Anna was firm but affectionate in her refusal: they had not yet finished their studies and had no means of support. Undeterred, Han proposed to her over and over, too impulsive to tolerate deferred gratification.

In the end, the decision was made for them when Anna fell pregnant. Girding herself against the stories Han had told her of his fearsome Henricus, Anna agreed to meet his father. Henricus, though furious at Han's recklessness and deeply prejudiced against the Muslim faith, was won over by this intelligent, level-headed girl. He blustered about the importance of Han's studies, his career, but he sensed that here was someone who might keep his heedless son's feet firmly on the ground.

'You realise the boy is a dreamer. If you do not discipline him, he will never be able to support you and the child. Do you think you can keep him in check?'

Anna laughed, warming to this gruff man in whom she saw something of Han.

'I will try, sir.'

His blessing when it came, was conditional: Anna had to agree to convert to Catholicism and raise their children in the Catholic faith. They married in the spring of 1912 and, with no

money to set up home, moved into a small apartment above Anna's grandmother's house in Rijswijk.

Immediately, Han converted the bright, spacious loft in their new home into 'his studio'. He was excited, elated: finally he was an adult – free to make his own decisions, to carve his own way in the world. He had a wife who worshipped and admired him, who believed in him and nurtured his talent. In their first breathtaking year together, he could barely take his eyes off her silken skin. She was his first willing model, and even as her belly swelled, he would call on her at all hours of the day to come and pose, endlessly excited by her bare foot, the tender nape of her neck, the delicate curve of her breasts as he worked on a painting. Anna became increasingly worried that he was devoting little time to his studies. Han, whose only architectural work had been to redesign the university boathouse where the couple had met, told her he had no intention of being an architect. He was an artist, he said, and would support Anna and their child by the wiles of his pencil. Anna insisted he should complete his degree in architecture. He had studied for five years, she argued, it was important to spend these last months revising so that he could pass his exams. It would take time to establish himself as an artist; in the meantime architecture would offer the family much-needed security.

Han would have none of it. Perhaps, he admitted, he could not expect commissions and portraits before he had proved himself, but in the meantime, he was prepared to dip his brush into the tawdry world of newspaper illustration. He approached a number of editors who asked him to provide samples. For one, who had asked for illustrations of a bear to accompany an amusing story, Han worked himself into a frenzy, making endless visits to the zoo to sketch bears at play, studying the stuffed bears in the

Natural History Museum and poring over books by naturalists. When he submitted the fruits of his labour the exasperated editor pointed out that the illustration was totally unsuited to the coarse four-colour printing process of a newspaper.

Han threw himself into a detailed research of letterpress and offset printing. Being intelligent and inventive, he was at first fascinated by the limitations of printing and went so far as to devise a method of his own which, he claimed, would obtain the same results from a two-colour process of blended inks, thereby saving publishers money on plate-making and printing. Taking a number of illustrations which demonstrated the invention, he returned to the editor who was impressed by Han's determination, but doubtful that this ingenious two-colour offset process would work. He asked if he could show the samples to his printer. Han spent a week in excited anticipation of the commissions that would result from his discovery. He was stunned when the editor informed him that the printer had advised that the process was impossible; furthermore, that they doubted that Han had used only two inks in creating the illustrations. In the first year of his marriage, Han did not earn a single florin from his pen.

Han cursed the entire profession of publishers and printers as charlatans and philistines. It had been a mistake, he told Anna, to ever prostitute his talent for the common coinage of commercial art. He was an artist, a great artist. Anna sighed; though heavily pregnant, she had done her best to support and encourage Han in his attempts to find work but in their short time together she had become accustomed to her husband's mood veering between unbridled optimism and cavernous despair. She was in awe of his talent but frustrated that he seemed so impractical. He clearly had ambition but was too thin-skinned to deal with even the slightest criticism.

When Han told her he had abandoned commercial illustration and was working on something for the Institute of Technology, Anna was relieved. 'Perhaps it is for the best,' she said gently, 'you need to concentrate on your studies, you have your finals soon.'

Han snorted. 'I'm not worried about the exams – I'm quite sure I will pass. No, that's not what I was talking about. I've decided to enter for the Institute Gold Medal.'

The quinquennial Gold Medal awarded by the Technische Hogeschool, adjudicated by some of the foremost figures in fine art, was intended to honour a single work by a student, which in their considered opinion represented the pinnacle of artistic achievement. The prize had no monetary value, but the prestige and honour it conferred could launch an artist's career. Graduates from the past decade were customarily encouraged to submit their finest work for the prize. If he entered, Han would be the only candidate with no formal training.

'No, Hantje,' she said firmly, 'where will you find the time? The baby is due in November, your finals are in December and this masterpiece would have to be completed by January. It's too much. How will we survive with a small child if you fail? Your father certainly won't support us.'

'I don't need my father's money, Anna. By the time the baby comes, I will have finished the picture and can concentrate on my finals. I'll be an architect and an artist!'

As his subject, Han chose something which was startling in its ambition: a watercolour of the interior of the St Laurenskerk in Rotterdam. The interplay of lines and arches allowed him to draw on the skills he had acquired in his architectural studies, tested his eye for detail and offered him ample freedom to display his dazzling near-photographic technique. He wanted to capture not only the restrained Brabantine gothic

style, but also a sense of spirituality, of worshipful tranquillity. He quickly realised that mere architectural detail would overwhelm the picture and decided instead to work in the style of Johannes Bosboom, the nineteenth-century Dutch romantic realist famous for his church interiors. In fact, his composition was disturbingly reminiscent of Bosboom's brooding, almost monochrome *Choirloft of the Grote Kerk in The Hague* which Han had seen in the Gemeentemuseum.

The initial drawing was a tour de force, capturing in intricate detail the complex tracery of towering stone, but it was too meticulous, too formal, too cold. Han spent whole days in the magical half-light of the St Laurenskerk, sketching the choir loft, the high altar, the soaring nave of the cruciform basilica, struggling to catch some quality of light, trying – as he explained to Anna – to capture 'the sound of a Bach chorale in light'.

In November, when Jacques was born, the watercolour was still not completed and Han felt frustrated, trapped, overwhelmed. Abruptly, he abandoned his painting of the Laurenskerk, in a panic; Anna had been right and he would be neither architect nor artist. He settled down to study for his finals. In the evening glow of the attic rooms in Rijswijk, he watched Anna nursing Jacques, a *tableau vivant* of Madonna and Child, and prepared for his next examination. He felt happier now, more confident. Once he had passed his exams, he reasoned, he could work as an architect for a few years and slowly build his career as an artist. When the results were published, Han was crushed to learn that he had failed.

A week later, as meekly as his bristling anger would allow, he stood before Henricus in his father's study in Deventer.

'And what precisely do you expect from me?' asked his father. 'I agreed to sponsor your folly in studying architecture if you

were prepared to work. Instead, you idle away your time drinking and carousing, you get a girl in trouble and – against my better judgement – I give my blessing to your marriage. Now you expect me to support your wife and your bastard child?'

'I've been trying to support my family,' Han said, 'I have been discussing the possibility of work as an illustrator for one of the newspapers in The Hague.'

'I might have guessed you would be doodling again. Art is the root of all your troubles.'

Han hung his head, feeling a queasy sense of déjà vu, remembering himself in this very room when he was ten years old, the ache in his hand as he scrawled, over and over: *Ik weet niets, ik ben niets, ik kan niets*; I know nothing, I am nothing, I am capable of nothing.

He babbled excuses and promised his father he would devote himself entirely to his studies if only Henricus would continue to pay his allowance for another year. His father demurred. He could not condone Han's failure but he agreed to *lend* Han the money at the standard banking interest rate if he would agree to abandon the foolish notion of being an artist. The money was to be repaid immediately Han secured work as an architect. Han nodded and for the first time in his life he doubted himself – perhaps his father was right, perhaps art was nothing more than a trivial idiocy: look at the childish daubs that passed for genius nowadays.

When Han returned to Rijswijk, it was Anna who persuaded him to finish the watercolour of the Laurenskerk. Taking it from his folio and placing it on the easel, Han could immediately see what was missing: sunlight. Suddenly animated, he explained to Anna and the baby as it burbled in her arms how he would warm the charcoal shadows of the stone with an umber wash and describe a torrent of sunlight from the

stained-glass windows of the nave flooding the transept with a numinous golden glow.

When it was finished, they stood and looked at it.

'It's perfect,' murmured Anna.

'Not perfect, no – nothing is ever quite as you imagine it – but I think it is complete.'

'It's perfect,' she murmured again.

A Study of the Interior of the Laurenskerk was unanimously awarded the Gold Medal by the judges of the Delft Afdeling Algemene Wetenschappen van de Technische Hogeschool in January 1913. Passing over entrants dabbling in the hazy waters of Impressionism, the coveted honour was bestowed on a resolutely traditional watercolour by a young man with no formal artistic training. Perhaps the judges were trying to shore up art against the rising tide of modernism and were overjoyed to see in Han's watercolour the legacy of the nineteenth century.

Though Han received no money with the award, the study – a genuine van Meegeren – sold for the extraordinary sum of a thousand guilders, the equivalent of almost six thousand dollars today. At last, he was officially an artist – the greatest Dutch artist of the last five years. Perhaps, after all, he was a genius.

As soon as he had won, Han told his wife he was abandoning his architectural studies. Despite his promise to his father, he had no intention of re-sitting his final exams, though he was shrewd enough not to inform Henricus of his decision since the family still needed the allowance. Anna, who had grown fond of her gruff father-in-law, was worried – especially as Henricus's allowance was intended as a loan.

Han sneered. 'The man is a boor, he deserves everything he gets. Fleecing philistines by fair means or foul is common sense in my book. Father would never allow me to be an artist.

Remember how he treated Hermann?' Anna said nothing. She knew her husband would never forgive his father for forcing Hermann to return to the seminary; for his part, as Han saw it, in Hermann's death.

It may have been Anna's misgivings or his increasing confidence in his future as an artist that eventually persuaded Han to confront his father. When Henricus learned that Han had no intention of re-sitting his exams, he was furious, but his rage turned to apoplexy when Han told him he intended to enrol in the Hague Academy to take the degree in fine art which would give him the standing and the recognition to earn his living as an artist. Henricus curtly informed him he would not get another penny in support.

'I don't need your money,' Han snapped, 'I shall sit my exams in my first year; after that I shall earn my living as an artist.'

The Hague Academy was bewildered and dismissive that a student wished to enrol merely to sit his final exams, but having interviewed this curious young man and reviewed his portfolio they agreed that he would be permitted to sit the exams the following summer. In the meantime, the Delft Gold Medal ensured a steady stream of commissions, but Han was surprised and disappointed that his work commanded so little in comparison with the fortune paid for the Laurenskerk study. His first painting, a portentous portrait of a prominent businessman in the style of Rembrandt, earned him barely sixty guilders. It was enough, if Han were diligent, to make a living. At first, Han was excited by the opportunities that portraiture offered; he wanted to explore his subject's character, bring to light the timorous or injured soul of the sitter. But his patrons were not interested in his psychological insights – as a plain but affluent burgher informed him in no uncertain terms: 'My husband is not paying you to paint me as I am, but as I ought to be!'

'I don't know what the woman expects,' Han fumed to Anna. 'Doesn't she realise I'm an artist? No – not an artist, the finest Dutch artist of the last five years. I'm not some hired sycophant.'

As the months passed, Han, disillusioned with the work, began to spend his days wandering the canals, sketching the flower barges and the carts, the fishermen at the port. He refused to go back to the Institute of Technology and study for his exams and twice became so distracted by his sketching that he forgot that there was a sitter waiting for him in his Rijswijk studio.

Anna became desperate. The couple had little money, the accounts with the grocer and the butcher went unpaid and months passed without a commission. Local shopkeepers began to refuse her credit. Finally, she was forced to borrow money from her grandmother to tide them over. When she told Han, he seemed unconcerned.

'We have to eat, Anna. I am an artist – the least I can expect is to be able to eat as well as a stevedore. In fact, I deserve to live at least as well as the bourgeois fools I'm forced to paint.'

Seeing her glare at him, her sensuous lip quivering with humiliation, he smiled. 'Don't worry – we will pay her back soon enough. I am working on a commission which will pay off all our debts and leave us with money to spare.'

Anna looked at him questioningly, but Han simply smiled and shook his head, touching his finger to his lips. He had never been secretive about his work. In fact, he had always admired the fact that his wife had a degree in fine art and could discuss his work intelligently. So it was that, some days later, Anna crept into the studio to see what Han was working on. She was surprised to discover a watercolour almost identical to his prize-winning *Interior of the Laurenskerk* on his easel.

It is not a crime to copy a work of art. For centuries, artists have learned their craft by imitating the works and the techniques of great artists until they have absorbed the lessons of the masters. Into old age Rubens copied and improved on the work of those he admired. Delacroix, despite his meteoric career, numbered more than a hundred copies of paintings by Raphael and Rubens among his work. Nor is a copy necessarily a lesser painting than an original: in 1976, Christie's auctioned two near-identical paintings. *Approaching Storm* by Willem van de Velde, an artist whom Turner had complained was a better painter than he could be, fetched £65,000; *Approaching Storm, in the manner of Willem van de Velde the Younger*, by J.M.W. Turner, sold for £340,000. Artists copy the pictures of those they admire, those they aspire to, acknowledged masters whose work embodies everything they hope to achieve. Han's acknowledged master was himself.

When Anna confronted him about the painting, Han was short-tempered and defensive. 'It's hardly unknown for an artist to revisit a subject,' he quipped dryly, 'besides, the study of the Laurenskerk earned me twenty times more than the fawning portraits I've been forced to paint.'

'I don't quite understand,' Anna said gently. 'Of course an artist often returns to the same subject, but this is more than that: it looks almost identical to your first study. Is it a commission?'

'Of a sort,' Han said equivocally, 'it's for a foreign collector who is passing through Delft. He was very impressed by my original.'

'But you're not selling it to him as the original, surely.'

'What if I am?' Han was indignant now. 'It's every bit as good as the original – better in my opinion, my technique and my ability are greater now than when I won the Gold Medal.

He's getting a better painting and I'm not charging him a guilder more.'

'Han, you can't – it's dishonest – it's a forgery.'

'How can it be a forgery? I'm not deceiving anybody. It's my own work, a genuine van Meegeren. Is it aesthetically inferior to the original? Will he derive less pleasure from it? If you put the two side by side, no critic alive would be able to tell which was the original and which the copy. The man is buying the painting not the medal – in any case, he's only here for a few weeks, so he'll never know.'

Anna was forced to agree that the new study was as beautiful, perhaps more beautiful than his original. Why then, she asked, would he wilfully misrepresent it? It was dishonest, worse, it was unworthy of him. Here was a collector who was truly an admirer of his work. Surely, Anna argued, he would not balk at paying a thousand guilders for a more brilliant work by the same artist. Embarrassed that he had doubted himself, and encouraged by his wife's unshakeable faith, Han eventually agreed.

Anna offered to negotiate with the buyer, but Han insisted on going himself. Even then, he felt compelled to lie to save face, telling the buyer that he had made the second study because he could not bear to be parted from the original. The buyer nodded sympathetically but amended his original proposition: rather than the thousand guilders agreed, he offered Han eighty.

In the summer of 1914, Han confidently took his seat among the veteran students in the magisterial examination hall at the Hague Academy. This, he thought, was his final rite of passage. With a degree from the finest academy in the land, he would command the attention of critics and dealers, he

could apply to join the Hague Kunstring, and finally begin to carve out a career for himself. He was stunned and angered when, after his first exam, the adjudicators awarded him an 'insufficient' for his portraiture.

Han was at his best when indignant. His final exam was to be a still life. He arrived in the academy library to find an antique vase and silver candelabrum set out on a small table. It was a subject he had painted a dozen times in the styles of Pieter Claesz, of Jan de Heem, of Willem van Aelst. He quickly sketched the outline of the painting then, looking up, he focused on the invigilators. Here were the men who had thought his portraiture 'insufficient'. In accordance with regulations, all of the academy professors were required to invigilate, sitting behind a long oak table under the vaulted ceiling like a *tableau vivant*. Han set aside his sketch and began again.

It was a tour de force: at the centre, the requisite still life, daylight gleaming on the candlestick, the labyrinthine cracks in the porcelain of the antique ewer. Behind it, he had painted full portraits of each of his professors, some attentive, others indolent, each a miniature in the grand Dutch style. Behind his judges, the great library itself: the magnificent stone archway flanked by walls of scholarly tomes of leather and gilt. It was a *magnum opus*, a prank, an act of insolence, a plea for acceptance. The astonished examiners awarded Han a prize for his audacious 'still life', and hung his painting prominently in the halls of the Koninklijke Academie van Beeldende Kunsten.

On 4 August 1914, Han graduated as a Bachelor of Fine Arts. He barely noticed that it was the very day that Germany invaded Belgium and Britain declared war.

5

THE DRINKING PARTY

Painting: the art of protecting
flat surfaces from the weather
and exposing them to the critic.

Ambrose Bierce, *The Devil's Dictionary*

Han watched as the last still life was hung, stepping back to gaze at the gallery walls. On the far wall, a splinter of sunlight picked out a graceful charcoal sketch of Anna, half-turned, sultry and exotic as on the first day he had seen her. As tradesmen carried in crates of wine and beer, he paced the elegant, intimate corridors of the Kunstzaal Pictura, where for a month his work was to be displayed. In a few short hours, the rooms would be filled with friends and family, prospective buyers, critics from the national press. A wave of dread thrilled through him: the opening night of his first solo exhibition.

Anna had arranged everything in a desperate bid to save their foundering marriage. In the months after Han's graduation more than two years earlier, he had disdainfully turned down the offer of a professorship at the Hague Academy – a position which would have offered the family financial security. Europe was at war and though Holland was neutral, thousands of

young men, some much younger than Han, signed up to fight. Han's only interest in the war was artistic: he dreamed of being sent to the front line, like a modern-day Goya, to catalogue the horrors of war, but photography had robbed him of that imagined glory. The commissions he expected to crown his success failed to materialise – in wartime, art was a frivolous extravagance – and some months later Han was forced to go cap in hand to the academy for a part-time position. Though the salary was poor, it was enough for Han and Anna to move out of her grandmother's house and finally set up a home of their own in Han's beloved Delft.

Reinvigorated by the move, Han worked tirelessly on a series of architectural studies, dazzlingly realistic churches painted from audaciously imagined aerial viewpoints. This was the best work he had ever done, he told himself, as dealer after dealer tactfully flattered his technique but declined to afford him gallery space. Anna was shocked by how quickly Han's optimism spiralled into despair as each succeeding gallery-owner offered the unsolicited advice that Impression-ism, pointillism, fauvism were the way forward. By the time she gave birth to their second child, Pauline (later known as Inez), in March 1915, Han had slumped back into depression, abandoning his studio to spend the pittance he earned as a teaching assistant in bars and cafés. He felt trapped in his marriage, angry that the Sumatran princess he had married was now a frugal Dutch *huisvrouw*. At home his talent was a dead weight, but in the bars, a delicate sketch was enough to secure an introduction to a beautiful girl who was happy to believe he was an artist of genius.

Anna was at her wits' end. With two small children and a mountain of bills, she was once again forced to borrow from her grandmother. She saw less and less of Han, and when he

came home he was drunk. More worrying were the nights he did not come home and the whispered gossip of friends that he was seeing other women.

One night, as he was slipping on his coat to go out she challenged him: 'Han, you can hardly expect my grandmother to support us for ever. You have to work.'

'I do work,' he snapped, 'I spend all day correcting assignments by students without a whit of talent.'

'We can't live on eighty guilders a month. No, Han – I mean paint. You have to paint.'

'Why?' he asked wearily. 'My students' modernist scrawls have a better chance of selling than mine. Ask any gallery-owner.'

'Stay home, please. Finish the painting.' She gestured to the picture on his easel of herself with Jacques and Pauline. There was great tenderness in the painting.

'I can see so much love in this portrait – but if you love us, why are you never home?'

'I paint church interiors, Anna, but I don't believe in God,' Han said with a sigh. 'Why would I finish this canvas? Who will ever see it?'

'Then I shall organise a one-man exhibition.'

Han laughed bitterly, lit another cigarette and went out.

But Anna was as good as her word. She visited every private gallery in Delft, taking with her a number of Han's paintings and when she could not find a place to host an exhibition, she began to negotiate with gallery-owners in The Hague. In addition to the standard commission on every painting sold, she offered to pay for the gallery space if the owner would advance one third of the cost. In the end, the proprietor of the Kunstzaal Pictura in The Hague – either touched by her faith in her husband or avaricious enough to be indifferent – agreed. She had a space.

To fund the exhibition, Anna approached her wealthy

Dutch relatives. A major gallery had enough faith in Han's talent to mount a solo exhibition, she told them, she simply needed to borrow a little money to make it a success. In return, each of them would receive a percentage of the profits from the exhibition. Slowly, she scraped together the money and in the autumn of 1916 announced to Han that his first solo exhibition was arranged. The gallery was booked for four weeks, from April through to May 1917. She would contact the newspapers and the critics, invite the guests, arrange the wine. All he had to do was paint.

Han was exhilarated. In a few short months he painted more than he had in two years, buoyed up by his versatility, his talent. He had no subject in mind, no vision to impart: he painted classical seascapes and landscapes in thick impasto, sketched mysterious charcoals, painted delicate watercolours of the flower barges on the Delft canals and humble labourers at work in the fields. Peering into Han's studio, it was as though a century of artistic revolution had never happened. Nothing in his works acknowledged the paroxysms of innovation which had shuddered through the world of art in the years since Han's birth. Impressionism had given way to post-Impressionism and neo-Impressionism, to the shortlived Nabis and thence to fauvism; art nouveau would reach its apex with the Vienna Secession exhibition a year from now; cubism and Futurism were electrifying critics in Paris and New York and already art journals were filled with new terms like Vorticism, suprematism and biomorphism. Han, meanwhile, was painting portraits in the manner of van Dyck.

Han's first solo exhibition coincided with two major events in the history of art. As Han worked on a still life that might have been painted three centuries earlier by Pieter Claesz, twenty miles away in Rotterdam, Theo van Doesburg was

putting the finishing touches to the first issue of *De Stijl*, the magazine around which the great Dutch art movement of the twentieth century would crystallise and introduce Piet Mondrian to the world. While Han painted Anna and Inez as a poignant, traditional *Madonna and Child*, a thousand miles south in the Cabaret Voltaire in Zurich, Hugo Ball was addressing poets and artists in one of the defining moments of twentieth-century art:

> How does one achieve eternal bliss? By saying dada. How does one become famous? By saying dada. With a noble gesture and delicate propriety. Till one goes crazy. Till one loses consciousness. How can one get rid of everything that smacks of journalism, worms, everything nice and right, blinkered, moralistic, Europeanised, enervated? By saying dada. Dada is the world soul . . .

This was the Dada manifesto, a desperate, impassioned reaction to the horrors of war. Dada was not art, it was anti-art, a credo ruled by absurdity, nonsense, chance and chaos, a rejection of everything that Han believed, cherished, practised – and it was to change art for ever.

Before a single painting had been hung in the Kunstzaal Pictura, Marcel Duchamp – barely a year older than Han – would craft the sculpture which would come to define the twentieth century. Duchamp, carefully choosing a factory-made urinal from the J.L. Mott Iron Works, rotated it ninety degrees and signed the piece R MUTT, 1917. Just as Han was preparing to welcome guests to his solo exhibition, Duchamp submitted his 'readymade', titled *Fountain*, to the Society of Independent Artists for an unjuried exhibition, in which any artist paying the fee of six dollars could exhibit. The society,

of which Duchamp was a board member, convened an emergency meeting and voted to withdraw this 'immoral' sculpture from the exhibition as 'not being art'. Duchamp resigned from the board shortly after the incident. In *The Creative Act*, he wrote:

> In the last analysis, the artist may shout from all the rooftops that he is a genius: he will have to wait for the verdict of the spectator in order that his declarations take a social value and that, finally, posterity includes him in the primers of Art History.

The verdict of the spectator is in. Almost a century later, BBC News commented gravely:

> A white gentlemen's urinal has been named the most influential modern art work of all time. Marcel Duchamp's *Fountain* came top of a poll of 500 art experts . . .
>
> 'The choice of Duchamp's Fountain as the most influential work of modern art ahead of works by Picasso and Matisse comes as a bit of a shock,' admitted Simon Wilson, a British art expert hired by the poll organisers to explain the results. 'But it reflects the dynamic nature of art today and the idea that the creative process that goes into a work of art is the most important thing – the work itself can be made of anything and can take any form.'

From their comments on the BBC message board – *a travesty! a disgrace! da Vinci would turn in his grave! These artists are taking the proverbial, surely?* – the bourgeois are still clearly *épatés*.

<p align="center">* * *</p>

As the first guests arrived at the Kunstzaal Pictura, Han watched guardedly, straining to identify any critics mingling with Anna's friends and family and gallery regulars. He felt a surge like an electric jolt as the gallery-owner affixed the first red dot, marking a painting 'sold'. He sipped his wine, careful not to drink too much. He hovered on the periphery of conversations, catching snatches of praise, watching as another good burgher bought one of his canvases.

'Mijnheer van Meegeren?'

'Yes?'

Han turned to see a rather formally dressed middle-aged man.

'Karel de Boer.' The man offered his hand.

'Of course, of course,' Han shook the man's hand warmly. Karel de Boer was among the most influential of Dutch art critics.

'And this is my wife, Jo.'

Han turned and immediately recognised the celebrated actress Joanna Oelermans – or Joanna van Walraven as she was billed. She was a strikingly handsome woman, tall and slender with a face that seemed carved in oriental alabaster.

'Your paintings are very fine.' She took his outstretched hand and for a moment he was torn between gratitude and concupiscence. Han turned back to Karel.

'So good of you both to come . . .'

'Not at all . . .' de Boer smiled. Han ached to ask what he thought of the exhibition, wanted to drag him from painting to painting and explain his technique, his inspiration, his method.

'It's obvious you have a great love of the Golden Age,' de Boer remarked and Han tried to detect some criticism or compliment in the words.

'I suppose . . .' Han tried not to sound defensive, 'I really

don't understand many of these current obsessions in art. I mean, artists making thick, obvious brushstrokes. Don't the public realise that it is easy to show your brushstrokes – every child or novice reveals their brushwork – much more difficult to create subtle gradations which give the illusion of the real. Not that I'm afraid to show my brushwork or to use impasto if the subject demands it. I have little interest in these fashionable "innovations". The techniques perfected by Raphael and Vermeer are good enough for me.'

Han felt a glow; the flush of wine and the coursing excitement sharpened rather than dulled his performance. He was animated, witty; above all, he seemed relaxed, unconcerned about his fate. As the last of the guests straggled out of the gallery, Anna came over and hugged her husband.

'We've sold three paintings and several of the drawings.' She smiled. 'Now all we have to do is wait for the reviews . . .'

The exhibition was a success. The critics were fulsome in their praise. Han's work, they agreed was 'excellent', he was 'an extremely versatile artist'. De Boer wrote a considered, positive review. By the time the exhibition closed four weeks later, every canvas, every watercolour had been sold.

The success of the exhibition made it possible for Han and Anna to move to a larger house in The Hague and brought a steady stream of new commissions. His success and modest celebrity meant that he could now charge as much as a thousand guilders – the equivalent of six thousand dollars today – for his gloomy, priggish likenesses in the style of Rembrandt and van Dyck. Han cultivated his friendship with Karel and Joanna de Boer, and was rewarded by being accepted into fashionable intellectual and artistic circles. He was even elevated to membership of the elite Haagsche Kunstring –

the Hague Art Circle – an old boys' network which offered a splendid opportunity for him to meet like-minded reactionaries who agreed with his opinions on the aberrations of modern art and the venality of critics and dealers.

In The Hague, Han rented an artist's studio a short walk from the family home, explaining to Anna that he could not concentrate on his work with Jacques and Inez constantly demanding his attention. Here, he worked on portraits, experimented with new styles and also offered private lessons to middle-class girls. He was not concerned with imparting the eternal truths of art to these young women, he was employed merely to teach them how to paint a spray of spring flowers. The armoury of the complete woman had changed little since Jane Austen wrote, 'A woman must have a thorough knowledge of music, singing, drawing, dancing, and the modern languages, to deserve the word . . .' Like embroidery or playing the piano tolerably well, art was one of the talents a prospective husband valued in his bride-to-be. For his part, Han's pupils afforded him something more intoxicating than sex, they offered him unqualified admiration, called him Maître, hung on his every word, eagerly watched every movement of his pencil.

It is ironic that Han's most famous picture – the most famous, at least, to which he signed his own name – was something he dashed off in less than ten minutes during one of his classes. It was to become the single most reproduced image in twentieth-century Holland, appearing on greeting cards, calendars and prints.

To add spice to the monotony of still lives and decorous life drawings, Han had arranged to have a young deer brought from the nearby zoological gardens for his students to sketch.

He himself had sketched the skittish doe so often that when one of the young ladies wagered that he could draw the little creature in ten minutes, he completed the pencil sketch in nine. At Anna's suggestion, Han took the picture to a number of local printers, suggesting they might like to use the image for a commercial poster. No one seemed interested in Han's sweet, rather sentimental sketch. Han was neither surprised nor disappointed, but as an experiment, as he was leaving a meeting with a printer who had turned down the sketch, he mentioned in passing that the animal was Queen Juliana's deer. It was not entirely untrue – the zoo belonged to the monarch, though it is unlikely that the queen herself had ever set eyes on the animal. This new information helped the printer to recognise the sureness of line, the poignancy of the doe's frail stance. It was, the printer said, 'a charming vignette'; beautifully executed, a perfect subject for a greeting card or a calendar perhaps. Han was contemptuous. As if it were not bad enough that his finest paintings were sold for a fraction of what his portraits brought in, now this inconsequential sketch had sold – not because of the aesthetic qualities of the drawing, nor even because of the artist's signature, but because the beast was owned by a queen.

Despite the improvement in their fortunes, Anna sensed that she was losing Han. When he was not at his studio, he spent his time drinking with his friends from the Kunstring and, more and more often, in the company of Joanna Oelermans. From their first meeting, Han knew that he coveted not only Karel de Boer's respect, but also his wife. Han had asked if he might paint her portrait and with Karel's consent, Jo agreed. The portrait was merely an excuse for endless sketches and pre-liminary work. The commission stretched out over weeks and

months. They were frequently seen together walking arm-in-arm along the canals, talking about art and life. Han called her Jolanthe, and courted her with all the delicacy with which he had once wooed Anna. For her part, there was something mercurial in Han that Jo found attractive. Inevitably they became lovers. Han was bored with married life and jealous of the freedom and elegant dissipation of his friends. As an artist, conventional bourgeois morality did not, he reasoned, apply to him. If the world did not care that Leonardo was homosexual, that Baudelaire contracted syphilis, that Gauguin abandoned his wife, Han believed his own peccadilloes were eminently forgivable. His friends warned him that cuckolding one of the most eminent art critics in the country was hardly likely to further his career. Anna, tired of listening to another concerned friend confide that she had seen Han and Joanna together, confronted her husband. Han protested that his relationship with Jo was platonic, intellectual, spiritual, but gossip flourished in the Hague Art Circle, where members joked that it was unsafe to introduce one's wife to Han van Meegeren.

Karel de Boer was deeply bitter that an artist whose career he had promoted could so publicly humiliate him and he and his colleagues were to forcibly remind Han how influential the critic's voice could be.

Han's second solo exhibition, held in the Kunstzaal Biesing in May 1922, was titled Bijbelsche Tafereelen (Biblical Paintings). It was curious that Han, a professed atheist, should mount an exhibition entirely of religious works, though he may have been inspired by three months he spent travelling in Italy in 1921. Certainly, there were elements here of the religious altarpieces of the Renaissance, though filtered through an art nouveau sensibility. For all his railing against

his father's dour Catholicism and his conviction that religion had been the death of his brother Hermann, Han was drawn to the spiritual, the mystical. The exhibition was a glorious failure. Though the reviews dutifully praised Han's skill as a draughtsman, they were quietly devastating: 'A gifted technician who has made a sort of composite facsimile of the Renaissance school, he has every virtue except originality,' one critic suggested. Another noted his failure to imbue his works with passion: 'Whenever he sets out to paint Christ, he is so overwhelmed by the notion of nobility and solemnity that the resulting Christ figures are often insipid and sickly, sometimes miserably forsaken, always weak and powerless.' A third summed up the exhibition with the barbed, 'It left me feeling that I had seen it all before and that I will not remember it for long.'

Shaken, Han turned to Anna for support but his wife, worn down by the impossible job of being Mrs Han van Meegeren – factotum, cuckold, mother, muse – was less than sympathetic. Her forbearance had run dry. In March 1923 they were divorced and soon afterwards, taking Jacques and Inez with her, Anna left for a new life in Paris.

6

A CAREFUL CHOICE OF ENEMIES

Restoration is one of the surest
methods scientifically to substitute
new paintings for the old ones.

Etienne Gilson

Han nurtured his betrayal as a gardener might a delicate orchid. Although the last years of his marriage had been wretched, he missed his children whom he loved in a maudlin, desultory way. In the first months after their divorce, he was diligent in visiting Paris to see his Jacques and Inez but increasingly he embraced a dissolute bachelorhood. He painted little, dashing off commercial work to subsist, constantly failing to send maintenance to Anna. Han wallowed in his failure. Critics were corrupt and ignorant, art dealers were swindlers and philistines, women were treacherous and peevish. This he would tell anyone who would listen.

Fortunately, his two closest friends harboured disillusionment and dissipation that rivalled his own. Jan Ubink was a poet with a number of slim volumes to his credit. That he made his living from tabloid journalism he attributed to benighted critics and readers who failed to recognise his talent. Theo van

Wijngaarden, like Han, was an artist of the old school but he had failed to achieve even Han's modest success and made his living as a restorer of old masters. Night after night, over endless cigarettes, wine and absinthe, they pooled their bitterness and their disappointment and revelled in the revenge fantasies of the impotent.

Han suggested to Theo that they might work together. He was drawn to the idea of art restoration, to a fantasy of discovering and painstakingly restoring lost masterpieces of the Golden Age. Van Wijngaarden, who already knew Han's work, was impressed by his knowledge of seventeenth-century techniques, his ability to analyse and create pigments, his attention to detail and his understanding of the brushstrokes of the masters. Theo's contacts and his snake-oil charm coupled with Han's exhaustive knowledge of the techniques and raw materials of the Golden Age made for an ideal partnership. They travelled together frequently – to Germany, Italy, anywhere in fact where Theo thought there was a bargain to be had. Han was fascinated by the work which allowed him to make use of the arcane alchemy he had learned from Bartus Korteling and transform the workmanlike canvases which Theo found in flea markets and junk shops into fresh and vibrant works of art.

The profession of the restorer is an honourable one, but the line between restoration and repainting is slender and shifting and many a restorer has crossed it to censor or to 'improve'. Even those works which are part of our cultural subconscious, works which we know intimately even if we have never seen them, are not immune to the restorer's brush. When Michelangelo completed *The Last Judgement*, the monumental fresco for the altar of the Sistine Chapel, the figures were naked. Pope Paul III's adviser Biagio da Cesena was shocked by this 'shameless display of flesh', sneering that the painting was 'not for the chapel of a

pope, but for a bathhouse or tavern'. After Michelangelo's death, Pope Paul IV issued an edict forbidding the painted nude and commissioned Michelangelo's apprentice Daniele da Volterra to primly cover the genitals. (El Greco, to whom he first offered the commission, disliked Michelangelo's masterpiece and would accept only if he could paint an entirely new fresco.) As recently as 1993, when the fresco was last restored, it was decided to preserve da Volterra's wisps of cloth and protect us from the naked truth. More famous still is the legend of the Mona Lisa's eyebrows. When Vasari wrote his description of da Vinci's portrait, he commented on her 'uncommonly thick' eyebrows. Since anyone who has been to the Louvre knows that *La Joconde* has no eyebrows, it has been suggested that the injudicious use of a solvent during seventeenth-century restoration removed them completely (though the competing theory that Italian women of the period commonly shaved their eyebrows and that Vasari wrote his description without ever seeing the portrait of Lisa Gherardini is more compelling).

Prudishness and error, however, are as nothing compared to the damage done to paintings in the name of commerce. Over the centuries, hundreds of reverential studies of the Holy Family have been 'restored' by painting out the figure of Joseph and cutting down the canvas to create a much more saleable *Madonna and Child*. Often, a painting that is thought too crude, too visceral to appeal to a buyer may need the subject to be subtly shifted. When Lucas Cranach's *Salomé holding the head of John the Baptist* was restored, the saint's bleeding head on the salver was overpainted with gold and precious jewels. The canvas, now retitled *The Goldsmith's Daughter*, quickly found a buyer. Even the patron who commissions a portrait is not safe: twentieth-century X-rays discovered that Sir Joshua Reynolds's graceful study of the Payne

sisters seated at the piano was in fact a portrait of Mrs Payne and her daughters. The rather plain elderly lady had been overpainted by a restorer to fashion a more saleable canvas. Mrs Payne *mère* has since been returned to her rightful place.

Wittingly or unwittingly restorers down the centuries have 'improved' upon works of art. The *Barberini Venus*, one of the most famous sculptures in the world and said to be 'so beautiful that she inspires love in all who see her' is a Roman copy of a Greek original. When it was bought by the banker-cum-art dealer Thomas Jenkins, the head, the right arm and left forearm were missing. The goddess of love had even lost part of one buttock. The statue is a cut-and-shunt: Jenkins had the sculpture 'restored' by the leading Roman restorer of the day, Bartolomeo Cavaceppi, who attached a corseless head to the headless body. Unfortunately, the only suitably sized head he had in stock was a representation of Agrippina wearing a veil. Cavaceppi had to chisel away the veil to reveal the face, and trimmed the neck to fit the torso. He grafted the missing limbs on to the statue, coyly placing Venus's hand over her pudenda (an unlikely pose in Roman times). Thomas Jenkins brought the *Venus* back to England where he sold it to William Weddell of Newby Hall as an original. When Christie's offered it for sale in 2002 (happily admitting the extent of the restoration), it almost quadrupled its estimate to fetch $11,800,000, the highest price ever achieved for any antiquity at auction.

But if restoration is the handmaiden to Fine Art, she is also the midwife to forgery. In *Drawn to Trouble*, the forger Eric Hebborn recounts his apprenticeship working for the art restorer George Aczel at Haunch of Venison Yard. Hebborn proved an excellent student, quickly mastering the art of restoration, learning to gently 'improve' on mediocre daubs, to discover beauty in muddy shadows, even a signature where

none existed. One morning, Aczel arrived with a dealer who placed a canvas on Hebborn's easel. The dealer was enthusiastic about his find.

'Aczel, old boy, I've made an exciting discovery – what do you think of this Van de Velde?'

'Very interesting,' replied Aczel, 'very interesting indeed. I think it's a job for Mr Hebborn here. What do you say, Eric?'

'Van de who?' asked Hebborn.

'It is a Van de Velde, Eric, and a very fine one I should say, wouldn't you?' He turned back to the dealer.

'Not too fine, not too fine, something for the small collector I imagine. After all it needs fairly extensive restoration and the museum people might be finicky. Then there's the problem of attribution. On the other hand, if the signature should appear during the cleaning . . .'

Hebborn stared at the canvas. It was completely blank.

Han's foray into restoration was not without incident. In 1923, Theo acquired two remarkable seventeenth-century paintings in an advanced state of disrepair: one depicted a young cavalier, the other a boy smoking a pipe. Like art dealers throughout the ages, van Wijngaarden saw only the worst in what he bought and the best in what he sold: if a seller arrived with what appeared to be a Rembrandt sketch, Theo would disparage the piece, suggest it might be a copy – anything, in fact, that might drive down the price; if, on the other hand, a buyer expressed interest in purchasing a genre piece in the manner of Pieter de Hooch, Theo had no compunction in telling the credulous soul that in his professional opinion it was indeed a de Hooch – and, after all, perhaps it *was*.

The Laughing Cavalier and *The Satisfied Smoker*, though murky and badly damaged, were clearly in the style of Frans

Hals, and Theo was convinced they were by the master himself and he trusted that Han's deft brushwork would restore the paintings to their former glory.

Han carefully removed several layers of tinted varnish and a number of clumsy previous attempts at restoration. It was a difficult and fastidious process. *The Laughing Cavalier* was painted in oil on panel and the board had split with centuries of wear. When he stepped back to assess the painting, he realised that there were large areas where almost all of the paint had flaked or disappeared over the years. Sections of the portrait would have to be almost entirely remodelled.

Han worried about the extent of the repainting. Although oil paint is dry to the touch within three days, it takes as long as fifty years for the medium to completely evaporate and the surface to truly harden. Han knew that any prospective buyer would use the standard test, swabbing an inconspicuous corner of an old painting with cotton wool soaked in alcohol, or holding the wad above the surface of the canvas where the fumes would cause any new paint to soften. He showed the painting to Theo and explained his concern; Theo assured him that he would explain which areas had been restored to any prospective buyer, but suggested Han use oil of lavender rather than linseed oil as a medium since, being more volatile, it would mask the extent of the restoration.

Han quickly and easily identified the pigments he needed and created small, hand-ground batches indistinguishable from the original paint layer. His long years studying the Golden Age and his passion as an apprentice for imitating the works of the masters gave him an understanding of Hals's rapid brushstrokes, his dramatic shading and the characteristic silvery sheen of his work, so different from the golden glow of a Rembrandt. Slowly, the portrait took shape again, as if

instead of applying paint, Han was gently lifting a veil. When it was complete Han felt oddly elated: it was as perfect a recreation of the *Lachende Kavalier* as he could imagine. It was his work, and yet it was a genuine painting of the Golden Age.

Theo had the picture taken for authentication to one of the foremost art historians, Cornelis Hofstede de Groot, former deputy-director of the Mauritshuis and a critic instrumental in defining the *oeuvre* of both Rembrandt and Vermeer. De Groot authenticated the painting and offered a certificate praising it as an 'exceptionally fine Frans Hals'. Based on this categorical attribution, it was offered to Muller & Co, a reputable auction house, who bought the painting for 50,000 florins – more than $160,000 today.

The auctioneers took the unusual step of having the painting re-authenticated by Abraham Bredius, the great expert on Dutch baroque painting. Bredius immediately dismissed the painting as a forgery, citing the fact that large areas of paint surface reacted to the alcohol test. Alarmed, the auctioneers returned to de Groot, insisting that he assume one-third of their losses. De Groot refused to accept financial liability, and restated his conviction that the painting was genuine. A panel of experts was convened to study the painting and detected extensive recent repainting; in the surface layer, they also discovered traces of artificial ultramarine, cobalt blue and zinc white, pigments which were not produced until the nineteenth century. In addition, two of the nails which held the circular panel together were clearly nineteenth-century. While de Groot accepted that these were merely evidence of recent restoration, the committee determined that *The Laughing Cavalier* was a forgery and de Groot bought the painting for his private collection.

Two years later, in 1925, when de Groot published *Echt of*

Onecht (Genuine or Forgery), he was still convinced that the Hals was genuine. He argued that though the original blue in the painting would have been ultramarine, the cobalt blue was the result of later restoration; he insisted that zinc white, far from being an invention of the nineteenth century, had been used by the ancient Greeks and that an artist like Hals would have known how to make it himself. The two nails, he suggested, had been replaced by the restorer who had revarnished the painting. As to the panel itself, de Groot maintained: 'It is perfectly in keeping, the parquetry is the result of a repair carried out years, perhaps centuries, later. Most old masters painted on board show signs of parquetry of old and newer wood.'

Theo was furious that Bredius's denunciation had cost him a lucrative commission, but Han was devastated; the public wrangling confirmed his belief that the 'expert opinion' of critics amounted to little more than a certified hunch. A critic might be fallible, and yet there was no recourse against his judgement. The fate of a painting, of an artist, could rest on one man's instinct.

Though Karel and Joanna de Boer divorced in 1923, it was not until 1927 that Han finally married his mistress. She was beautiful, famous, intelligent and artistic and her faith in Han's talent was unshakeable. Like Anna, Jo could make Han believe in himself, but she was also happy to indulge Han's whims. She did not nag him when he went drinking with Jan and Theo, did not question him about the pretty girls her friends said they had seen on his arm. In the words of Han's friend Van Genderren Stort, Joanna was the perfect muse for Han: 'She was his mother, his daughter, his friend, his lover, his secretary, his protector and his model.' He began to see more of his children. Jacques, now fifteen, often came from Paris to spend

the holidays with his father. The boy was a promising artist and Han was overjoyed that he could encourage and support his son. Jacques came with him to the bars and cafés, where Jan and Theo, the poet *manqué* and the restorer, listened as his father held forth persuasively on the decadence of modern art and the ills of critics and dealers. The faithful snickered and grunted their agreement, but the art world seemed to move on inexorably without them.

It was Jan Ubink who suggested that they redress the balance by publishing a monthly journal which would offer the traditionalist a forum in which to coolly appraise fashionable ideas of modern art. Despite the slings and arrows he had endured as a poet, Ubink still had a touching faith in Bulwer-Lytton's maxim: 'Beneath the rule of men entirely great, the pen is mightier than the sword.'

The first issue of their art review *De Kemphaan* (The Gamecock) was published in 1928. Han's cover illustration depicted the art critic as a sneering Fascist wearing a monocle. Jan wrote the impassioned editorial: 'One of the tasks we have set ourselves is to draw attention to the great guiding principles. Obviously, we will lay ourselves open to spiteful comments, because we shall not hesitate to call to order everyone who mistakes his slum for a metropolis or his garden path for a transcontinental highway.'

A dozen or more columnists (in fact the triumvirate wrote all of the articles using numerous *noms de plume*) derided every artist who had put brush to canvas since Delacroix and Géricault almost a century earlier. To the first issue, Han contributed an ugly, sneering caricature of 'modern artists':

> Their posturing has created a recognisable stereotype with an intense, lingering gaze, ditto handshake and a curious gait.

Though they vaunt their objectivity, they kowtow to the snobs and the nouveaux riches they meet among the plebs. They are surrounded by acolytes, parasites, and proselytes; writers of introductions, assistant governors of lunatic asylums, prophets of painting, necromancers, ersatz philosophers and hypocrites. They are protected from the meddlesome public by idiots, racketeers, impresarios and opportunists.

The slimy little group of women-haters and negro-lovers (the avant-garde of pan-European style) is a little too immoral to be discussed here.

De Kemphaan was published to general indifference for less than a year. That his barbs failed to rock the foundations of the art establishment surprised only Han. The small Dutch art community was accustomed to his jeremiads and interpreted them as the maunderings of a second-rate artist, a fogey and a drunk. His very public affair with the wife of an esteemed critic had cost him valuable allies and his reactionary and often racist views won him few friends. Most worryingly, his ideas were now out of step with the Haagsche Kunstring which was beginning to clamber into the twentieth century. In April 1932, when Han, who had been secretary at the Hague Art Circle for some years, suggested he might run for the position of chairman, thirty of the younger members threatened to resign, arguing that Han would 'not be objective and give due recognition to all opinions'. Han withdrew his candidacy and tendered his resignation from the society. To his surprise, it was accepted. In their letter, the members of the committee unwittingly rubbed salt into the wound: while they congratulated him on his abilities as a fundraiser, they regretted his resignation because Han 'represented a spirit in the art world that is dying out'. Not yet forty, Han contemplated the ruins of

his career. His solo exhibitions barely drew, in the glorious Dutch expression, *'anderhalve man en een paardekop'* – one and a half men and a horse's head. Discouraged that peers and critics who had once seen in him a promising young artist, now dismissed him as a fogey, and outraged by the art of his time, he looked about him and, life being what it is, he dreamed of revenge.

THE RENAISSANCE MAN

7

THE FORGER'S ART

Forgeries are an ever-changing
portrait of human desires. Each
society, each generation, fakes
the things it covets most.

Mark Jones, *Fake? The Art of Deception*

The artist arms himself only with talent, the forger is a true
Renaissance man. This is not to contest the genius of the
former, who with oil on canvas or hewn marble, in metal
or with the embalmed bodies of dumb beasts can conjure
something that evokes pity and terror, awe and admiration.
The forger's apprenticeship is somewhat more difficult.

Every forger hungers for recognition, for a place in the
canon, a scrap of wall in some illustrious gallery to call home.
Though there are doubtless forgers who are content to churn
out immediately recognisable copies or pastiches, the accom-
plished forger is a perfectionist. In order to succeed he (as in
many criminal careers, women are under-represented) must
become a skilled art historian, a restorer, a chemist, a gra-
phologist and a documentalist if he is to exploit his talents as a
charlatan. It is not a vocation for the indolent.

The forger's chief skill, however, is his ability to lie. 'There is a stage in the telling of lies,' wrote the distinguished criminologist Hans Gross, 'where the normal condition has passed and the diseased one has not yet begun.' The forger must transcend this stage if, like van Meegeren, he is to earn a place in John G. Howells's *Reference Companion to the History of Abnormal Psychology* as the paradigm of *pseudologia fantastica*, the pathological liar. Slighted, the conman lies to revenge himself on his detractors; humiliated, he lies to obtain a sense of power; plagued with doubt, he lies to fuel his own self-deception. Han had cultivated a lifelong disappointment with the world, had nurtured mistrust until it flourished into paranoia, brooded over his insecurities until his need to prove himself consumed his every waking thought. As he would later tell his accusers: 'I decided to prove my worth as an artist, by painting a perfect seventeenth-century canvas.' It was an eminently sensible decision since the twentieth century had no interest in his work. Han had failed to follow the most elementary lesson for the artist, as espoused by the critic George Moore: 'It doesn't matter how badly you paint as long as you don't paint badly like other people.' Born out of time, a realistic artist in an age of surrealism and abstractionism, he realised he had only one option open to him: he would become a forger.

First he had to choose a victim – a painter whose identity he would usurp. Though he may have considered Ter Borch or Pieter de Hooch, he quickly settled on Vermeer. His reasons were aesthetic and pragmatic in equal measure. Vermeer was the artist whom Han admired above all others. A quintessentially Dutch master who had elevated genre painting above the populism of de Hooch's card-players and peasants pissing in the street into something noble, something that in the twentieth

century seemed alive with psychological insight, hidden passions, elliptical narratives. Emotionally, he felt a bond with Vermeer. Here, Han believed, was an artist neglected and wronged by critics. One who had died almost unknown, whose paintings had languished for centuries until time finally vindicated his genius. Han's was a simplistic but common interpretation: though Vermeer's fame had faded after his death, he had certainly been a successful and influential artist in his lifetime. He was a master painter and member of Saint Luke's Guild, twice elected Head Master by the artists of Delft. His disappearance from the canon of Western art owed more to the paucity of his work and the fact that he had no school, no pupils to carry on his name. But what attracted Han were the twin facts that, since his 'rediscovery' by Thoré/Bürger, Vermeer's reputation had soared to rank along with Rembrandt as the acme of Dutch artistic achievement, and yet what little was known of his life and works was so incomplete that it would be easy to add to the catalogue of accepted work.

Han's scheme was simple and perversely moral: 'I devised a plan to paint a picture based on my own ideas, in my own style, but by using seventeenth-century pigments would ensure that the painting would pass the five tests which any genuine seventeenth-century painting must pass.' He would not resort to copying or to creating a pastiche of several works. The subject was to be one which the artist had never painted, an original van Meegeren. The painting, he determined, would have to be a major work. He did not want to slip an inconsequential canvas into the artist's canon by stealth, he wanted to paint something which would cause the art world to re-evaluate the canon itself. He would have it authenticated by a leading expert in the field and sold, ideally at auction. When his work was proudly displayed in a prominent museum,

admired and acclaimed by all, then and only then would he announce his charade, forcing the critics and the dealers to admit their humbug and the public to recognise his genius.

Han did not doubt his ability to paint a major Vermeer, but just to be certain, he painted a minor genre piece, *Lady and Gentleman at the Spinet*, and in the spring of 1932 sold the canvas to a Mr Tersteeg, the son of the former director of Goupil's gallery in The Hague. *Lady and Gentleman at the Spinet* (plate 6) was pastiche, filled with explicit allusions to authenticated Vermeers. On the right, a gentleman stands, his pose, his broad-brimmed hat and shawl copied in every detail from Vermeer's *The Glass of Wine*; the lady is a mirror image of the girl in *Two Gentlemen and a Girl with a Wineglass*, the draperies and the framing echo the composition of *The Allegory of Faith* while the abandoned lute is similar to the one in *The Love Letter*. Van Meegeren's first Vermeer is forgery by numbers: a patchwork of easily recognisable quotations from the master's work in an all-too-familiar setting down to the light spilling from the window on the left on to a painting which is almost identical to the rugged landscape in the style of Jacob van Ruisdael that hangs above the clavecin in *The Concert*. Tersteeg had no doubts as to its authenticity and was happy to offer van Meegeren 40,000 guilders for the painting.

With the proceeds Han bought his first car: a Dodge sedan. He knew nothing about cars and had not the first idea how to drive. The man who sold him the Dodge had to explain how to use the brake and the accelerator, what the choke was for, even when he should use the horn. He even gave Han a quick driving lesson, and, jolting and stuttering, Han drove his new toy – one of barely two dozen such cars in Holland in 1932 – back home to show Jolanthe. Jo excitedly asked Han if they

might take a spin. Han, who wanted nothing more than to get as far away from Holland and the dreary puritan Dutch soul as he could manage, suggested they drive to the south of France and on to Italy. It was a belated honeymoon, a brilliant adventure: they climbed into the sleek black sedan and headed south.

Two weeks later, the rickety car crossed the French border at Menton, and lurched down the long mountain road towards Ventimiglia. Houses in vibrant chalky colours sat perched precariously on the hillside, and, slung from every window, laundry snapped loudly in the warm breeze. Han was intoxicated by the Mediterranean: the colours seemed to shimmer and shift, the air trembled in the heat, strange plants and flowers bloomed and everywhere the people seemed garrulous and friendly. They flapped their hands when they talked, linked arms when they walked, they seemed sensuous and vital and altogether unlike the dour Dutch burghers they had left behind.

While *Lady and Gentleman at the Spinet* was passed from dealer to expert, Han and Jo spent several blissful days in Milan wandering the galleries and honeyed sunlit cloisters of the Pinacoteca di Brera. It was not Han's first taste of the glories of Italian art, he had spent three months travelling through Italy in 1921, but now that he was searching for a subject for his forgery he saw new possibilities in the desolation of Mantegna's *Lamentation over the Dead Christ*, the elegant restraint of Raphael's *Marriage of the Virgin*. He was tempted by *The Last Supper*, which they visited at the Convent of Santa Maria delle Grazie. Despite the terrible disrepair and an unwise attempt by Stefano Barezzi to detach Leonardo's fresco from the convent wall, Han was moved by the faces of the disciples, caught in this moment between revelation and betrayal.

He quickly dismissed the subject as too hackneyed. Hans
Holbein had painted the disciples as dignified and luminescent;
in Bassano's *Ultima Cena* they were unruly, drunk or asleep. In
the Brera in Milan, Han had witnessed the sheet lightning of
Rubens's stormy and turbulent *Last Supper*. There was noth-
ing for him to bring to this subject.

In Rome, he was overwhelmed by the sheer scale of the
work of Michelangelo Merisi da Caravaggio. He spent hours
in San Luigi dei Francesi sketching and studying the hypnotic
cycle of the life of Saint Matthew. Day after day in almost
every gallery he visited, Caravaggio's dramatic chiaroscuro
stared him down: the defiant suffering of *The Crucifixion of
Saint Peter* in Santa Maria del Popolo, the boy David, almost
remorseful in his victory, gazing at the severed head of
Goliath in the Galleria Borghese. He was struck by the
visceral energy, the sheer humanity of these religious scenes.
Here was a painter of such force, such passion, that he had
stirred a group of Dutch students to forsake the staid con-
straints of Flemish painting and adopt the style of a master the
Dutch had never seen. In the decade before Vermeer was
born, the Utrecht Caravaggisti – Brugghen, Honthorst, Both
and Baburen – had briefly, brutally, changed the face of
Dutch painting. Their legacy was evident in the work of
Rubens and Rembrandt, and though there were elements
of it in Vermeer's early pictures, there was scant trace to
be found in his mature work. Han did not know that scholars
have come to believe Vermeer himself studied in Utrecht
where his mother-in-law Maria Thins knew the artist Abra-
ham Bloemaert. Certainly Maria Thins's private collection
included a number of paintings by the Caravaggisti and, as
Han certainly knew, Vermeer himself owned Baburen's *The
Procuress* which he used as a backdrop to both *The Concert*

and *A Young Woman Seated at a Virginal*. What if Vermeer, too, had fallen under the spell of Caravaggio?

It was no more than a passing notion: Han did not yet know how he might contrive a 'seventeenth-century' painting – how to find the right canvas, how to harden the paint, how to induce the *craquelure* – the fine network of cracks which is the mark of age and maturity. Until he devised a technique to deceive the expert and his alcohol swab, the X-ray machine and the chemist, the subject for an 'early Vermeer' was un-important. He was excited and enthusiastic, talking animat-edly about returning to his work. Joanna was happy to see that his crippling self-doubt seemed to have dissipated. He was once again the charming roué who had stolen her from her husband ten years earlier.

As the car once more climbed the steep hill out of Venti-miglia and crossed the French border, Han felt a twinge of regret at the thought of returning to The Hague. There seemed to be nothing left for him in the Netherlands: he had resigned from the Kunstring and though never publicly named in the scandal surrounding the 'forged' Frans Hals he had severed his professional ties with Theo van Wijngaarden. He could not even look forward to spending time with his children since Anna had left France to return to Sumatra, taking Jacques and Inez with her. There was nothing left for them in the Nether-lands but petty-mindedness and snobbery and the indifference of the art world. The Dodge sedan itself seemed to slow at the thought of the lowering skies that awaited them; it laboured for a few miles more and shuddered to a halt in Roquebrune-Cap-Martin.

Han and Jo spent the afternoon strolling through the labyr-inth of streets of Roccabruna, the medieval fortress conceived by Conrad 1st, Count of Ventimiglia, to protect the western

frontier of his domain. In the hills that looked out over the sprawling Mediterranean, Roquebrune was the last picturesque stop made by the *train bleu* before arriving in Monte Carlo. They dined at the Grand-Hôtel where once the Empress Elisabeth of Austria was a regular visitor, savouring this enforced appendix to their holiday. It was here that they heard of a house for rent outside the village and, on a whim, they went to view Primavera, a magnificent villa set in a garden of roses and citrus trees in the Domaine du Hameau. From this eyrie the great windows looked out across the village to the dazzling blue streak of the Mediterranean. The landlord, a plump, agreeable gentleman by the name of de Augustinis, was taken by the artist and his handsome wife and, as they were about to make their excuses and return to the hotel, offered the property for four dollars a week. Without a moment's thought or a word to his wife, Han took the landlord's pen and signed the lease. It was only later, walking back towards the hotel in the gathering dusk, that he told an astonished Joanna that they were leaving the Netherlands for ever.

8

THE PRICE OF ULTRAMARINE

O thou afflicted, tossed with
tempest, and not comforted,
behold, I will set your stones
in antimony, and lay your
foundations with lapis lazuli.

Isaiah 54:11

Han gathered the tools he needed to practise his artistic alchemy. Carmine and madder, lead and mercury he easily obtained from chemists and the artists' supplies shops in The Hague. He bought a dozen shaving brushes: by 1930, artists' brushes were routinely made of sable, but Vermeer, Han knew, had used only badger-hair brushes so from the shaving brushes he would fashion his own. In an antique shop, he bought a number of seventeenth-century wine goblets and some pewter serving plates to serve as props. Still he lacked his philosopher's stone: nowhere in the Netherlands could he acquire the lapis lazuli he needed to make ultramarine. In the end, he travelled to London, where he visited the world's foremost colour chemists at 38 Rathbone Place. Winsor and Newton sold him four ounces of raw lapis lazuli.

The stone can be dated back seven thousand years when it was used to adorn the royal Sumerian tombs of Ur; it was prized in ancient Egypt where it was used to decorate the sarcophagi of the pharaohs. It is among the rarest of stones, being mined principally in Badakshan, Afghanistan, the oldest mine in the world, which supplied the pharaohs and the temple painters of Afghanistan, the Chinese and Indian artists of the Middle Ages. It first appeared in European painting in the altarpieces of Giotto and the illuminated manuscripts of four-teenth-century Italy. Rarer than gold, the finest lapis lazuli has, for centuries, been more expensive than the vulgar yellow metal. Artists traditionally used the pigment sparingly, reser-ving ultramarine for the robes of Mary and the Christ-child. By the sixteenth century, azurite or chessylite replaced natural ultramarine. But Jan Vermeer disliked azurite and used natural ultramarine, not only as a focal point, but extensively in the underpainting of his canvases. By the time Han first saw the nugget of blue stone shot through with a gold tracery on the bench in Bartus Korteling's studio, it had been superseded in the nineteenth century by synthetic ultramarine and cobalt blue. Over the next three years, Han would buy twelve ounces of lapis lazuli from Winsor and Newton at twenty-two dollars an ounce – the price of gold in 1932 was twenty dollars per ounce.

Back in The Hague, he scoured bookshops for anything that might help in his deception. He bought C.F.L. de Wild's classic study *Over de technick van Vermeer* and Alex Eibner's *On alternatives to linseed oil and oil paints*, a treatise on the various media he might use. It was here that he happened on a recently published volume which proved essential reading for the neophyte forger: A.M. de Wild's *The Scientific Ex-amination of Pictures* – a detailed account of up-to-date

discoveries in the chemical analysis of pigments and the use of ultraviolet light and X-ray photography in detecting forgeries.

Han now needed several small canvases on which to develop his techniques and, more importantly, a process for hardening the paint. He would also need a large canvas on which to paint his masterpiece. Han did not have the wherewithal or the inclination to buy and bowdlerise a genuine de Hooch or a van Mieris, so he spent several weeks scouring minor galleries for second-rate paintings he could buy cheaply. For the test paintings, small canvases would suffice, but he needed to be sure that both canvas and stretcher were of the right period. He went so far as to check the nails which held the fabric in place: such details had been crucial in the Frans Hals debacle. The canvases had to be sturdy, with little sign of wear, since Han would need to remove the existing painting without damaging or fraying the fabric.

Joanna was surprised and irritated when Han came home with some small tawdry painting he had bought. The house was almost packed up and Jo was angry with her husband for spending time and money on such frivolities. Han bluffed her, arguing that in this he saw a Ter Borch he might restore, in another a frame he thought worth preserving. Finding six small seventeenth-century paintings proved a challenge, but Han's search for a large canvas was proving fruitless.

Art, if it is not esteemed, does not survive. Time gives short shrift to lesser artists, unloved paintings disappear through indifference and neglect. Han haunted galleries and junk shops, haggling over paintings, but he could not afford even the modest prices a major work by a minor artist commanded. Finally, in a junk shop, he saw a painting that he knew would suit his needs. A vast, murky oil, almost four feet by six feet, it depicted the raising of Lazarus. It was clearly seventeenth-

century and from the style it seemed that the artist might have
been a minor contemporary of Vermeer. Han examined the
back of the painting: the canvas looked sturdy and unda-
maged; he checked that the painting had not been later
recanvased, inspected the nails with which the artist had
affixed his essay at immortality.

'How much?'

The dealer looked up from the jumble of knick-knacks he
was pricing. 'A thousand guilders.'

'I think you've made a mistake with the zeros.' Han smiled.
'The painting is by some nonentity, and it's not difficult to see
why he's been forgotten: the anatomy is poor and the model-
ling is atrocious.'

'An interesting assessment,' the dealer said coolly, 'but if it is
really as bad as you say, why would a gentleman of your taste
wish to buy it?'

Han could hardly explain that he wanted to strip the
existing painting from the canvas and use it to create a
new Vermeer. He shrugged and – a quick-thinking and
accomplished liar – explained that he was looking for a
seventeenth-century painting for a client furnishing his new
country house in Laren. Something inexpensive that would
complement the west wing.

'I need a large work for a dark corner of the drawing-room. I
thought the shadows would show this piece off to its best
advantage. But perhaps you're right, perhaps my client should
hold out for something a little more interesting.'

Han bought an old map which he would later use in one of
his experimental forgeries, and a silver-topped jug much like
the one in Vermeer's *The Music Lesson*. Before he reached the
door, the dealer called him back, offering the *Lazarus* for half
the original asking price. Han demurred, but eventually agreed

to buy *The Raising of Lazarus* for about two hundred dollars – the equivalent of almost three thousand dollars today. If he were to make a return on his investment, Han's 'restoration' would have to be superlative.

If Han was daunted by the sheer scale of his criminal enterprise, his fears were allayed when, returning home, he discovered an article in the *Burlington* – by Abraham Bredius – entitled 'An Unpublished Vermeer' detailing his 'discovery' of *Lady and Gentleman at the Spinet*. Han glanced fearfully at the opening paragraph: '. . . the splendid harmonious colouring, the true Vermeer light and shade, and the sympathetic theme proves it to be one of the finest gems in the master's *oeuvre*'.

Han's heart quickened – Bredius's attribution was fulsome and categorical. Han smiled to himself as the august critic enumerated the similarities to extant works by Vermeer. 'The curtain on the left,' Bredius wrote, 'is the same as that which appears in his large picture, now in America, *The New Testament*.' But he felt a surge of gratitude when Bredius informed him that the pupil had surpassed the master, underscoring the psychological nuances Vermeer brought to his subject. Bredius was rapturous about the girl's expression: 'timid, and yet inwardly well-pleased with herself. It is not often that we find such a delicacy of feeling on a Vermeer face.'

His hands trembling, Han put down the magazine just as Joanna came into the room.

'Han, what is it? Are you all right?'

'It's nothing, nothing . . . I'm fine. It's just . . .' He smiled at her, suddenly flushed with confidence. 'I'm ready to start a new life.'

9

A SUPERIOR PICASSO

The world, they say, is a
thought in the mind of God.
When the Almighty conceived
Roquebrune-Cap-Martin,
He must have been joyous.

Louis Nucera

In Han's only drawing of the Villa Primavera, it rises like one of Mad Ludwig's follies from a barren crag, with flights of steps cut into the living rock. Behind this citadel, misty mountains recede into the distance. Perhaps this is how he saw the yellow stucco villa at number 10, Avenue des Cyprès. Certainly, there was a tower with a winding staircase, though it did not soar into the clouds as Han dreamed, there were spacious balconies overlooking the mountainside and the lights of Monte Carlo to the west, and the Italian hills to the east. For a couple with no children, it was a palace.

Han set up his studio in a second-floor bedroom, which the blaze of sunlight from the south illuminated all afternoon. In the basement, he established a laboratory where he could experiment with the technical problems of creating a genuine

seventeenth-century Vermeer. His bread and butter, while he worked on the dish he planned to serve cold, was portraiture. The Côte d'Azur was teeming with expatriates: wealthy merchants from England, actresses and musicians, bankers from America, and minor princes from inconsequential European countries, all of whom needed a portrait which would display their ego to its best advantage.

In The Hague, Han could command a thousand guilders for a portrait – here, he could charge two or even three thousand *dollars*. The portraits were traditional, obsequious, often thunderously melodramatic. In his gloomy portrait of the concert pianist Theo van der Pas (plate 4), the assembled spectres of Bach, Beethoven, Schubert, Chopin et al. loom over the rapt performer more like executioners than muses.

Han and Jo had found a small paradise here. They entertained lavishly at Primavera and Joanna was always eager to go dining and dancing in nearby Monte Carlo and Menton. Old friends from The Hague, the Quateros, the van Wijngaardens and the van Genderen Storts were regular visitors and, when Anna returned from Sumatra so that Jacques could pursue his studies in Paris, Han's children often spent their holidays in Roquebrune. The gifted Dutch artist, known by the honorific Maître, and his devastatingly beautiful actress wife were welcomed into the community. Han might easily have echoed Albrecht Dürer when he said, 'How I shall freeze after all this sun! Here I am acknowledged as a gentleman, at home a parasite.'

Han would spend as much as half of his working day on his lucrative commissions or at his serious painting. The rest of the time he spent in his makeshift laboratory in the basement of Primavera learning the rudiments of chemistry.

From his study of A.M. de Wild's *The Scientific Examination of Pictures*, Han knew that he had four crucial problems:

- Prepare only those pigments and paints Vermeer would have used, since chemical analysis could be used to test for anachronistic pigments.
- Remove all of the original seventeenth-century painting, so that nothing could by detected by X-ray.
- Contrive a method of hardening the paint so that it was impervious to alcohol testing.
- Reproduce the *craquelure* which is the hallmark of a genuine old master.

The first was easy for Han, who had always prepared his pigments by hand. When working on his own paintings, he had not needed to worry about the pigments he used, but he had discovered how easy these were to detect when he had used cobalt blue in his restoration of *The Laughing Cavalier*. He had bought his own raw materials, since the industrial cylinders used to make commercial pigments created a fine, homogeneous powder utterly unlike the often coarse grain of genuine seventeenth-century paint.

For the yellows, he would use gamboge from the resin of the garcinia tree, yellow ochre, an easily obtained mineral oxide which simply needed to be washed, ground and sieved, and lead-tin yellow, the characteristic luminous yellow of the ermine-trimmed shawl in Vermeer's *Woman with a Pearl Necklace*. For his reds he had obtained mercury oxide to make cinnabar, burnt sienna and carmine, which he could make from the powdered bodies of the cochineal beetle. Since Vermeer's shadows were rarely true black but deep umbers, he would make bone black but use it sparingly. He would add a little green earth to the flesh tones, an anachronistic quirk even in Vermeer's time when most artists had abandoned it in favour of umber. All that remained was the blue: though Vermeer had been known to use smalt and

indigo, both of which were easily prepared, Han had already acquired a supply of natural ultramarine which he, like Vermeer, intended to use extensively.

Han's second challenge was to remove all traces of a painting from a seventeenth-century canvas. From his reading of de Wild, he knew that it had become commonplace to subject a painting to the Röntgen ray. Though Han had never seen an X-ray machine, he knew its quasi-magical properties were capable of revealing an artist's tentative sketches beneath the surface of the paint and occasionally unmasking the forger who had left another artist's work beneath his own.

Han first experimented with solvents. While alcohol affected only fresh paint, caustic potash (potassium hydroxide) was known to break down even centuries-old paint, but he discovered that it ate into the brittle fabric of old canvas. Han determined that he would have to remove the paint by hand, layer by layer. The many layers of varnish could be carefully removed using artist's grade turpentine. Then, using soap and water and a pumice stone, he would begin to loosen the topmost layer of paint. Inch by laborious inch, he discovered, he could remove each layer, sometimes with the help of a palette knife. If he were to cheat the all-seeing X-ray, it would not be enough to remove the visible painting, he would have to remove the pentimento, or underpainting, with which the artist had sketched out his composition. Eventually, he would come to the 'ground', or priming layer, usually a thin layer of umber and gesso. To remove this – even with the most meticulous care – risked tearing or splitting the canvas, and Han decided it was safe to leave it as it contained no hint of the original artist's intention.

The two remaining problems: how to harden the paint making it impervious to alcohol and how to induce a believ-

able *craquelure* were intimately related. It is the centuries of slow hardening of the paint which also produces the cracking: as the oil evaporates, the paint shrinks, forming minute islands. With changes in temperature and humidity, the wooden stretcher expands and contracts, increasing the appearance of the crackle. Though it was simple to cause hardened paint to crack simply by rolling the canvas over a cylinder, the result was limited to the surface layer and the crackle too homogeneous to pass for that of an old master. Genuine *craquelure* varies according to the pigments used: areas of lead white generate broad, deep cracking, thinly layered paints – particularly lakes – produce hairline cracks.

The problem of crackle would have to wait, however, until he had found a way to harden the paint. There seemed to Han only two possible ways to cause oil paint to harden quickly: either by replacing linseed oil with a more volatile substance as a medium for the oil paint, or by applying heat to dry the surface artificially. In his restoration work for Theo, Han had experimented with essential oils, in particular oil of lilac and oil of lavender, both of which are more volatile than the linseed oil traditionally used. The results – as Bredius had proved – were unsatisfactory: the paint did not withstand an alcohol test, and would certainly not create a crackle as it dried.

Han's first experiments using heat to dry the paint proved no more successful. He used scraps of canvas, painting a thin spectrum of Vermeer's palette on to each. For the firing, he used a commercial electric oven. It was difficult to regulate, but it was enough to discover what he had already guessed: at high temperatures, the paint dried quickly but the colours were distorted: a halo of violet appeared around the ultramarine, yellows and whites caramelised to a rich brown, the paint surface blistered and the edges of the canvas were singed.

Heated at lower temperatures for periods of hours or even days, the paint never truly hardened and the colours blanched, losing all their brilliance and intensity.

For more than a year, Han experimented. He built his own oven – little more than a narrow letterbox with a heating element and a thermostat to adjust the temperature, but the results were the same; the trial paintings either melted and burned or became sun-bleached and anaemic.

Han was not initially worried about his technical failures. If he were to succeed, he realised, the technical aspects of his forgery had to be perfect. In the meantime, Joanna and Han were captivated by this lush life of alternating indolence and excess. They attended lavish balls and exquisite dinners at which Jo could flaunt her finery. In return, the van Meegerens threw sumptuous parties in the gardens of Primavera at which Han humbly accepted the adulation that, as an artist, he felt was his due.

He loved to take guests on a tour of his studio, a private glimpse of the artist at work. Here were potboiler portraits, their dramatic shadows and heightened nobility cribbed from Rembrandt, watercolours of whores and sailors in seamy nightclubs borrowed from Toulouse Lautrec and crude symbolist works like *Grain, Petroleum, Cotton* which aspired to the elliptical masterpieces of Odilon Redon Henri and Jan Toorop half a century before. Solemn biblical tableaux vied with sentimental portraits of Joanna, a dove perched on her outstretched hand, and the graphic fantasies of *I Have Summoned Up the Depths*.

For the most part, the procession of bankers and businessmen, actresses and aristocrats admired Han's no-nonsense realism and delighted in the sheer craftsmanship of the work, so Han was shocked when Joseph Cameron, an American

businessman whom Han was eager to impress, proved disappointingly unforthcoming during the tour.

Cameron was a disciple of the 'moderns'. He already owned a captivating Chagall and had recently acquired a painting by Giorgio de Chirico; he admired Picasso and solicited Han's advice on whether he should make an offer on a Salvador Dalí phantasmagoria.

Han was surprised and alarmed to discover this viper in his own backyard and passionately restated his antipathy to the moderns. Han and Cameron often argued good-naturedly but animatedly over a bottle of Margaux on the balcony of Primavera. Han was haughtily dismissive of the 'techniques' of cubism and surrealism and mocked what he called the 'primitive infantilism in art from the ancient negro, supported by the idiotic notion that the straight line is "stronger" than the curve'. Architects dating back to the ancient Greeks, he opined, knew better. Cameron was quietly scornful: art, he argued, was in a constant state of flux – to paint like a Renaissance artist today was to ignore how much the world had changed. The artist had a duty to react to the camera, to industrialisation, to question the very nature of art itself.

During one such spat, Han stomped from the balcony into his studio dragging a reluctant Cameron with him. He took a primed canvas and sat it on his easel and, as his guest watched, took a palette knife and with brash strokes began to anatomise and dissect a woman's face in primary colours. He set the eyes at curious angles, flattened the nose and placed both ears on one side of the head. Then, with a broad brush he took pure carbon black and outlined the portrait with angular lines. Cameron was astonished at the emerging painting. After a bare twenty minutes, Han stepped back, lit the cigarette which had been hanging from his lips throughout

his frenzied work and said coolly: 'A superior Picasso, I think you'll agree.'

Cameron picked up the canvas and admired it. It was, he would later admit, an excellent pastiche of a Picasso *Tête de femme*. The colours had the vibrancy and the tumult of the master, the incised lines of thick impasto chiselled into the canvas with the blunt end of the brush were uncannily exact. He handed the painting back to Han.

'You see?' Han sneered. 'It's the work of a child.' He tossed the canvas into a corner.

'May I borrow it?' Cameron asked. 'I'd like to hang it with the genuine moderns I have in the villa. I'm interested to see what my cultured friends think of my new "acquisition".'

'Leave it,' Han said testily, 'I have no wish to have a third-rate cartoon displayed anywhere.'

'I'll buy it, then,' Cameron said, 'I'll pay whatever you usually charge for a commission, and if my friends decide it is a Picasso, I'll double it.'

'I'm not in the business of forgery,' snapped Han, 'but if I were, I wouldn't forge an inferior artist's work.' He picked up his palette knife and slashed the canvas. 'The man has no technique that could not be mastered by a backward child – what is something like this compared, say, to the genius of Vermeer? Let's have another drink . . .'

He had already retired to the balcony and was sipping his Margaux, flushed still, partly from the exertion but mostly from anger and frustration that Cameron should take this work so seriously.

'You know that Dalí is a devoted admirer of Vermeer's work?' Cameron attempted to mollify his host.

'Really?' Han thought as he lit another cigarette. 'It is hardly surprising, I suppose – he is the only one of the moderns with

any technique – but his subjects: rotting birds and Freudian symbols and clocks with the consistency of ripe Camembert.'

'But you will admit that no child could fake a Dalí.'

'Perhaps not,' agreed Han, 'but any artist could do the same with a random assortment of nonsensical symbols. Just set it all against a rolling desert plain, add some decomposing wildlife . . .'

'Perhaps we could make it a commission?'

For half an hour, they idly discussed what such a hypothetical Dalí might look like. Though initially Han seemed tempted by the challenge he later laughed it off. It would, he realised, require extensive study of a painter whose work he barely knew and heartily despised; the result might be a technical *tour de force* but Han had other, more pressing, technical problems to attend to.

10

THE PLASTIC VIRTUES

In the Bakelite house
of the future, the
dishes may not break,
but the heart can.

J.B. Priestley

It may have been the moment when he first picked up the receiver of his newly installed telephone, or when he reached out to turn on his Marconi wireless set; it could have been something as routine as sharpening a pencil; all we can know is that one day Han van Meegeren realised he was surrounded by an intriguing substance known as *plastic* – specifically the first commercially made plastic, *Bakelite*. It is likely he lived with the substance without ever wondering what it was or how it was made. Now, suddenly, he was curious about this 'plastic' which Leo Baekeland promoted with the slogan 'The Material of a Thousand Uses'.

By the 1930s, Baekeland's synthetic solid was being used in everything from ashtrays to lampshades; it was even carved by craftsmen to create jewellery. All Han knew was that, some-how, simple chemicals could be combined to create a resin

which would harden to a solid mass: what if this plastic might replace plant oil as a medium in paint?

Though Han had no scientific training, he was curious to see whether some aspect of Baekeland's research might prove useful in his search for a medium. The chemical composition of Bakelite, he discovered, was nothing more than phenol and formaldehyde which, when mixed together and heated, hardened perfectly if allowed to cool and dry. Phenol he knew as carbolic acid; formaldehyde, a water-soluble gas, was used to preserve biological specimens and as an embalming fluid. Both, Han discovered, could be obtained from any chemist and the process for hardening the resulting resin required no more than a steady heat (special ovens known as Bakelisers had been produced since 1909).

Han procured small amounts of the chemicals and began to experiment. The formaldehyde had a particularly noxious smell and, working in the basement laboratory, Han was regularly forced to surface for air – or more often cigarette smoke. Initial trials seemed promising. Han mixed the chemicals in equal quantities to produce a resin which, though somewhat sticky, could easily be worked with a brush or palette knife. At first he was worried that the resin had a dull brownish tinge that might alter his pigments, but the final effect resembled that of antique varnish.

Han initially prepared batches of colour, mixing the raw pigment with lilac oil and the phenol-formaldehyde solution, and began painting short strips of new canvas to see how they would react to heat. He quickly discovered that it was necessary to mix very small quantities and work in rapid strokes or the resin and paint mixture became viscid and unusable. For his first samples, he painted short strips of single colours and heated them in his crude oven at 95°C for an hour. He was

excited to find that when he removed them, the colours remained brilliant and true, but the surface was not entirely hard. He tried another batch, this time painting a rainbow of seventeenth-century colours on each, and fired the strips at a steady heat of 105°C for two hours. When he removed the canvas it was hard to the touch and the colours, as before, were as brilliant and intense as when he had applied them: they had not bled into each other, there was no sign of scorching or blistering. He allowed the strips to cool and then, taking a swab of cotton wool soaked in a solution of one part alcohol to two parts turpentine, held it above the surface of the paint. The fumes had no effect. He took a new swab, this time with two parts alcohol to one part turpentine, but it too had no effect. Even when he rubbed the paint surface with pure alcohol, the paint did not desaponify. Dizzy, as much from the formalde-hyde fumes as from his elation, he went upstairs to his balcony, stopping, perhaps, to grab a bottle of Pouilly-Fuissé from a newly imported Williams Ice-O-Matic.

'Jolanthe?'

He settled into his chair, lit a fresh cigarette and stared out over the Mediterranean dusk. Jo popped her head round the French windows, wearing a midnight-blue evening gown: the very gown in which he had painted her, serene and entrancing, a dove perched on her outstretched hand.

'Han, aren't you dressed yet? We're having dinner with the Camerons tonight.'

'Jo, come and sit down. Have a drink with me; we're celebrating!'

All through the formal dinner, Han's mind was racing. Though his preliminary experiments showed potential, he would need to methodically test this new medium with each of Vermeer's known pigments, and with every possible com-

bination. Since the resin was fast-drying even at room temperature, he would have to find a way to mix batches of colour which did not congeal within a few minutes. Tomorrow, he would test the process on one of the genuine seventeenth-century canvases he had bought to see whether either the resin or the heat would damage it. Even if he could harden the paint without damaging the brittle canvas, there was, he realised, still the problem of inducing the essential *craquelure* in his 'plastic paint'.

In the weeks, perhaps months that followed, Han blended experimental batches of paint. He would first mix the resin with lilac oil and use the resulting concoction to make up his paints. The result still became claggy and unworkable after a short time. While it was sufficient to paint a small area, it would be impossible to do the detailed modelling on a face or the reflections in a silver bowl. He tried mixing small batches of paint using lilac oil as his medium, then, carefully, he dipped his brush first into the paint, then into the phenol-formaldehyde solution and applied smooth easy strokes. This succeeded perfectly: the paint on the brush was easy to work with, and that remaining on his palette did not solidify. Though working in this way changed the rhythm of his painting, after a few months the process was second nature to him. Brush, palette, resin, canvas, brush, palette, resin, canvas. With this small success came new worries. Han wondered whether traces of his synthetic medium might be detected by chemical analysis but, he reasoned, much of the phenol-formaldehyde solution evaporated during the drying process and besides, while a chemist might test an old master for contemporary pigments, he would hardly look for the presence of plastics.

Before he could paint and fire a completed canvas, he needed a new oven. He had begun his experiments using a commercial

oven; later he had created a small, flat makeshift oven with a crude regulator to control the temperature. If he were to risk one of his seventeenth-century canvases, he had to be certain that the temperature was constant so the new oven would need an accurate thermostat. More importantly, it had to be large to easily accommodate *The Raising of Lazarus* which was almost four feet by six.

He built the new oven himself. It was a simple rectangular box measuring some sixty-five by fifty inches, with a letterbox opening. Although he had little aptitude for the sciences, Han pored over manuals and visited electrical suppliers to find heating elements and an accurate thermostat. He may have sought advice in wiring the curious device, though it would have been difficult to explain to an electrician what such a large and bizarre contraption was intended for. The new oven had a flue connected to the chimney of Primavera so that the billowing fumes of the resin did not permeate the house, and a glass door allowing Han to monitor any changes in the paint surface.

Han refined his technique, painting a number of experimental canvases in the styles of Vermeer and Ter Borch. Though all were technically superior to many of Han's later forgeries, he made no attempt to sell them – it seems clear that in his first heady days as a career criminal, he was holding himself to the strict amoral code he had devised whereby he did not want to win fame through mere pastiche.

We cannot know in which order Han painted these practice pieces, but it seems likely that *A Woman Reading Music* was the first. It is delicate and beautifully executed, richer and more complex than *Lady and Gentleman at the Spinet* with none of the crude caricature of his first attempt, but it is based entirely on a painting Han knew intimately from his visits to the

Rijksmuseum: *Woman in Blue Reading a Letter*. For some, the painting is Vermeer's finest achievement. Arthur K. Wheelock in his *Johannes Vermeer* writes:

> In no other painting did Vermeer create such an intricate counterpoint between the structural framework of the setting and the emotional content of the scene. A mere description of the subject – a young woman dressed in a blue jacket reading a letter in the privacy of her home – in no way prepares the viewer for the poignancy of this image, for while the woman betrays no outward emotion, the intensity of her feelings is conveyed by the context Vermeer creates for her.

The woman, thought to be Vermeer's wife, is heavily pregnant. She stands, head bowed, by an escritoire reading a letter. She is framed by the tranquillity of the room: in the foreground gloom a blue chair echoes the blue of her dress; behind her, an indecipherable map hangs on the shadowy wall. She alone stands washed in a flood of sunlight from an unseen window on the left. She seems to be reading intently, her lips parted, her fingers seemingly tensed, since they appear to crease the letter as she holds it. There is no further narrative: we do not know what news the letter bears, or how it will affect her in the moment after she has read it. She is captured in a frozen moment that may change her life.

Han's imitation, *A Woman Reading Music*, brings together many of the same elements, but it affords no such suspense. The woman is now seated at the desk. The tilt of the head, her clothes, her hair are almost indistinguishable from the original save for the fact that she now wears the pearl earrings which lay on the desk. The map which hung on the wall has been

replaced by a painting. What is missing from the painting is a narrative, a frozen moment on which the woman's fate may turn. She seems to be reading a musical score. Like Vermeer, Han left the painting unsigned.

This was Han's first attempt to use the techniques he had devised to create a completely convincing old master. First, he had to remove the seventeenth-century original from his two-hundred-year-old canvas. This he did using only water and a pumice stone, leaving untouched large sections of the ground, the original priming layer, for fear of damaging the canvas.

Using gamboge and umber, Han sketched out the penti-mento – the preliminary outline of his composition. He fired the canvas for two hours at a steady 105°C and, when he removed it, the paint was hard, and some of the original crackle had come through. In those areas where he had painted thickly, the crackle did not reappear. The results were promis-ing, but his technique would have to be refined if he were to produce a canvas which genuinely appeared to be three hun-dred years old. Finally, he began work on the painting itself. It may have been because he did not intend to sell the work or submit it for attribution, but he was loath to waste his limited supply of costly ultramarine and so used cobalt blue in his composition. Once finished, he fired the painting again and after two hours removed a brilliant, intense genre portrait of the woman in blue. It may have sat on his easel for several days and each time he stepped into his studio he would be struck by a detail which rang true or some error of style or substance he had made.

To create the *craquelure*, Han rolled the canvas gently over a cylinder, bending and warping it to crack the hardened paint. The result was superficially impressive, but it did not truly resemble the crackle of centuries: it was too uniform in its

distribution and penetrated only the surface layer of the paint. There was, he realised, another serious problem: the *craquelure* in his new Vermeer seemed too fresh, too recent. Even after a coat of tinted varnish, the colours seemed too vivid, the light almost searing. It took him some time to realise what was missing: dirt. The dark russet tracery of centuries of dust and debris which marks a painting out as old.

Han's third Vermeer was a departure. *A Woman Playing Music* is not based on any extant work, nor like *Lady and Gentleman at the Spinet* is it a composite of several. This was van Meegeren's first 'original' old master and his finest 'genre' painting. It portrays a woman with a lute, her gaze turned to an archetypal Vermeer stained-glass window which floods the room with light. Subtle cues to other Vermeers replace the ripe plagiarism of Han's earlier attempts. The woman's hair is covered by a white scarf like that worn by the girl in Vermeer's *The Glass of Wine*, her blouse is modelled on that worn by the woman in *Officer and Laughing Girl*, but Han had gained in confidence and felt no need to slavishly copy: the composition is his own, and the woman's face, her distant gaze as she tunes the lute capture the stillness and restrained narrative of a true Vermeer. Han felt a nervous elation, fuelled by the success of his technical discoveries. He was painting easily and fluently now, he sensed that he had grasped the essence of Vermeer's brushstrokes, the serenity of the master's interiors, the delicate layers of lakes and washes which orchestrated this symphony in light. With *A Woman Playing Music*, the final piece of the puzzle – the *craquelure* – had been solved. Han had discovered that the crackle from the original seventeeth-century painting would spontaneously reappear if he was careful to paint in thin layers, baking each layer before continuing with the painting. A coat of varnish applied to each layer while still warm forced

the *craquelure*, preserved like the tracery of centuries in the original ground, to re-emerge in each succeeding layer as it dried. The resulting network of fine lines was utterly convincing. Excited now, Han abandoned his work on *A Woman Playing Music*. He had perfected his technique and was aching to make a start on the painting that would make or destroy him, yearning to create a work which would overturn centuries of received wisdom, force the world to reconsider Vermeer's *oeuvre* and, in doing so, allow him to slip into the canon of Western art unobserved. He had only to find a subject.

11
THE HOBO WHO WAS CHRIST

Those who do not want to imitate anything, produce nothing.

Salvador Dalí

Han and Jo took a long-planned holiday in the summer of 1936, attending the Olympic Games in Berlin. Some have seen his decision to attend the games as a political one, evidence of an ideological sympathy with Nazism, but though Han's views on art were reactionary, and echoed fascist notions of the degeneracy of modern art, it is likely that Han, like most of the ingenuous West, simply did not realise the enormity of what was to come. Though there had been a campaign to boycott the games, supported by Lee Jahncke, the American member of the International Olympic Committee, Jahncke was expelled from the committee for his pains and replaced by Avery Brundage, a former American Olympic athlete who steered the vote of the Amateur Athletic Union to a narrow victory. In 1935, in a chilling echo of what was to come, Brundage accused a 'Jewish-Communist conspiracy' of attempting to keep the United States out of the games.

In Berlin, Han and Jo were met with an awe-inspiring spectacle of Nazi propaganda at full throttle. Fluttering banners

bearing swastikas vied with the Olympic flags on every public building, painting the sky over Unter den Linden an ominous red. All over the city, they saw large mysterious booths – 'viewing rooms' set up to allow the citizens their first glimpse of 'television'. Han and Jo attended the opening ceremony in the vast neoclassical stadium where the Canadian Olympic team, alone among non-Fascist countries, gave the Nazi salute 'in a gesture of friendship'. No one, it seemed, had listened to the minister for propaganda, Joseph Göbbels, in 1933: 'German sport has only one task: to strengthen the character of the German people, imbuing it with the fighting spirit and steadfast camaraderie necessary in the struggle for its existence.'

In reality, the van Meegerens's holiday had little to do with politics and nothing to do with sport. Han preferred to spend his time wandering the deserted halls of the Charlottenburg Palace and the Gemäldegalerie while Joanna went shopping. They spent their evenings at sumptuous restaurants or at the Berlin Staatsoper. In the Gemäldegalerie, Han passed several hours sketching Frans Hals's *Malle Babbe*, the crazed, drunken 'witch of Haarlem' with an owl perched on her shoulder (the Dutch, eschewing skunks and newts, favour the expression *zo beschonken als een uil* – 'as drunk as an owl'). The painting Henry James described as 'dashed upon the canvas by a brush superbly confident' would one day offer Han another subject for his forgeries.

Arriving back in Roquebrune, Han leafed through a newly published history of eighteenth-century Dutch painting. It was a detailed and comprehensive account of the Golden Age by two of the leading experts in the field: Dr D. Hannema, the director of the Boijmans Museum in Rotterdam, and Dr Arthur van Schendel, later director of the Department of Paintings at the Rijksmuseum. Han immediately turned to the chapter on Vermeer and was rewarded with a myth he

could make his own. Since de Groot's 1907 *catalogue raisonné*, Vermeer's reputation had continued to soar, but no more was known about his life and the true extent of his work than Thoré/Bürger had discovered almost a century before. History, like nature, abhors a vacuum, and on this barren terrain speculation and fable had flowered. In the chapter on Vermeer in *Noord- en Zuid-Nederlandsche schilderkunst de XVII eeuw*, Hannema and van Schendel advanced a theory which would provide Han with the subject for his forgery. Though Vermeer's output was small, there was, they argued, a glaring disparity of style and subject between Vermeer's earliest painting, *Diana and Her Companions*, and his first mature work, *The Milkmaid*. Vermeer's early paintings were large sweeping Italianate canvases, with the broad brushstrokes and characteristic chiaroscuro of Baburen and the Utrecht Caravaggisti, utterly unlike the 'serenity of heart and nobility of spirit' which characterised his late work. In this void, Hannema and van Schendel imagined a missing Vermeer which would one day unite the two: Vermeer, they stated confidently, had clearly painted several religious subjects in his youth, only one of which had survived.

The idea was not a new one. Hannema and van Schendel were merely lending weight to a theory first proposed by Abraham Bredius when attributing a controversial 'early Vermeer'. Bredius's epiphany had come in 1901 on a trip to London where 'in the window of a London art dealer I saw a painting. I recognised Vermeer in it.' It seemed an unlikely attribution. The painting was a brooding, shadowy work reminiscent of the Caravaggisti, the canvas was much larger than anything Vermeer was later to paint, the figures almost life-size. Most importantly the painting was a religious piece, depicting *Christ in the House of Martha and Mary* in a setting

similar to the contemporaneous work by Erasmus Quellinus. Only one other Vermeer is religious in nature, *The Allegory of Faith*, a curiously atypical late Vermeer, commissioned by a Catholic patron, whose style – polished and theatrical – is more reminiscent of Dou and van Mieris than of Vermeer's work.

When Han first saw a reproduction of *Christ in the House of Martha and Mary*, he doubted it was a Vermeer at all; and yet something in the tranquillity of the scene, the basket of bread that Martha holds, the oriental rug which seems to echo that which appears in *Maid Asleep*, evoked the work of the Sphinx of Delft. The signature I V Meer – small but easily identifiable – is inscribed on the stool on which Mary sits, though Bredius would have known that the signatures on *The Astronomer* and on *The Geographer* had already been dismissed as forgeries.

Bredius's attribution was vehemently disputed. Many critics believed – some still believe – that the painting was painted by the Utrecht artist Jan van der Meer, but Bredius was unshakeable in his conviction that it was an early work by Jan Vermeer van Delft. For Bredius, the painting was incontrovertible proof that Vermeer's early work had been strongly influenced by Italian painting and, he argued, it was very likely that Vermeer had travelled to Italy in his youth and been inspired by Caravaggio himself. If so, surely there were other religious paintings by Vermeer which had yet to come to light.

It was an appealing theory. After all, barely fifty documented works by Vermeer were known to exist, and none offered even the intimation of a transitional period between the early style of *Diana and Her Companions* and *The Procuress* and the tranquil domestic studies of *Lady Reading a Letter* or *The Lacemaker*. If *Christ in the House of Martha and Mary* were genuine, it was extraordinarily unlikely that Vermeer, a devout

Protestant who had converted to Catholicism to marry Cath-
arina Bolnes, would have painted no other religious subjects.
Now, the foremost curators of Holland's heritage had joined
Bredius and the critic P.B. Coremans in wishing a new Vermeer
into existence. No critic would be able to resist discovering a
painting which substantiated some long-cherished theory. The
forger need only uncover the critic's deepest desires and make
them real; now that they had told him what they most desired,
Han had only to make their dreams come true. 'The world,' as
Thomas Hoving admits, 'wants to be fooled.'

Han thumbed through his sketchbooks and found those he
had brought back from his trip to Italy four years before. He
scoured page after page before lingering on a charcoal sketch.
Han remembered the drawing. He had spent an afternoon in
the Palazzo Patrizi sitting in front of Caravaggio's *The Supper
at Emmaus* trying to capture the subdued drama of the mo-
ment. It was the perfect subject; other than Rembrandt, no
artist had painted *The Supper at Emmaus*, and it was inescap-
ably linked to Caravaggio who had returned to the subject on
three separate occasions. In this transcendent moment when the
risen Christ reveals himself to his disciples, Han could see
beyond the tenebrism of Caravaggio to the stillness at the heart
of the painting, the central still life: a table, a beaker of wine and
Christ breaking bread for his companions. Here was a Car-
avaggio Han could imagine being painted by Vermeer.

On a bright autumn morning in 1936, He took down *The
Raising of Lazarus* and began. He gently removed the painting
from the seventeenth-century stretcher, careful to preserve the
original nails which secured it and the small leather squares
which had protected the canvas from rust. Han's next act was
the most peculiar: he carefully cut a strip of canvas some
twenty inches wide from the left-hand side of the painting,

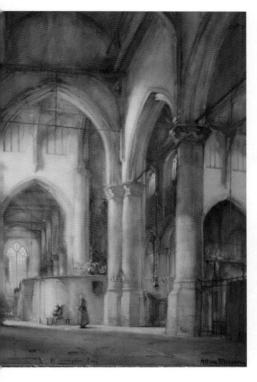

1. *Interior of the Laurenskerk* won the untrained van Meegeren the coveted quinquennial Hague Gold Medal.

2. *Jo with Dove*, van Meegeren's sentimental portrait of his second wife Joanna Oelermans.

Hertje (The Little Deer). ...n's sketch, drawn in nine ...utes to impress his ...dents, became the most ...roduced image in twentieth-...tury Holland.

4. *Theo van der Pas*. Han's melodramatic potboiler portraits flattered his subjects.

5. One of Han's unsold 'trial' forgeries, *A Woman Reading Music*, is cribbed entirely from Vermeer's *Woman in Blue (below right)*.

6. *Lady and Gentleman at the Spinet*, van Meegeren's first forgery, is a collage of references to authenticated Vermeers.

7. Vermeer: *Woman in Blue*.

8. Han's 'masterwork', *Die Emmausgängers*, is an utterly atypical 'Vermeer', though the allusion to Vermeer's *The Astronomer* is unmistakable.

9. Vermeer:
The Astronomer.

10. *Malle Babbe* (unsold). Han's attempt at forging Frans Hals was considered by P.B. Coremans 'as good as any of the works of Hals' pupil Judith Lyster'.

11. Frans Hals: *Malle Babbe*.

12. *A Woman Playing Music*. As Han's confidence grew, he no longer felt the need to pastiche extant works by Vermeer.

20. By 1943, drug-addled and alcoholic, Han's forgeries had become crude ugly daubs, yet *Isaac Blessing Jacob* was authenticated as a Vermeer and sold for the equivalent of $11 million.

21. Authenticated by a committee of eminent Vermeer scholars, The Washing of Christ's Feet, was Han's last – and least – forgery.

22. *Christ with the Woman Taken in Adultery*, despite the crude modelling and slapdash execution, became the pride of Reichsmarschall Hermann Göring's collection.

23. Despite van Meegeren's confession, experts would not believe he had forged the 'sublime' *Supper at Emmaus* and had him paint 'a new Vermeer' (*below*) watched by court-appointed guards. 24. *Young Christ Teaching in the Temple* (*above*) was the result.

25. *A Young Woman seated at a Virginal*, sold at Sotheby's in 2004 for $30 million, was long thought to be a van Meegeren. Many experts dismiss its re-attribution to Vermeer, calling 'this nasty little picture' 'a tasteless mishmash' of genuine Vermeers.

leaving the canvas almost square, forty-five inches by fifty. There was no artistic reason to cut down the canvas, since he had yet to begin his composition. Han later explained that he had cut down the painting so that, when the time came and he revealed his deception, he would have tangible proof. Lord Kilbracken sensibly suggests that if Han needed such proof, it would have been easier for him to buy a Box Brownie and photograph the work in progress. Why Han should make an already difficult task more complicated is impossible to say, but since there is no other plausible reason, we are forced to accept that Han had every intention of revealing himself as the author of the *Emmaus*.

'As a result of cutting down the canvas,' Han explained, 'I had to cut down the old stretcher to the same extent, and so I also displaced to the right the corner braces on the left-hand side of the stretcher.' This was a delicate and dangerous operation since the old wood would be dry and fragile and any obvious repairs to the stretcher would immediately arouse suspicion. None the less, he took a handsaw and, leaving the braces in place, carefully removing the corner nails, cut a twenty-inch section from the left-hand side of the stretcher, sanding it so the amputation was invisible before re-attaching the frame and the supporting braces.

Han set the stretcher aside and mounted the canvas on a sheet of plywood to begin the laborious task of removing all but the priming layer of *The Raising of Lazarus*. Given the size and fragility of the canvas, the process may have taken him several days. Using soap and water and a pumice stone, and a palette knife or a coarse fibre brush to remove stubborn islands of the original paint, he neared the original ground; he had to be increasingly careful; the priming layer had to be preserved intact if the original age crackle was to come through. He had all but

completed his tedious graft when he happened on a patch of lead white which refused to come loose. Despite patient scouring with his pumice, he could not detach it from the primer and became worried that he was about to destroy the priming layer or, worse still, rip the canvas. From de Wild's *The Scientific Examination of Pictures*, he knew that lead white would glow brilliantly on any X-ray and so decided to incorporate the stubborn blot into his own composition. But there was another area where the canvas was sheer and the underpainting of a woman's head clung to the ground. He removed everything he could, mentally rearranging his composition yet again, hoping he might incorporate the shape somehow into his porcelain jug whose lead white paint would obliterate the stubborn head on an X-ray. Exhausted and frustrated he stepped back and surveyed the canvas. The dull brown priming layer was intact, its crackle evident even in the poor light of his basement laboratory. Han decided that he had done all he could. Over the original priming layer, he painted a thin 'levelling layer' of gesso and umber, mixed with his phenol-formaldehyde resin. He took the immense canvas and placed it carefully in his oven and baked it. When he removed it, he was reassured to discover that the filigree of *craquelure* had appeared intact in his levelling layer. If Han could induce this crackle, layer by layer, right to the surface of the painting it would perfectly correspond to the underpainting of the original which he had all but stripped away. The two layers making up the pentimento were similarly lightly painted so that Han could induce the crackle in each. After baking he painted the surface with a thin layer of varnish which he allowed to dry naturally. What remained was easy, he had only to paint a masterpiece.

That evening, chain smoking on his balcony, Han re-read the passage in the Gospel of Saint Luke:

And, behold, two of them went that same day to a village called Emmaus, which was from Jerusalem about threescore furlongs. And they talked together of all these things which had happened. And it came to pass, that, while they communed together and reasoned, Jesus himself drew near, and went with them. But their eyes were holden that they should not know him.

There is no atheist like a lapsed Catholic: for years Han had raged against his father's God, rebelled against this vengeful, dictatorial moralist, the God who had taken his brother Hermann, leaving him with a sick rage that had burned within him for two decades. Yet, as he read, his apostasy fell away. 'And it came to pass, as he sat at meat with them, he took bread, and blessed it, and brake, and gave to them. And their eyes were opened, and they knew him; and he vanished out of their sight.'

Han spent six months working on *The Supper at Emmaus* and, for all its faults, it is perhaps his finest work. There is no hint of pastiche here, no slavish copying from Vermeer's work. The painting is a van Meegeren through and through, similar in style and composition, in modelling and in sentiment to his own religious paintings. Han studied the sketches he had made in the Palazzo Patrizi and laid out the composition of his *Emmaus* such that any art historian would immediately recognise Caravaggio's hand. It is a simple group portrait: Christ faces the viewer, his eyes half-closed in prayer, his right hand raised to bless the bread he is about to break. On his left sits Cleopas, who gazes in awe at the risen Christ. Facing him, an unnamed disciple, wearing a rough-hewn tunic, looks towards Jesus, his back to the viewer, his face a sliver of profile. Behind the disciples stands a serving girl, her face as serene and as

simple as a Madonna, her hand reaching towards the jug of wine.

Han brought the canvas, tacked now to a temporary stretcher, to his studio on the second floor where he had already laid the table for his Supper. The pewter plates gleamed on a starched linen tablecloth, the bluish sparkle of the seventeenth-century glasses sat reflected in the silver-topped porcelain jug. Han set fresh bread on the plate which would be before Christ. Here was the central still life of his composition.

In the warp and weft of the tapestry of lies which constitutes Han's life, the circumstances in which *The Supper at Emmaus* was conceived are the most contentious. Han and Joanna had lived together for almost ten years, she was his confidante and his lover, she came and went from his studio as she pleased. She was passionate about art and a fervent believer in Han's talent – if indeed she knew nothing about his forgery, how did he keep her from his studio for the long months necessary to complete the painting?

In a sworn statement, Han would later attest, 'I sent my wife away for the whole period because I wanted no witnesses to my work. I knew that I needed perfect solitude if I was to create a work of art that would amaze the world and confound my enemies.' How he convinced Joanna to leave the villa for the six months it took to paint *The Supper at Emmaus* he did not say, nor did he explain where she spent her enforced holiday. In his confession, Han even claimed that Jo turned up one day unannounced, convinced that he was having an affair and hoping to catch him *in flagrante delicto*. Jo scoured every room in the villa searching for some mysterious serving wench or society lady and when she found none, left, 'Taking with her the swimming costume which had been the pretext for the sudden visit of a suspicious wife.' Perhaps it was this detail

which persuaded the Dutch authorities not to press charges, though they clearly did not inquire further. It is a charmingly manipulative story and worthy of Han's talents as a liar, but there is no verifiable truth to it. Had the authorities interviewed the owner of the villa, Monsieur de Augustinis, he would have told them that Han was never alone at the villa for more than a day or two. Though de Augustinis did not live on the property, he had a house in the nearby Domaine du Hameau and knew the van Meegerens well. He occasionally made social visits and personally collected the rent once a month. Had Joanna been away for half a year, he would certainly have remarked on her absence.

Further proof of Joanna's presence at the villa during the period when the *Emmausgängers* was painted is provided by the local police who arrived unannounced one morning in the early autumn of 1936.

A young girl had disappeared from Roquebrune and horrified villagers were convinced that she had been abducted and murdered. Though Han had lived near the village for five years, he was still very much an outsider; his baleful face, even sporting the beret he affected during his years in France, had something of the deviant in it. His moustache, trimmed closely, looked a little too much like that of Adolf Hitler. On an uncommonly warm morning, a villager noticed smoke spilling out of the chimney at Primavera. Convinced that Han had murdered the unfortunate wretch and was disposing of the corpse, he contacted the local *gendarmerie* who had little trouble convincing a local judge to provide them with a warrant. They arrived at the villa as Han was carefully baking the levelling layer on to the prepared canvas. They were met at the door by Joanna. Han, emerging from the basement laboratory, was surprised and shocked to find two uniformed

officers brandishing a warrant and demanding to search the property. Han had heard nothing of the missing girl and had no idea what they might be looking for. It may even have flickered across his mind that somehow 'they' knew what he was working on and were here to find evidence of his forgery. Few people could have been more relieved to discover that they were merely a suspect in a murder inquiry. Han took the officers on a tour of Primavera, and led them to the basement where he showed them the oven in which the canvas for the *Emmaus* was simmering gently. He was an artist, he explained, working on a delicate new experimental process. The oven was an integral part of his research. The curious contraption was much too small to contain the remains of a child, however young; none the less one officer dutifully peered through the glass door of the oven and saw what appeared to be a canvas. Han did his utmost to seem polite and unhurried; in fact, he was worried that if the officers stayed much longer, his precious canvas would scorch or burn.

Legend shrouds the models used for the figures of Christ and his disciples in painting the *Emmaus*. Han contends that the figures of the disciples and the serving girl sprang from his fertile imagination. Only for the figure of Christ did he feel he needed a model. The focal point of his composition had to be a breathtaking portrait of God made Man, the risen Christ raising his hand to bless the bread, revealing the miracle of the resurrection to his disciples. Han did not want his Christ to be the tender handsome prophet of Raphael, but a labourer, his face weathered and aged by suffering and pain; a Christ with the compassion and vulnerability of a Rembrandt self-portrait. Providence, divine or secular, intervened to provide him with just such a man.

One morning, according to Han's account, as he was taking his morning coffee on the balcony, there was a knock at the door of the villa. Han leaned over the balcony and called down, and the face that looked up at him was Christ himself.

'*Signore*, I don't suppose you have a bit of work going? I've been labouring on a farm here, but the harvest is over and I need money to get back to Italy.'

'Wait there a minute,' Han said, and went downstairs. When he opened the door, he saw an unshaven, thickset man, his face weathered and lined by the sun, his clothes dirty, his hair dishevelled. In that sunburnt face, Han saw a stoic dignity, a nobility of spirit, a living Rembrandt portrait. He invited the man in and offered him something to eat.

While the *zoticone* tucked into his breakfast, Han proposed that he might have some work for the man. The labourer looked up and grunted.

'I'm not rightly sure what I can do – I'm a labourer and it doesn't look like you have any fields need harvesting.'

'I am an artist,' Han said, giving the word all the solemnity he could muster, 'a painter, and I need a model for a painting I am working on. You might stay here at the villa for, say, two or three days while I sketch you.'

'Can't think why anyone would want to paint me.' Han's guest laughed and shrugged his shoulders. 'All right, then . . . But you'll pay me?'

'Of course,' said Han, 'I'll give you whatever you usually earn for a day's work and you won't have to lift a finger. And you'll get your food and wine besides.'

The labourer shrugged again, the deal was done. Han fetched his pad and began to sketch the man's face: the high forehead, the deep-set eyes, the sunken cheeks and the slightly melancholy mouth.

According to Han's account, the tramp stayed at Primavera for three days. On the first day, he sat fidgeting in Han's studio as the artist completed several charcoal portraits and sketched the man's gnarled hands. Han offered him whatever he would like to eat, but in Han's words, 'All he would eat was rye bread and garlic washed down with wine.' On the second day, he had the man wear a makeshift tunic and sit for him in his studio as he began to block in the face of Christ on his canvas; eyes downcast, one hand holding the loaf, the other poised to bless the bread and wine. He spent several hours trying to sketch in as much detail as possible while he had his model.

When they had finished for the day, the man asked if he might see the painting. Knowing that his guest had probably never set foot in a gallery in his life and never would, Han waved a magnanimous hand.

'Of course.'

The Italian stood for a moment in silence before the half-finished painting.

'Who am I?' he asked.

'Sorry?'

'Who am I meant to be?' the man asked. 'And who are these other folk?'

'It is a painting of the risen Christ. In the Gospel of Saint Luke, Christ appears to two of his disciples as they are walking to the village of Emmaus. but they do not recognise him. It is only at this moment,' Han gestured to the painting, 'as he blesses the bread and breaks it, that they realise they are in the presence of Our Lord.'

The man turned pale and quickly blessed himself. 'I don't know as you should be painting a sinner like me as Our Lord.' For a moment, the man hesitated about staying on, but Han placated him, assuring him he was as worthy a model as any

man. Even so, Han was woken in the night by whimpering and went downstairs to find the itinerant worker sobbing in his sleep. On the third day, as Han pressed several hundred francs into the man's horny hand, the tramp, Han maintained, could not shake his 'fears of unworthiness' and asked if Han would pray for him. Watching from the balcony as the figure of the labourer shuffled down the steep hill towards Roquebrune, Han insists that for the first time in twenty years he offered up this prayer: 'God – if there is a God – please don't blame this man for his part in my work; I take full responsibility. And if You exist, please do not take it amiss that I've chosen a religious subject for my "Vermeer". No disrespect is intended, the choice is purely coincidental.' A lawyer would have been hard pressed to frame a more circumspect act of contrition.

Lord Kilbracken, in his biography, writes: 'Van Meegeren was an inveterate liar, but I hope this particular story is true and can think of no reason why he should have invented it.' The simple reason is that Han was indeed suffering from *pseudologia fantastica*, a personality disorder now usually known as 'factitious disorder' in which the patient tells complex and intricately detailed stories about his life, both present and past. Such stories are usually on the edge of plausibility, deftly weaving fact and fantasy and if confronted the subject will admit that they have lied, only to offer some new explanation riddled with more convincing fabrications. In the words of the psychologist Charles Ford, 'Attempting to determine the "truth" from these persons is like trying to catch a greased pig.'

A wholly different tale accounting for the models in *The Supper at Emmaus* is provided by Frederik Kreuger, whose biography is based in part on the unpublished autobiography

of Jacques van Meegeren. Kreuger offers what he calls 'a much simpler scenario':

> In that scenario Jo posed for each of the four characters in turn. Jo was an actress and well knew how to hold a pose, it was something she had done all her life . . . The three male figures he painted without a face, which he could fill in later. Only the serving girl bringing in the wine has Jo's face, sufficiently altered so as not to be recognisable. A simple task for an experienced artist like van Meegeren.
>
> While it cannot be proven that this is how it happened, it is certainly plausible. Experts from the Rijksmuseum and the Boijmans who have considered the scenario agree that it could well have happened this way.

'*The Supper at Emmaus* is even more of a fake than we thought,' Kreuger adds. 'These are not the disciples at Emmaus, but a quadruple portrait of Jo.'

It is a colourful but unlikely theory. The worshipful Cleopas, his face turned towards Christ, his arm resting along the table is too similar to the head and arm of Vermeer's *The Astronomer* to be coincidence. It is likely that in painting a Vermeer so radically different from any known subject, Han wanted to provide a ready allusion to an undisputed Vermeer. Han did not need a model for the face of the disciple facing Christ, since there is only the intimation of a profile and a shock of black hair falling on to his simple grey tunic. As to Christ's countenance, the high forehead, the sunken eyes and gaunt cheeks are so similar to Han's self-portraits that he is unlikely to have needed anything more than a mirror and a beatific gaze. As for the bodies, there is little suggestion of solid flesh beneath the folds of the disciples' tunics. As several critics have remarked,

Cleopas's arm is so contorted that it would have to be broken in two places to adopt the pose.

Han's genius in *The Supper at Emmaus* does not lie in the trickery he used to conjure the disciples, nor in the mythical figure who may have posed for the Christ; it is in fulfilling the prophecies of Bredius and Hannema and creating out of whole cloth a 'middle period' for Johannes Vermeer van Delft. Taking Caravaggio's dynamic composition, Han simplified the elements to create a sense of tranquillity more proper to the Dutch interiors of Vermeer's mature period. A bright window on the left – barely a luminous rectangle – prefigures every Vermeer window in the decades to come. The colours are sparse and quintessentially those of Vermeer: Christ's robe is almost pure ultramarine, that of Cleopas a mixture of gamboge and lead-tin yellow; the serving girl's hooded tunic is burnt umber and carbon black; the frugal linen tablecloth, lead white and beneath it – in a gesture worthy of Vermeer himself – Han lavished pure ultramarine on a humble undercloth. He was careful even to follow Vermeer's characteristic use of green earth in the deep flesh-tones.

The still life at the centre of the piece was the easiest: Han had painted so many still lives in the seventeenth-century style that the sheen of the pewter plates, the glint on the empty wineglasses, the flash of light on the long neck of the porcelain jug were second nature to him. Where Christ's hand is poised above the bread to be broken, Han added a burst of *pointillé* – thick dabs of paint like scattered grains of light – a technique Vermeer first used in *The Milkmaid*.

When Han finally stepped back from his painting he had good reason to be pleased. Though it looked unlike any Vermeer the world had ever seen, still there were subtle hints which an expert might detect – in the colours, the composition,

the face of the disciple Cleopas. It was, he felt, his finest work. But there was much still to be done.

The decision whether or not to sign the painting must have troubled Han. Barely half of Vermeer's paintings bear a signature, and many of these are doubtful. A signature is so easily forged that Han knew it would be unlikely to persuade an expert – in fact, a prominent signature might even arouse suspicion. Perhaps, Han thought, he should leave the painting unsigned; it would be all the more satisfying to leave it to the critic to make the attribution. Until this moment, nothing Han had done was illegal – his crime was in signing the work with the graceful and ornate flourish *I V Meer*. It was a curious choice: the signature is similar to that which appears on the late Vermeer *Girl with a Pearl Earring* rather than to the simpler *Meer* found on *Christ in the House of Martha and Mary* – the painting to which Han expected the *Emmaus* to be compared. Perhaps the elegant cursive of Vermeer's full signature was too tempting; perhaps Han felt that the *Emmaus* was too unlike any known Vermeer to risk leaving it unsigned. It may be that Han thought he had *earned* the right to sign the master's name.

Though in his years of experimentation Han had painted a handful of old masters and submitted them to his furnace, it is not difficult to imagine that Han stood chain-smoking for two hours, twitching and fretting by the oven as the *Emmaus* cooked. Any fault in the thermostat could destroy six months of work, six years of planning. Lead white would be particularly sensitive to any small shift in temperature, caramelising the tablecloth and the jug. There was no disaster: the paint came out as it had gone in – the colours powerful and shimmering, the scene somehow more miraculous. Han quickly painted a thin layer of varnish over the surface and waited as it dried and the crackle surged up from the layer

beneath. Then, laying the painting flat he took a broad brush and a pot of Indian ink and covered the entire surface of the painting, watching as this blue-black veil dried on the varnish, obscuring everything. Then, taking a rag dipped in soap and water, he washed away the ink before removing the layer of varnish using a turpentine and alcohol solution. All that remained of the ink was a web of dark lines like centuries of dust. Then carefully, almost tenderly, Han varnished the painting, using a tinted brownish varnish which he allowed to dry overnight.

In the morning, not daring to look at his perfect creation, he seized a palette knife and, before he could change his mind, slashed at the canvas. No painting could have survived three centuries without damage. He made a small tear in the fabric and gouged several areas of paint. With deliberate clumsiness, he re-sewed the small jagged tear in the canvas just above Christ's right hand and with studied carelessness repainted those deep gashes in the surface paint. Then, one last time, he took a lightly tinted varnish and applied it to *Die Emmaus-gängers*. His genuine 1937 Vermeer was complete.

12

A QUESTION OF ATTRIBUTION

> Men are so simple and
> yield so readily to the
> desires of the moment
> that he who will trick
> will always find another
> who will suffer to be tricked.
>
> Niccolò Machiavelli

Barely five miles from Roquebrune where Han was carefully re-attaching the *Emmaus* to its original stretcher, the respected critic Abraham Bredius, now retired, was just beginning his day. On this balmy August morning, the Mediterranean sun lapped at the shutters of the Villa Evelyne to which he had retired fifteen years earlier. Despite the late summer warmth, Bredius was swathed in the eccentric array of furs and shawls he always favoured. As he sipped his morning coffee, he leafed through his notes and began jotting some thoughts for an article he was writing for the *Burlington*. Had he known that barely five miles away a second-rate artist was plotting to destroy his reputation he would have barked his stentorian laugh. He was too old now, he had a

lifetime of study and achievement behind him, his reputation was impervious.

As a young man, Abraham Bredius had preferred honest arrogance to hypocritical humility. Now almost eighty-two, he had yet to find a reason to change. Unlike Han, he had not been born in a provincial backwater with a philistine father but into a prominent family of Dutch gunpowder merchants. He grew up in a magnificent townhouse on Amsterdam's Prinsengracht surrounded by his grandfather's collection of old masters and Chinese porcelain. His mother died when young Abraham was barely ten, but the boy was close to his father: 'My dearest father, the greatest treasure I possess.'

Johannes Bredius had expected his son would follow him into the trade, but when the boy proved to be a gifted pianist, he encouraged his precocious talent. Bredius was twenty-one when he realised that he did not have the makings of a concert pianist and abandoned his studies, unwilling to devote himself to something at which he could never hope to be better than good. To assuage his son's bitter disappointment, his father paid for Bredius to spend some years in Italy where the young man was to immerse himself in art. In Florence, Abraham was befriended by Wilhelm von Bode, the director-general of the Berlin museums. It was Bode who suggested that Bredius apply himself to his own heritage. While it was possible to study Dutch painting in Paris and Berlin, it would not be possible to do so in The Hague or Amsterdam until 1907, and then largely thanks to the pioneering work of Abraham Bredius.

By the time he was twenty-five, Bredius was deputy-director of the Museum of History and Art in The Hague; by thirty-five director of the Mauritshuis. In his time there Bredius documented and re-attributed much of the collection with the help

of his deputy Hofstede de Groot; more importantly he began to aggressively collect major Dutch works. During his tenure, the Mauritshuis acquired 125; in the fifty years before he was appointed, the total was just nine. He was a formidable and eccentric figure on the Dutch art scene: when Rembrandt's *Saul and David* was offered for sale in 1898, the Rembrandt Association voted to buy it for the nation – but when the Dutch government balked at the price, Bredius munificently announced that he would 'sell his horse and carriage' to buy the painting which he donated to the Mauritshuis.

In the course of his career he would lend twenty-five paintings to the Mauritshuis, all of which he later bequeathed; he donated forty more to the Rijksmuseum. His monographs and books and his popular writings in *Oude Holland* argued passionately for the preservation of Dutch heritage. In print and in private he was combative and quarrelsome. Within a year of taking up his position he had re-attributed thirty-seven of the museum's paintings – to the anger and disgust of his predecessor – and was busy selling off 'inferior works'. He threatened to resign with tedious, melodramatic regularity and carried on longstanding public vendettas against other critics and government ministers in the pages of the popular press.

As Han slotted the seventeenth-century tacks into the stretcher, taking care to replace the small leather squares which for more than two hundred years had protected the canvas from rust, he was considering how best to approach Bredius. Though both had been members of the Haagsche Kunstring, it is unlikely that the two men had ever met. There was much for Han to admire in Abraham Bredius. The two men were self-taught and shared an abiding passion for Dutch baroque art and a mistrust of 'the moderns' who, Bredius alleged, had brought about a 'seemingly fantastical degeneration of art'.

Instead Han had come to despise the man. If Han's contempt for the art establishment had a face, it was Abraham Bredius. He had seen in the critic's offhand denunciation of *The Laughing Cavalier* the overweening confidence of the charlatan. The man's despotic pronouncements epitomised the arrogance of the coterie of self-appointed arbiters of taste and authenticity who, Han believed, had failed to appreciate his genius and had derided and dismissed his art.

But it was a shrewd choice. There were other critics, other art historians, other experts to whom he might have submitted *The Supper at Emmaus*, but none as eminent as Abraham Bredius. An attribution by Bredius for a problematic, atypical Vermeer would silence other critics. It was Bredius who had attributed *Christ in the House of Martha and Mary* to Vermeer and conjectured the existence of other religious works by the artist. Han hoped to appeal to an old man's vanity, his yearning to crown his career with one last 'discovery' that would shake the world. It was a calculated risk, since Bredius's pronouncements were as capricious as they were confident and he had been scathing in dismissing what he called 'pseudo-Vermeers', commenting on the gullibility of another major critic, 'What a heresy, is it not, to describe a work of the eighteenth or nineteenth century as a Vermeer?'

Replacing the *Emmaus* on the easel of his Roquebrune studio, van Meegeren studied the colours, admired the radiance and luminosity of blues and yellows, the serenity of the mood. He began to piece together a crate for the canvas; he had a train to catch, an appointment to keep.

Han knew that he could not directly approach Bredius. Even if the rumours of his involvement in the Frans Hals scandal had not reached the august critic, Bredius would instinctively distrust him because of the articles in *De Kemphaan* in which

he had mocked the art establishment. He needed a middleman, someone whose moral probity was beyond question, to bring the painting to Bredius's attention. He had settled on an old acquaintance, Dr G.A. Boon, a respected lawyer and former member of the Dutch parliament who now lived and worked in Paris. The two men had met only briefly: once while Han and Jo had been living in The Hague, and again while Boon was holidaying in the south of France. Boon considered himself a patron of the arts; he was someone whose superficial knowledge of Dutch painting Han might exploit.

He did not contact Boon before his trip. When he arrived in Paris, he checked into a hotel and telephoned Boon to ask if they could meet urgently. Boon was surprised – the two men had only a casual acquaintance – but Han was insistent that they meet immediately, saying only that he needed Boon's help in a matter of great importance. Boon protested that he was busy and offered to meet later in the week, but Han was adamant. Though exasperated by the man's cloak-and-dagger tactics, his refusal to explain the nature of his business, Boon was none the less intrigued and agreed to meet Han for lunch.

'I have been acting as an agent for some paintings for a woman I met,' Han explained as they sat sipping cognac together in a Paris café, 'Mavroeke . . .'

'A pretty woman, I don't doubt.' Boon smiled conspiratorially.

'I wouldn't wish to be indiscreet,' van Meegeren was happy to embellish his fantasy benefactor, 'but I know that I can rely on your discretion. She and I are, as you suspect . . . intimate.'

'You always had a fine eye for a lady . . . as I'm sure your old friend de Boer can attest.'

'Obviously, Jo knows nothing of this,' van Meegeren said

quickly, 'she knows only that I have received some paintings from Italy which I am to sell on commission.' This much was true – van Meegeren had received a number of shipments of paintings from Italy, and the story he was now telling may have contained some grain of truth.

'She is of an old Dutch family – they had a fine old house in Westland – though she moved with her father many years ago now to a small village near Cosmo in Italy. I met her while she was visiting the Riviera and we have become . . . close.'

'Indeed?' Boon smiled knowingly.

'Her father was a great connoisseur and collector – in fact she tells me that when they moved he brought one hundred and sixty-two old masters with him: an exceptional collection: Holbein, El Greco, Rembrandt . . . Though the collection has been divided up now that her father is dead – some of it to Mavroeke, some to her sister who lives near Strasbourg and the remainder to her cousin who has a château in the Midi. Her problem is that she has decided she wishes to leave Italy.'

'Ah,' Boon frowned, 'and the Fascists will not let her export the paintings?'

'Precisely.' Van Meegeren smiled, reassured that even someone on the periphery of the art world knew that it was forbidden to export works of art from Italy.

'These paintings of hers, do you think they are valuable?'

'While Mavroeke has, well . . . other charms, I'm afraid she knows very little about art. Of the paintings she has sent me so far, most seem to me to be of no importance. Family portraits, sentimental landscapes, you know the idea; but I have come upon one painting I think may be interesting . . .'

'Really?' Boon leaned towards Han, whose voice had dropped to a conspiratorial whisper. 'What is it?'

'I can't be sure.' Han shrugged. 'I'm hardly an expert on the period, and the painting is not at all typical of his work – but I think it may be by Jan Vermeer.'

'*Wat leuk!*' Boon nodded appreciatively. Though he knew little of art, he had heard of Johannes Vermeer, an artist who had emerged from obscurity to take his place alongside Rembrandt and Holbein.

'But I don't see how I can help . . .'

'It is a small matter. If I am to sell the painting, it must first be authenticated. Obviously, Mavroeke cannot take the painting to have it appraised.'

Han was tolerably honest in explaining why he could not represent the painting himself. His intemperate articles in *De Kemphaan*, he told Boon, together with his affair with the wife of a famous critic, had soured his relationship with the Dutch art world. Would Boon, he wondered aloud, consider submitting the painting for authentication by an acknowledged expert on seventeenth-century Dutch art?

'If it is a Vermeer, then it is a work of enormous national importance and I think it should be returned to the Netherlands.' Van Meegeren was happy to play on Boon's patriotic spirit.

'I shall be happy to act as a go-between if you think it will help,' Boon said, 'but I have no idea whom I might take it to. I know some of the Paris art dealers – Georges Wildenstein? Perhaps he might look at it for me.'

'I think you should approach a specialist. Someone who understands Dutch baroque art. Hofstede de Groot, maybe – though perhaps the foremost authority in the field is Abraham Bredius.'

'Of course, of course . . . So all you need is for me to contact this Bredius and ask him to examine the painting.'

'Yes . . .' Van Meegeren hesitated, 'Though I am not sure Bredius will agree. I believe he has retired to Monaco now, though I know he still writes for the *Burlington* in London and for *Oude Holland*. You're a lawyer – perhaps you could persuade him.' This was the moment when Han had to take a risk, to embroil Boon in his deception. 'As I said, my name could not be mentioned for fear it might prejudice Bredius's opinion. But there is another problem – we must also protect Mavroeke and her family. There can be no question of mentioning that the painting was smuggled out of Italy. If the Fascists were ever to find out she would be in grave trouble.'

'Ah, yes . . . I understand, of course.' Boon frowned. He could see the problem: there was no way that an 'honest' account of the painting's provenance could be given without causing potentially serious problems for this upstanding Dutch woman, and making it highly unlikely that a national treasure would be restored to its rightful home in Holland.

'We . . .' Van Meegeren paused for effect, 'we would have to give a different account of its provenance.'

Together, they concocted a new story: Boon would introduce himself to Bredius as legal counsel to a young woman from a family living in the Midi, the sole heir to the goods and chattels of her French father and Dutch mother, both deceased. Why van Meegeren asked Boon to conspire in a lie is unclear; it was a risk, and an unnecessary one, since Han could just as easily have invented the story of the family in the Midi and simply asked Boon to be discreet as to their name. The most likely explanation is that Han wanted Boon to be complicit in a lie which could destroy his reputation if it were ever discovered. This would make it impossible for Boon to later admit that van Meegeren had been involved in the sale. By dangling a story of a noble Dutch family, a secret mistress, Fascists who

must be outwitted, he offered Boon precisely the sort of fantasy
that would interest him, for Han knew how to appeal to the
virtue in others, to use their honesty, their patriotism, their
discretion against them.

'I've brought the painting with me. It is upstairs in my hotel
room – perhaps you'd like to take a look?'

Han had no real interest in Boon's untutored eye, but this was
the first time he had shown the *Emmausgängers* to anyone and
the awe and reverence that Boon lavished on the painting
heartened him.

'How much do you think it might be worth?' Boon asked.

'That very much depends,' Han said, 'there are so few
authenticated Vermeers – I doubt one has come on the market
any time this century.'

'But in general terms – if this Bredius agrees it is genuine – is
it worth twenty thousand guilders? Fifty thousand, one hun-
dred thousand?'

'As I said, no Vermeer has come on the market as a
comparison – there are fewer than forty in existence. But if
it proves to be genuine, then it would be an important painting,
very important . . . I certainly believe it should not be sold for
less than a million guilders.'

No sound could have been more welcome to Han than the
the soft click as Boon's jaw dropped.

On 30 August 1937, Boon wrote to Abraham Bredius at the
Villa Evelyne in Monaco, briefly outlining how he had come to
represent a painting he believed might be of interest and asking
if he might submit the painting for the Maître's eventual
authentication. Bredius agreed and suggested Boon bring the
painting to him in Monaco.

Han accompanied Boon to the Gare d'Austerlitz where the lawyer had reserved a *couchette* on the *train bleu* to Monte Carlo. Han remained in Paris. Everything, now, was out of his hands. If Bredius rejected the *Emmaus*, everything was lost: not only the months, the years of work and experimentation, not simply the money that was to be made selling a 'genuine' Vermeer, but his last shred of self-esteem. If Bredius dismissed it, it would be pointless to submit it to any other expert: the art world, then as now, was a small, closed circle and news of a suspect painting would quickly spread and no reputable dealer or critic would entertain it. If Bredius said it was genuine, there might be those who doubted his attribution, but the opinion (for it would be no more than an opinion) of a single expert would be enough for the painting to find a place on the walls of a prestigious gallery. Han went back to his hotel, took two of the morphine tablets he had recently been prescribed, and tried to relax.

The following morning, nervous but proud, perhaps, to be a part of this patriotic enterprise, Boon stood on the doorstep of the Villa Evelyne. Bredius's manservant ushered him into the studio where the ageing critic, wrapped in a fur stole, eased himself painfully from his chair. There are likely to have been few preliminaries, little small talk: Bredius was anxious to see the painting. The old man watched as Boon opened the crate and delicately removed the painting. Bredius settled his wire-rimmed glasses on his nose and taking the painting gingerly, examined the canvas and the stretcher. The canvas itself was clearly centuries old, worn in patches, easily perhaps old enough to be genuine. He propped the picture against a wall and stood back. His heart immediately lurched into his throat; a depth of feeling welled inside him as great – perhaps greater – than he had felt when he first set eyes on *Christ in the House of Martha and Mary*.

'Well?' Boon inquired after a long moment.

'How did you say you came by it?'

'I am representing a young woman who may wish to sell,' Boon began, launching into the agreed story. 'An old Dutch family from somewhere in the south of Holland. They had a castle in Westland, near Naaldwijk, I believe. Her mother moved to France when she married, the painting is one of a number she brought with her as her dowry.'

Bredius nodded, only half-listening, intent on his inspection of the painting. He was drawn in by the unmistakable brilliance of Vermeer's archetypal colours, the gamboge, the lead-tin yellow, the ultramarine. Taking a *loupe* from his desk, he studied the intricate tracery of the *craquelure*, murmuring half to himself. Boon meanwhile warmed to the story, finding it surprisingly easy to embellish now that he had begun:

'There were many paintings – in the region of a hundred and sixty if I remember correctly. She – my client – contacted me because since her parents' death the family has fallen on hard times rather. I must say I was disappointed by the paintings. Workmanlike, perhaps, but they seemed to me of no real interest: this one I came across in one of the disused bedrooms. I don't believe she remembered it was there. Her father apparently had thought it *assez laid*, too ugly certainly for it to be hung in the public parts of the house. It was simply gathering dust there, but I saw it and thought . . .'

'It is interesting, certainly,' Bredius interrupted. He took a small flask from his desk and a wad of cotton. 'May I?' he asked Boon. 'It is a simple alcohol solution – a standard test – I shall stop the moment there is any sign of wear.'

Boon nodded; Han had explained the procedure. The old man took the alcohol swab and held it over a corner of the painting. The fumes rose like a heat haze in sunlight. The paint

did not react. Bredius took a stronger solution and once again brought the wad of cotton over the painting. Then, gingerly, like a lover making his first caress, he stroked the surface of the painting gently. He removed the swab and stared at the pristine cotton.

'I wonder . . .' Bredius sounded a little flustered now. 'Would it be possible for you to leave it with me for a day or two to study it?'

Boon agreed, giving Bredius the name of the hotel where he was staying. The manservant showed him out. Bredius barely looked up, entranced by the *Emmausgängers*, noting the characteristic shaft of light falling from the window at the left of the picture which bathed the figures with a tender radiance, considering the oblique, ethereal serenity of the Christ. It was the answer to his prayers.

In the two days that followed, Bredius would have been wise to remember Sainte Thérèse's maxim: 'More tears are shed over answered prayers than unanswered ones.' The painting seemed so perfect – fitting like the forgotten piece of a puzzle into the mystery of Vermeer's career, corroborating everything he had ever written on the subject. The composition unmistakably recalled Caravaggio's *Christ with the Disciples at Emmaus*, but the colours and the light were unquestionably those of Vermeer in Dresden. It was, as he would later write, '. . . quite different from his other paintings and yet every inch a Vermeer . . .'

It is certainly true that Bredius was an old man, that his eyesight was failing, but Han was not relying on an old man's infirmities; on the contrary, he was depending on Bredius to use all of his acumen and his considerable intellect to decipher the clues he had scattered through the canvas. The suggestion of the *Girl with a Pearl Earring* in the face of the maidservant,

the allusion to *The Astronomer*. Bredius would hardly need the signature to be certain . . .

Forty-eight hours later, Boon was summoned. He had enjoyed his impromptu holiday on the Riviera. Back in Paris, Han had tried to distract himself with customary vices, but knowing that the Maître held his future in his hands made even champagne taste of vinegar. When Boon was shown into the study, Bredius was clearly excited and impatient. He spoke quickly, animatedly about the colours, the *pointillé* on the bread, the face of Cleopas. Boon barely understood a word.

'So you believe it is genuine?' Boon asked at last.

Trembling slightly, the old man reluctantly tore his rheumy eyes from the canvas and nodding slowly, handed Boon an envelope.

Boon immediately phoned Han at his Paris hotel, but could not reach him. He phoned again that evening and the receptionist put his call through to Han's room. The telephone rang and rang in the darkness. At length the hotel operator came back on the line. '*Je suis désolé, Monsieur* . . . Would you care to leave a message?'

'No,' Boon said, unwilling to have his triumphant news conveyed by a desk clerk. 'On second thoughts, tell him Dr Boon called, tell him to call me at my office urgently.' He phoned once more before boarding the night train to Paris, but again Han was absent, partaking of some aptly named Dutch courage. Boon left no message.

From the Gare d'Austerlitz, Boon took a cab directly to van Meegeren's hotel. Han was at the front desk, checking his messages. The receptionist had just handed him a phone to return Dr Boon's call when Boon tapped him on the shoulder.

'Where the devil have you been? I tried calling half a dozen times.'

'What did he say? Bredius, what did he say?'

Boon ushered him away from the desk and the two men sat in the hotel bar. Han ordered strong black coffee. 'Well, what did he say?' Han nervously lit a cigarette.

'He thinks it is genuine. He really is a curious fish, wrapped up in all those furs . . .'

'He said it was genuine? What else – did he say anything about the painting, did he like it?'

'Here . . .' Boon handed Han the certificate of authentication. 'See for yourself . . . I haven't opened it.'

A waiter brought the coffee. Han stared at the envelope which bore Bredius's monogrammed letterhead, then quickly tore it open with his thumbnail and scanned the note. *'This magnificent piece by Vermeer, the great Vermeer of Delft, has come to light – may the Lord be thanked – from the darkness where it has lain for many years, unsullied, exactly as it left the artist's studio.'* Han realised he had been holding his breath. He drew deeply on his cigarette; *'almost unparalleled among his works'*. Han relaxed and began to smile. *'I found it hard to contain my emotions when the masterpiece was first shown to me.'* The smile broadened slowly to become a grin. He sipped his coffee. His head was still pounding, his hand holding the letter quivered slightly. *'Composition, expression, colour – all conspire to form a harmony of supreme art, supreme beauty. Bredius 1937.'* And then Han broke into a gruff, rumbling laugh.

13

A MOST STUPID AND MALIGNANT RACE

Grant me patience, just
heaven! Of all the cants
which are canted in this
canting world, though the
cant of hypocrites may be
the worst, the cant of
criticism is the most tormenting!

Laurence Sterne, *Tristram Shandy*

The letter in Bredius's elegant cursive, which Han held in his trembling hand, was worth much more than the painting which, at Boon's insistence, he now deposited with the Crédit Lyonnais for safekeeping. Though it was merely the opinion of one man, it would be all the art world would need to accept his forgery as a genuine Vermeer.

The role of the critic is crucial in the art world – as much now in the twenty-first century, as it was in the 1930s. Though new tests used to authenticate old masters have proliferated – infrared and ultraviolet examination, thermoluminescence, photospectrography, carbon dating and autoradiography – it is still the expert's discerning eye which makes the attribu-

tion, for, though tests can determine the age of a canvas, the composition of the pigments or the nature of the underpainting, they cannot determine a Rembrandt from a Rubens.

'A critic,' Whitney Balliett declares, 'is a bundle of biases held loosely together by a sense of taste.' Nowhere is this more in evidence than in Bredius's decision not to have the *Emmaus* submitted for X-ray and chemical analysis, not out of negligence, but because of his absolute confidence in his instinctive ability to tell a masterpiece from a forgery. The continuing success of forgers throughout the twentieth century is testament to the fact that it is a 'talent' which critics still prize today. Thomas Hoving, the former director of the Metropolitan Museum of Art, sees this intuition as the central gift of what he calls the *fakebuster*:

> Fakebusters are a rare breed of cat. They are connoisseurs who have the singular ability – call it a sixth or seventh sense – to detect a forgery instantaneously in almost every field.
>
> These people, who are primarily not book scholars and certainly not theoreticians, describe the feelings as a pull in the gut or a warning cry from a voice deep inside them. The talent cannot be studied and applied. It is nurtured and refined only by saturation.

Hoving seems to believe that the true expert is someone who, not by dint of learning and diligence alone, nor through exhaustive technical research, is possessed of a quasi-supernatural gift. Of course, the 'gut feeling' Hoving describes is informed by thousands of hours in the presence of originals; an expert will be intimately familiar with an artist's characteristic brushstroke, his subjects and his media. A keen eye will quickly spot an anachronistic detail, the hesitancy of the forger's hand compared to the assured spontaneity of the artist.

But experts are indeed a rare breed whose methods include arcane rituals: the art historian Richard Krautheimer, author of *Early Christian and Byzantine Architecture*, would pinpoint the year in which a sculpture was crafted by licking the mortar; another eminent art critic determines the age of an old master by solemnly chewing a sliver of varnish. It is a talent best nurtured in childhood: Joseph Duveen, perhaps the greatest American art dealer of the twentieth century, underwent an interesting initiation. To test young Joseph's 'gut feeling', his uncle lined up along a shelf some of the priceless porcelain in the Duveen family collection together with a number of near-perfect copies. Then, handing his nephew a walking-stick, he told the boy to smash all but the genuine articles. Duveen did just that.

One might be forgiven for thinking that the single defining gift of the expert is hubris.

The extent to which the art world still relies on the opinion of the expert in matters of attribution is in inverse proportion to the results: not only have experts failed to recognise some of the most preposterously crude forgeries, they have regularly dismissed genuine masterpieces with supercilious ease only to have their opinions reversed by equally confident experts. Many paintings have crossed this chasm from genuine to forgery more than once.

When Rubens's *Daniel in the Lions' Den* went under the hammer in 1885 it sold for £2,520. In 1963, by which time a confident expert had decided it was the work of Rubens's contemporary Jacob Jordaens, it fetched only £500, but less than two years later when another, equally confident, expert insisted it was 'school of' Rubens, it was sold to the Metropolitan Museum of Art for £178,600.

In *Art Fakes in America*, David L. Goodrich tells the

chastening story of Leo Ernst, a plumber from Dayton, Ohio, who in 1934 bought three canvases from a German sailor 'for next to nothing'. When he later married, his wife, who had studied art, discovered the crumpled canvases in the attic and asked her husband where he had bought them. 'They are nothing,' he told her. 'Just some junk I got gypped on.' Anna Ernst, however, thought they might be valuable. She spent several years attempting to track down some reference to the paintings in public libraries, before deciding to visit New York, where she and her husband trudged from dealer to museum only to be informed by one expert after another that the paintings were copies or forgeries. 'The dealers,' Ernst recalled, 'told us to throw them in the ash can.' Anna was reluctant and continued her research, but it was not until 1966 – thirty years after her husband had bought the paintings – that she stumbled on an old, yellowed newspaper which gave an account of the 1922 break-in at the Großherzoglichen Museum in Weimar during which two German soldiers had looted a number of paintings which the article described in some detail. The descriptions were strikingly similar to the paintings in her attic. Taking the canvases and the newspaper clipping to the very same galleries which had dismissed them years earlier, Anna and Leo Ernst were rewarded when the same experts immediately and confidently recognised the Rembrandt self-portrait, together with major works by Ter Borch and Tischbein.*

* This was their *only* reward. On the advice of the Metropolitan in New York and the FBI the paintings were seized by the US government as 'enemy property' and eventually returned to East Germany. In 1972 Leo Ernst complained, 'Why don't I get anything? People have called me up from all over the world about the paintings, and the newspapers have written me up. But that doesn't give me anything. One German newspaper also wrote that I had died in 1946. What do I do with the newspaper articles? I just throw them away.'

If all this seems to be in the dim past, consider the portrait of George Washington which sold at Christie's in New York for $3,300 in 1987. Barely five months later, after an accommodating expert had certified the painting as the work of Gilbert Stuart, it was resold by Sotheby's in London for $495,000.

For every painting thus exalted, a dozen masterpieces are relegated to the limbo of 'artist unknown'; among them, some of the best-loved paintings of the classical Western canon. This is not to say that they are forgeries, but that our notion of what is authentic has changed. Nowadays most scholars would agree with Nelson Goodman's definition: 'The only way of ascertaining that the *Lucretia* before us is genuine is thus to establish the historical fact that it is the actual object made by Rembrandt.' Historically, however, this was not so. In the Italian city-schools of the baroque and in the Amsterdam of Rembrandt's time, a master painter would sign any painting made under his tutelage. All of these works would once have been thought 'authentic', but the emergence of the idea of the artist as a lone genius, a solitary creative force, has irrevocably changed this. In 1920 there were more than seven hundred attributed Rembrandts; today barely three hundred and fifty paintings are thought to be 'authentic' in the modern sense, and despite the millions of prints sold every year which attest to the contrary, *The Polish Rider* (discovered in 1897 by Abraham Bredius) and *Man with a Golden Helmet* in Berlin's Gemäldegalerie are no longer attributed to the master. Does it matter whether *The Polish Rider* is by Rembrandt or his pupil Willem Drost – after all is it not the same painting? In a very real sense, it is not: by Drost *The Polish Rider* is worth about 10 per cent of the same painting when attributed to his tutor.

It is hardly surprising, then, that Han clung to Bredius's certificate of attribution. The first hurdle in his daring fraud

had been cleared, elegantly, effortlessly, but Han was all too aware that, in the words of Walter Kim, 'The market is the only critic that matters.'

As they stowed the crate in the vault of the Crédit Lyonnais, Han asked Boon if he would be prepared to handle the sale of the painting, offering the canny lawyer '30 per cent of the commission Mavroeke is paying me'. In the excitement, Han had almost forgotten his imaginary Italian lover. Boon readily agreed. Bredius, he told Han, was writing an article on the *Emmaus* for the *Burlington*. Han suggested that the sale of the painting should be delayed until it appeared. Excited now, Boon proposed to Han that they go for a drink to celebrate.

'Not yet, my friend, not yet,' said Han, keenly aware that art is not art until it's sold. Until then it is merely a storage problem.

Even before Bredius's article appeared, news of the painting had reached Amsterdam, London and New York. Joseph Duveen, consultant to the Frick Collection, immediately expressed interest in seeing it. He contacted Boon and asked if he might send a representative from his Paris office to view the painting before it was offered for sale. Boon phoned Roquebrune where Han, who knew of Duveen's formidable reputation, readily agreed. The viewing took place in the vault of the Crédit Lyonnais. When Han called to ask how the meeting had gone, Boon could say only that Duveen's man had been respectful and polite and had said only that he would discuss the painting with his client. On 4 October the following telegram was dispatched via Western Union:

NLT DUVEEN

BOTH SEEN TODAY AT BANK LARGE VERMEER ABOUT FOUR
FEET BY THREE CHRISTS SUPPER AT EMMAUS SUPPOSED

BELONG PRIVATE FAMILY CERTIFIED BY BREDIUS WHO WRIT-
ING ARTICLE BURLINGTON MAG BEGINNING NOVEMBER STOP
PRICE £ NINETY THOUSAND STOP PICTURE ROTTEN FAKE
STOP

For Han, it was a chastening experience. Nor was it the only
one. Georges Wildenstein, the president of the renowned Paris
dealers Wildenstein et Fils also dismissed the painting as a
shoddy forgery. Some months later, Margaretta Salinger, a
senior research fellow at the Metropolitan Museum of Art, was
to state that she came to the 'immediate conclusion on viewing
the picture that it was not a Vermeer'.

Van Meegeren's biographer Lord Kilbracken says that such
dissenting voices were 'forgotten in the wild enthusiasm a few
months later'. Fifty years later Thomas Hoving would disin-
genuously suggest, 'The word never got out because all the
French experts thought the thing too ludicrous to mention.' If
the art world today is a village, in 1937 it was a parish pump:
no painting certified by the legendary Bredius which purported
to be a Vermeer was 'too ridiculous to mention', especially
since the aforementioned experts did not voice their opinion
even after Bredius's article was published. The silence of the
critis was a combination of professional courtesy and self-
serving pragmatism. A public dispute would merely undermine
faith in the art market. In this towering edifice of expert
opinion, no one was prepared to throw stones.

Bredius's article, 'A New Vermeer', appeared in the No-
vember issue of the *Burlington*. It was a hymn to everything
Han had striven to achieve:

It is a wonderful moment in the life of a lover of art when he
finds himself suddenly confronted with a hitherto unknown

painting by a great master, untouched, on the original canvas, and without any restoration, just as it left the painter's studio! And what a picture! Neither the beautiful signature 'I. V. Meer' (I.V.M. in monogram) nor the *pointillé* on the bread which Christ is blessing, is necessary to convince us that we have here a – I am inclined to say *the* – masterpiece of Johannes Vermeer of Delft.

The subject is *Christ and the Disciples at Emmaus* and the colours are magnificent – and characteristic: Christ in a splendid blue; the disciple on the left, whose face is barely visible, in a fine grey; the other disciple on the left [*sic*] in yellow – the yellow of the famous Vermeer at Dresden, but subdued so that it remains in perfect harmony with the other colours. The servant is clad in dark brown and dark grey; her expression is wonderful. Expression, indeed, is the most marvellous quality of this unique picture. Outstanding is the head of Christ, serene and sad, as He thinks of all the suffering which He, the Son of God, had to pass through in His life on earth, yet full of goodness . . . Jesus is just about to break the bread at the moment when, as related in the New Testament, the eyes of the disciples were opened and they recognised Christ risen from the dead and seated before them. The disciple on the left [*sic*] seen in profile shows his silent adoration, mingled with astonishment, as he stares at Christ.

In no other picture by the great Master of Delft do we find such sentiment, such a profound understanding of the Bible story – a sentiment so nobly human expressed through the medium of the highest art.

As to the period in which Vermeer painted this masterpiece, I believe it belongs to his earlier phase – about the same time (perhaps a little later) as the well-known *Christ in*

the House of Martha and Mary at Edinburgh (formerly in the Coats collection). He had given up painting large compositions because they were difficult to sell, and painters like Dou and Mieris were already getting big prices for their smaller works.

The reproduction . . . can only give a very inadequate idea of the splendid luminous effect of the rare combination of colours of this magnificent painting by one of the greatest artists of the Dutch school.

The opening paragraph would have been enough, Han thought, to silence the naysayers – who, in any case, had not proved very vocal – but what followed made him exult: 'the highest art', 'this magnificent painting'. Han read hungrily, watching Bredius piecing together the puzzle he had created: the 'characteristic' colours, the nod to *Christ in the House of Martha and Mary*; Bredius had even gone so far as to contrive a reason why Vermeer had ceased to paint large religious works. The almost comical errors in the article – Bredius writes that the painting is 'untouched, on the original canvas, and without any restoration', failing to notice Han's deliberate vandalism and clumsy restoration, and twice suggests that the disciple in yellow is on the left – did nothing to detract from what Han thought was a *tour de force* of the critic's art: intuition, half-truths and imagination woven into an ecstatic dithyramb.

Bredius's final paragraph was telling, however: the reproduction was ugly: the small, muddy black-and-white photograph made the figures look lumpen, the composition cramped, and encouraged the rumour mill. 'The reproduction . . . did not give an accurate impression of the painting,' Georges Isalo wrote in the *Revue des Beaux-Arts*. 'Immedi-

ately, there were rumours: It's not a Vermeer! It's a forgery!'
But those who saw the painting itself were utterly convinced:
Hannema, the director of the Boijmans and his colleague van
Schendel at the Rijksmuseum thought it a masterpiece and vied
as to which of the great institutions was to bid for it. The
formidable Dutch art dealer D.A. Hoogendijk approached a
number of wealthy Dutch patrons attempting to raise the
necessary finance. A. M. de Wild, whose *The Scientific Ex-
amination of Pictures* Han had used as a crib sheet in preparing
his forgery, was completely convinced.

Hannema, still irked that Rembrandt's *The Nightwatch*,
which he had tried hard to acquire, had gone to the Rijksmu-
seum argued, 'I have come to the conclusion that everything
possible must be done to secure this masterpiece for the
Netherlands, and if possible for the Boijmans museum.'
Han encouraged Boon to sell the painting to the Dutch state,
claiming that as a work of national importance, it should be
repatriated to the country of Vermeer's birth. In fact, Han
knew that playing on the loyalty of his compatriots was the
surest way of securing a high price for his work. Besides, Han
wanted his painting to hang in a national gallery alongside
those he thought of as his peers. And when the time came for
him to reveal himself as the architect of this masterpiece, he
wanted all of those who had scorned him to pay heed.

D.A. Hoogendijk contacted W. van der Vorm, a Dutch
shipping magnate and patron of the arts, who agreed to put
up the lion's share of the money needed to secure the painting.
The balance came from the Rembrandt Society and a number
of smaller private donations, among them a generous con-
tribution from Abraham Bredius himself. The painting was
acquired for 520,000 guilders and donated to the Boijmans
Gallery.

Now that the painting was sold, the press coverage began in earnest: there were stories of the discovery in newspapers from Berlin to New York, sagacious profiles of Vermeer in the Sunday supplements, feature articles on the treasure to be found in one's attic. In the hundreds of column-inches, not a single dissenting opinion appeared: the critics who wrote were collectively awed, admiring, deferential; in the weeks, the months, the years that followed no one who doubted the authenticity of the painting dared to wield a pen. An unspoken consensus had been reached and those in the art world toed the party line. For Han, it was conclusive proof that critics world-wide merely aped each other's posturing, parroted the same opinions: he felt vindicated. He longed to howl his authorship from the rooftops, but there would be time, there would be time . . .

14

ALTERCATION WITH A MUSEUM GUARD

The ordinary man casts
a shadow in a way we do
not quite understand. The
man of genius casts light.

George Steiner

What can we say about the *Emmaus*? Is it, as Bredius thought, a luminous magnificent masterpiece? In Thomas Bodkin's introduction to the *catalogue raisonné* of Vermeer's work in 1940, while lamenting that so few works by the master existed, he added: 'Occasionally a sensational discovery, such as that of the superb *Supper at Emmaus*, which was found a few years ago in the linen-cupboard of a house in Paris,* occurs to remind us that similar possibilities are not exhausted.' By 1967, John Godley (Lord Kilbracken) in his biography of Han was to write: 'The fact that it is a forgery detracts immeasurably from its value as a work of art, but it is a fine picture and, by any standards, better than any other he had painted in his own name or was to paint in the future.' Godley goes on to

* Where the story of the Paris linen closet comes from is impossible to say.

suggest that 'There seems little doubt [but for the events that followed] . . . that the *Emmaus* would still be the pride of the Boijmans.' By 1991, Han would find little admiration even among his peers: the British forger Eric Hebborn in his autobiography *Drawn to Trouble* is damningly succinct in suggesting '. . . van Meegeren was neither a skilled painter nor a good draughtsman'. Later still, Thomas Hoving in *False Impressions* dismissed Han's most famous work as 'a monstrous daub' though he reluctantly acknowledged the fact that 'Sadly, plenty of contemporary aestheticians and deconstructivist art philosophers affirm that the van Meegeren garbage is as satisfactory as a genuine Vermeer.'

What we know of a painting invariably colours how we see it. Armed with the knowledge that *The Supper at Emmaus* is a forgery, it becomes difficult to arrive at an objective opinion, to disentangle the artist's work from what we know about it. In *Ways of Seeing*, John Berger explores the ways in which words can change not only how we see, but the very nature of what we see. On page twenty-seven, Berger reproduces a Van Gogh painting with the simple caption: *This is a landscape of a cornfield with birds flying out of it. Look at it for a moment. Then turn the page.*

When the page is turned, we find a reproduction of the same painting, now with the handwritten caption: *This is the last painting that Van Gogh painted before he killed himself.*

As Berger points out, 'It is difficult to define how the words have changed the image, but undoubtedly they have. The image now illustrates the sentence.'

Some statements go beyond merely influencing what we see. In semantics, certain phrases are known as 'performatives' because they perform an act or create a state of affairs when uttered under appropriate or conventional circumstances.

When spoken by a priest or an authorised registrar, the phrase *'I now pronounce you man and wife'* is a performative: the marriage begins the moment the words are spoken. When uttered by an art expert, the phrase *'This is a forgery'* is a performative, capable of transforming beautiful, intensely lyrical works universally proclaimed as masterpieces into manifest dross. The moment someone tells us that a painting is a forgery it somehow seems unthinkable that it was ever accepted as genuine. Suddenly, we can see its every flaw – the hesitancy of the forger's hand, the shallowness of his palette, his superficial grasp of anatomy, of light, of perspective. As John Berger affirms, 'It is authentic and therefore it is beautiful.'

There are those, however, who believe that Han van Meegeren utterly succeeded not only in painting like Vermeer, but in becoming the master. From the outset, it is true, Han's quest was curiously similar to that of the hero of *Pierre Menard, Author of the Quixote*. Jorge Luis Borges's story takes the form of a critical essay about the work of a French symbolist poet who does not wish to translate, much less transcribe *Don Quixote*; instead, 'his admirable ambition was to produce a number of pages which coincided – word for word, line for line – with those of Miguel de Cervantes.' In pursuit of the seemingly impossible quest, Menard first considers becoming Cervantes: wiping three centuries of European history from his mind, converting to Catholicism, seeking out some Moors and Turks to fight. In the end, he decides: 'the undertaking was impossible from the outset, and of all the impossible ways of bringing it about, this was the least interesting.' The real challenge is 'coming to the Quixote through the experiences of Pierre Menard'.

Without reference to the original, Pierre Menard succeeds in

writing chapters IX and XXXVIII of Book I of *Don Quixote* and a fragment from chapter XXII which coincide exactly with Cervantes's original. To the reader, it may seem an absurd feat, and yet to the critic whose essay forms the backbone of the fiction, while 'the Cervantes text and the Menard text are verbally identical, the second is almost infinitely richer.'

> The contrast between the styles is equally noticeable. The archaic style of Menard – a foreigner, after all – suffers from a certain affectation. Not so that of his predecessor, who confidently manipulates the everyday Spanish of his own time.

So too, Maurice Moiseiwitsch in his biographical study *The Van Meegeren Mystery* when he writes, without a whit of irony:

> In the final analysis, one may say that Van Meegeren's *Christ in Emmaus* is every bit as good as Vermeer's best work and that he was just as skilful a painter as the Master. In a sense, Han's achievement is greater than Vermeer's. Every artist knows it is far easier to paint or write or compose in one's natural idiom than produce an original work in the style employed by another. For Shaw to have written Shaw's plays is proof of genius; but for Shaw to have written a play attributed to Chekhov – and first-class Chekhov at that – is all but a test beyond human reckoning.

In the autumn of 1938, none of these considerations mattered. *The Supper at Emmaus* was not yet a van Meegeren, it was something rarer and more exquisite – an unseen canvas by the great Johannes Vermeer van Delft. The knowledge that it had

been painted by one of the finest painters in the canon of Western art coloured the judgement of all who saw it. All that remained now was for the newly authenticated masterpiece to be presented to the public. Han intended to return to Roque-brune to wait quietly and soberly for the inaugural exhibition of the *Emmaus* at the Boijmans Gallery, but was distracted somewhat by a lissom, blonde Swedish girl, with whom he spent a wild, extravagant week in Paris.

He met her on the third night of his 'quiet private celebra-tion' of his success in the Tsarewitsch, 'a nightclub of great refinement and lax morals, with prices to match'. She worked as a dancer. He was wearing the sober grey suit and tie he favoured, his greying hair was slicked back, his slightly sinister moustache waxed. He ordered a magnum of champagne and an ounce of caviar. When the orchestra played, he asked a dusky, big-hipped girl to dance, and invited her to join him at his table. Another magnum of Krug 1928, another dance and he brought back to the table a flaxen-haired Swedish girl, a silk butterfly primly veiling her pudenda and fishnet stockings accentuating long legs that went all the way up to the wallet in his breast pocket. Her friends joined them. The raucous, slightly peculiar Dutchman bought drinks for clubbers at the neighbouring tables. To ward off starvation, he ordered an-other ounce of sevruga caviar, feeding the overpriced fish eggs to bored, smiling dancing girls busy doing mental arithmetic. He would later boast that he asked the orchestra leader to play Berlioz's *Damnation of Faust*.

In this first long, debauched week, Han was invariably too drunk to consummate his infidelity, but still he bought his Swedish girl small exquisite gifts, and in a flurry of guilt spent his afternoons, hung-over, buying jewellery to give to Joanna. By the time he arrived back at Primavera, he was beginning to

worry. When he revealed himself as the author of the *Emmaus*, he would have to repay the money. Almost a third had already disappeared in fees and commissions and his week in Paris had made a noticeable dent in the remainder, but, he reasoned, with the fame from the *Emmaus*, he would easily make the money to pay everything back.

His sudden wealth was no mystery to Joanna since, despite the couple's later protestations, Han's wife certainly knew of the forgery, but to the citizens of Roquebrune and the maître d'hôtel in every restaurant in Monte Carlo, Han claimed that he had won the *gros lot* in the French national lottery. He boasted about it to croupiers in the casinos where his gambling began to take a pathological turn, mentioned it in the local bars every time he bought a round of drinks. It was meagre compensation for the recognition he had long been denied, but he could not yet boast about the masterpiece which had earned him half a million guilders.

In Rotterdam, the director of the Boijmans personally supervised the arrival of the pride of his collection. Despite Bredius's insistence that it was 'untouched, on the original canvas, and without any restoration', Hannema realised that before it could be exhibited it would have to be cleaned, remounted and framed. He entrusted the task to a man named Luitweiler, the most respected restorer in the Netherlands. Luitweiler decided that the seventeenth-century canvas was too fragile to work on and therefore elected to have it 're-canvased' – a painstaking process which entailed picking away the fabric of the original canvas fragment by fragment and attaching it to a new one. When Luitweiler had finished, all that remained of the canvas which had once held *The Raising of Lazarus* were the edges. He could not know that the frayed fringes of the original would one day be a matter of life and

death to Han. A new stretcher was made for the painting and the old one preserved for historical purposes. Only then did Luitweiler begin the process of restoration. With a dilute alcohol solution, he stripped off the top layer of varnish and then carefully began to remove Han's inept 'restoration' work. He repaired the small tear over Christ's right hand. Then, preparing small batches of paint and testing them to ensure they exactly matched the luminous colours of the *Emmausgängers*, he delicately repainted the areas which he assumed centuries of wear and mishandling had worn thin. Lastly, he applied a new layer of untinted varnish so that the dazzling canvas might be seen at its best. An ornate frame in the seventeenth-century style had been commissioned for the painting and once the canvas had been framed, it was returned to the Boijmans for display.

On 25 June 1938, as part of the celebrations for the jubilee of Queen Wilhelmina's reign, the Boijmans unveiled an exhibition entitled *Four Centuries of Masterpieces 1400–1800*. It was to be a sweeping overview of Western art including works by Bruegel, Rembrandt, Vermeer, Rubens, Watteau, Dürer and Titian. The poster to accompany the exhibition displayed as the exemplar of the achievements of classical art a detail from Vermeer's *The Supper at Emmaus*: the face of the serving girl, mute, serene, Han's portrait of Joanna.

Han and Joanna returned from Roquebrune for the exhibition. This was Han's exhibition but though Han hurriedly phoned his old friends from the Hague Art Circle, no one could get him tickets for the *vernissage*. In the end, Han had to content himself with going to the Boijmans the following afternoon, where he and Joanna queued and paid their entrance fee like everyone else. Once inside, Han slipped through the first room and stood in the central hall of the exhibition.

There, among the Vermeers on loan from the Mauritshuis and the Rijksmuseum, he saw his masterwork set apart on a pale cream wall. In the *Zeitschrift für Kunstgeschichte*, the critic Adolph Feulner described the scene: 'In the room in which the Vermeer hangs almost alone, it is as silent as a cathedral. A feeling of benediction spills out over the visitors, although there is nothing church-like about the painting itself.'

The Supper at Emmaus was besieged by admirers. Han had to elbow his way into the circle to gaze at his painting. Here, on a museum wall, resplendent in the magisterial frame, it looked every inch a masterpiece. Han stood listening intently, foraging for crumbs of flattery. Then, unable to restrain the urge, he reached out across the velvet rope which set the *Emmaus* apart and made to touch the canvas. In a moment he would delight in recounting for years to come, there was a flash of blue as a security guard seized Han's arm gruffly.

'Mijnheer, please do not touch – it is a very valuable painting, a national treasure.'

Han shrugged an apology and walked away.

In the days that followed, Han made a daily pilgrimage to the Boijmans to stand by the painting. The crowds never seemed to ebb, waves of them pouring through the hall to stand next to him. Now and then he would catch someone's eye and say: 'I can't believe they paid half a million guilders for this – it's obviously a fake!' and was thrilled to hear himself contradicted.

It became something of a party-piece. In the evenings, he went drinking with Theo and Jan, and friends from the Haagsche Kunstring. Conversation would inevitably turn to the exhibition and thence to the *Emmaus*.

Han would always begin categorically, 'Jo and I went to the exhibition. I must say I didn't think much of this new Vermeer. It's such an obvious forgery.'

Invariably someone would rise to the bait.

'Han, you're a complete philistine – of course it's genuine.'

'You simply don't know Vermeer's work – everyone knows he painted religious scenes when he was young.'

Han would draw out the conversation, expressing doubts about the composition or the theme. Often, he would bet a bottle of fine champagne that he could not be persuaded, then, slowly, as the assembled company discussed the precision of the brushwork, the brilliance of the palette, he would allow himself to be won over. He knew, as Ruskin did, that the true work of the critic is not to make his hearer believe him, but agree with him. The bottle of Krug was a small price to pay for such adulation.

Han invited his son Jacques to come from Paris. It had been two years since he had seen the boy, and he missed their long talks about art, his fatherly pride in his son's maturing talent. He took Jacques to the Boijmans and silently watched as his son moved through the exhibition halls, pausing when Jacques stopped to linger over a painting.

Afterwards, they walked to a nearby café. Jacques talked animatedly about his life in Paris and Han attempted to steer the conversation back to the exhibition. In his unpublished autobiography, Jacques van Meegeren relates that after several beers, Han could no longer contain himself and asked what Jacques thought of the exhibition. Jacques enthused about a Rembrandt self-portrait, or a Bruegel, but his father interrupted to ask what he thought of *The Supper at Emmaus*.

'It's a masterpiece – but a twentieth-century masterpiece, not a seventeenth-century one,' Jacques said emphatically.

'Then who do you think painted it?'

'You, *Papa*.' Jacques smiled. 'I can see it in the elongated form of the faces. The eyes are just as you always paint them,

you've even used your own hands as a model like you always used to do!'

In the margin of his manuscript, Jacques added in pencil – *And I've seen the wineglasses and the jug in your house.*

Father and son would not speak about the subject again until 1945.

If he was proud of his son's keen eye, Han must surely have been worried that if Jacques had recognised his father's technique in the *Emmausgängers* – a style Han had done nothing to conceal – it was only a matter of time before others noticed it. Though he was hardly a major artist, Han's work was well known in Dutch art circles. If he was to come forward and announce his magnificent hoax, step into the spotlight and declare his genius to the world, now was the time: he had the strip of canvas cut from *The Raising of Lazarus* and the sections of the original stretcher as evidence, he could explain his technique and show the critics his sketches. He would repay the money and sell the *Emmaus* as his own work, then he could paint again under his own name and the whole world would know it.

Within a month, he was working on a new forgery.

15
GROSS HABITS/NET INCOME

> All progress is based upon
> a universal, innate desire on
> the part of every organism
> to live beyond its income.

Samuel Butler

Revenge is sweeter far than flowing honey. For a decade Han had nursed his suffering and plotted the humiliation of his critics. He had dreamed of the day when he would confess to committing a masterpiece and contemptuously hurl half a million guilders at the feet of the bigoted critics he had duped. Now that he had money, he abandoned such grandiloquent notions.

Within weeks of returning to the Côte d'Azur, Han and Jo terminated the lease on Villa Primavera and spent the greater part of the proceeds of the *Emmaus* on a majestic house in Cimiez, an elegant suburb of Nice, where Henri Matisse was among their neighbours. The Villa Estate was a fantasy in Italian marble with twelve bedrooms and five reception rooms overlooking the sea. A separate wing housed a private gallery in which Han had a permanent collection of opulently framed

van Meegerens. There was a music-room, a sewing-room and a splendid library, to which Han brought his materials – his canvases, his pigments and his oven – converting the polished, panelled room into his studio-laboratory.

For a year, the van Meegerens lived like the princelings they invited to a seemingly endless series of parties. Friends and acquaintances came to visit from Holland and Roquebrune and their hosts entertained them lavishly in the extensive gardens where streams bubbled through rock pools, and an army of bronzed workmen tended the small vineyard, the olive grove and the rose gardens.

The money trickled away almost as soon as it was earned. Han's drinking had become compulsive – he would have a bracing shot of *jenever* in the morning with his staple breakfast of coffee and cigarettes, something which merely whetted his thirst for the revelries to come. He was increasingly dependent on the morphine tablets which were now indispensable to steady his hand when he painted. He seemed to smoke even more heavily than before, often lighting a cigarette while another was still burning in the ashtray, his fingers now ochre and umber.

In the golden year the couple spent in Nice, Han had little time and certainly no need to work. Even so, among the handful of canvases we know he painted were two forgeries in the style of Pieter de Hooch, signed in monogram PDH, paintings which despite his considerable technical skill are little more than pastiche. *Interior with Card Players* (plate 15) is a minor variation on *Card Players in a Sunlit Room* (plate 16) in the Royal Collection at Windsor. Han has reproduced the room in almost precise detail and the party as they sit beneath the great paned window have shifted only slightly. A map replaces the painting and the coat rack in de Hooch's painting, the cavalier

on the right has doffed his hat and placed it on an empty chair, the floor is copied from another painting by de Hooch and outside the window is the building painted by Vermeer in *The Little Street*. Han's second forgery, *The Drinking Party with Card Players* (plate 13) is cribbed directly from de Hooch's *The Visit* (plate 14), now in the Metropolitan Museum in New York. Though Han has opened a door in the rear wall to show a scullery maid at work, the room itself and the people it depicts are almost unchanged from the original.

He experimented with the styles of other artists too, painting a portrait in the manner of Ter Borch and, from the sketches he had made in Berlin, an impressive variation of Frans Hals's *Malle Babbe* (plates 10 & 11), but the crude cut-and-paste technique of such forgeries bored him and he left these last unfinished, unsold.

Sometime in the spring of 1939, he visited Boon in Paris, taking with him *Interior with Drinkers* which he claimed to have discovered among Mavroeke's cornucopia of treasures. While Boon sought an expert to authenticate this archetypal de Hooch – something he found all too easy, despite the murky provenance of the painting – Han returned to the bars of Pigalle in search of the lithe Swedish beauty he had met some months before. She was still dancing at the same nightclub and Han paid for two bottles of champagne to have her visit his table. As he confessed to Boon after the encounter: 'When I took her back to my hotel, I realised I only wanted her if I didn't have to pay. Afterwards, of course, I would have happily showered her with presents.'

'And did she?' Boon prompted.

'It's strange,' Han said. 'When I had no money, I thought I could never have a girl like that. Now that I do, I don't seem to need it. She said yes and I was so surprised that I almost cried.'

'Perhaps she genuinely likes you,' Boon suggested.

'I don't think so,' Han stubbed his cigarette emphatically, 'I think she recognised in me a fellow-whore.'

Boon took *Interior with Drinkers* to the prominent Dutch art dealer P. de Boer, who quickly sold the work to Daniël George van Beuningen for 220,000 guilders. Han, as always, insisted that his share of the monies be paid to him in cash.

Han returned to Nice richer than before, to his magnificent villa and his glamorous wife, but the gilt had begun to pall. His experiments forging de Hooch, Ter Borch and Hals bored him; he longed to paint another Vermeer. The imaginary middle period he had conjured for the great artist had allowed him to paint entirely in his own style. *The Supper at Emmaus* had been a quintessentially van Meegeren masterpiece, it had required only the fillip of another man's signature to make it priceless.

Han had been more surprised than anyone that his Vermeer, with an undocumented provenance that was no more than fantasy, had not been subjected to rigorous scientific testing. But Bredius and the art world elite had so longed for a new Vermeer, for a middle period which would bridge the void between *The Procuress* and *The Milkmaid,* that in their writings, they conjured new paintings. The critic P.B. Coremans felt able to state confidently that biblical Vermeers 'once adorned the premises of a secret religious society in the seventeenth century'. So it was that Han came to devise a new Vermeer. In July 1939, he wrote to Boon:

Amice,
Last Monday, Mavroeke appeared unannounced with letters from her daughter, of which one will prove very important. She wrote that Mavroeke's cousin, Germain –

the one with the château in the Midi – had asked to see her. He is 86 now, and dying of cancer, Mavroeke is one of his heirs. In her letter, Mavroeke's daughter said she had seen a photograph of the *Emmaus* . . . and remembered having seen a similar biblical painting, but much bigger and with a lot more saints in Germain's collection (which, as I told you has the same provenance as Mavroeke's). On Tuesday, I went there with Mavroeke: we spent two days searching and found no saints, only paintings from much later periods – until on Saturday, one of the servants told us there were some rolled-up canvases in the attic. It was there that we discovered the finest and most important painting ever created. It is *The Last Supper* painted by Johannes [Vermeer], much bigger and more beautiful than the Rotterdam painting [the *Emmausgängers*]. It is inspiring in its composition, noble and dramatic, more beautiful than any of his other paintings. It is probably his last work and is signed on the tablecloth. Approx 2.7 × 1.5 metres.

Having rolled it up again, we took a walk in the mountains like a couple of fools. What should we do now?

It seems to me almost impossible to sell it – though it is fresh from its mother's womb – not recanvased, undamaged, with no frame or stretcher. Having thought about it for a long time, I reluctantly rolled it up again.

Imagine a Christ of extraordinary sorrow, gazing with half-closed eyes over a wine goblet; a melancholy Saint John, Saint Peter – no, it is impossible to describe – this a masterpiece such as was never painted by Leonardo, Rembrandt, Velasquez or any other master who painted *The Last Supper*.

* * *

Whether Boon replied, whether in fact he ever received Han's letter we do not know. While the Munich treaty between Hitler and Chamberlain a year before had briefly allayed fears of war, the inexorable march of the Third Reich had continued apace, occupying the Sudetenland before the ink on the treaty was dry. The Kristallnacht pogrom of November 1938 and Hitler's poisonous address to the Reichstag in January 1939 on the subject of 'The Jewish Question' understandably unsettled Europe's wealthy, educated Jews, and those who had the means to do so fled to Switzerland and to the United States. Though we cannot know for certain whether G.A. Boon was among their number, we know that in the months between their meeting in the spring of 1939 and Han's arrival in Amsterdam in September of that year, the lawyer and former member of parliament fled the Netherlands and was never traced.

Han, too, was gripped by war and rumours of war. After the signing of the 'Pact of Steel' with Mussolini in May 1939, France seemed an increasingly perilous place to be. Han's decision, when it came, must have been sudden, for when the van Meegerens left the Villa Estate to return to the Netherlands, they abandoned almost everything they possessed, leaving the villa like a ghost ship, as though they had been spirited away.

Though no war had been declared, by the time Han and Jo arrived in Amsterdam in August 1939, civilian evacuations were already under way in London. Barely a week later, the German army marched into Poland and two days after that, on 3 September, France and Britain declared war. The van Meegerens decided they would stay in the Netherlands for the duration of the war. Since Germany had respected Dutch neutrality during the First World War, Amsterdam must have seemed like a safe haven in a Europe on the brink of chaos.

Han and Joanna arrived unprepared, and at first found it impossible to find a house. They spent five months living in a hotel in Amsterdam while Han searched for more permanent accommodation in the suburbs. It is perhaps because of this that he made no attempt to return to Nice to have his most valuable – and most incriminating – belongings shipped to Amsterdam. Aside from the opulent furniture and the paintings, four unsold forgeries lay propped against a wall in Han's basement laboratory and another, barely begun, sat on his easel. Somewhere, safely stowed in the basement, were the strip of canvas and the fragment of stretcher from *The Supper at Emmaus* – the evidence he had carefully preserved when he had intended to reveal his scam. By May 1940, when Han had finally found a house, the Netherlands was under Nazi occupation and the war on France under way. It was impossible now to retrieve anything from Nice and the Villa Estate would lie abandoned for a decade, commandeered briefly as an Italian military hospital. One mysterious shipment was made, however. On 6 October 1939, Han arranged for a Paris removals firm to collect 'Two crates containing pictures (260 × 190cm and 160 × 100 cm) and two crates containing various objects' from Cimiez. His arrangements with the shipping company are not known, but it is likely that it was the occupation which meant that the crates were held in Paris until 1941, when they were collected by the occupying powers – a note scrawled in German on the docket reads: 'Taken away, May 22nd, 1941'.

If Han was happy to abandon a fortune in furniture and genuine old masters, what treasures were contained in these crates he was so eager to ship to Amsterdam? The smaller canvas may have been a de Hooch, but the larger – measuring nine feet by five, must surely have contained the masterpiece which Han had described in such fulsome terms in his letter to

Boon. Whether this second crate contained *The Last Supper* was to trouble experts and critics for a decade after Han's death.

In the search for a new home, money truly was no object and Han settled on the exclusive suburb of Laren in the hinterland of Amsterdam. There, early in 1940, he bought De Wijdte, at 46 Hoog Hoefloo. The villa was a soaring modernist edifice designed by the noted Dutch architect Wouter Hamdorff. The immense, high-ceilinged living-room had floor-to-ceiling windows which looked out over the heather-strewn moorland of Laren to the hills of Hilversum beyond. In time, it would come to be the room that Han loved most. Draped in costly oriental fabrics, the great space would house Han's nascent collection of genuine old masters. A magnificent Jacob Maris landscape would hang above the east window, a portrait by Frans Hals by the arch of the doorway.

Han's new studio, he decided, would be in a sunny gabled room with a large gothic window. It took several months to replace the pigments and chemicals he needed, to build a new oven, and acquire genuine seventeenth-century Dutch paintings he could cannibalise for his work. It seems likely that the first forgery produced in his new studio was the *Head of Christ*, a study rather than a portrait; the face, like that in the *Emmaus*, is probably an idealised self-portrait: a study of God made Han: sorrowful and suffering, the sins of the world weighing heavy on his drooping eyelids.

Since Boon had fled, Han needed a new agent to represent his work: someone credulous yet credible, someone utterly unconnected with the Dutch art world. He settled on Rens Strijbis, a childhood friend working as an estate agent in Apeldoorn near Deventer. For the purpose, Han invented a

new impecunious Dutch family, now living in The Hague, who were forced to sell off the family silver. He showed the *Head of Christ* to Strijbis who knew nothing of art and, he later admitted, 'would not have given houseroom' to the painting, but the promise of 15 per cent of the sale assuaged his aesthetic misgivings. Han wove an elaborate conspiracy theory to explain why he could not sell the painting himself. Vested interests in the Dutch art world were ranged against him, he explained. He had been despised and rejected for daring to print the truth in *De Kemphaan*. He impressed on Strijbis the need for tact: under no circumstances could he reveal the identity of the noble Dutch family battling to keep the bailiffs from the door. As an estate agent, Strijbis needed little coaching in the art of the lie, but he flinched when Han suggested that he should accept no less than half a million guilders for the *Head of Christ* – a painting barely nineteen inches by twelve.

At Han's instruction, Rens Strijbis took the painting to Hoogendijk, who had handled the sale of the *Emmaus* three years before. As Han predicted, Hoogendijk immediately recognised in this minor masterpiece the hand of the great Vermeer of Delft. The dealer presented the portrait to D.G. van Beuningen who – having bought *Interior with Drinkers* – was keen to add a Vermeer to his prestigious collection. Van Beuningen offered 475,000 guilders for the painting of which Han received the equivalent of more than four million dollars in cash. Hoogendijk, Strijbis told Han, had suggested hopefully that he thought the *Head of Christ* might be merely a sketch for a major work yet to be discovered. He could not know that the major work – *The Last Supper* – was, in all probability, sitting half-completed in Han's studio in Laren.

Han styled his *Last Supper* as an epic work. To the left of the painting a luminous strip of light serves as a window flooding

the scene. At its centre, as Hoogendijk had predicted, is an exact replica of the *Head of Christ* for which van Beuningen had paid almost half a million guilders. On the right, a curiously androgynous Saint John sits, his face a copy of Vermeer's *Girl with a Pearl Earring* (see detail plate 19), his hand covering Christ's hand. It is altogether a less successful painting than the *Emmaus*. The composition is cramped, the space around the small table seems much too small to accommodate the crowded disciples, adoring, worshipful, intent on the fate of their Lord. In the background, Judas, swarthy and menacing, glances at the man he is about to betray. Since the *Emmaus* had not been subjected to extensive testing, Han was more slipshod in his technique. He removed only part of the original painting, *A Hunting Scene* by Jodocus Hondius. He was careless, too, in building the layers of pentimento, but the finished picture had the same air of authenticity, the same convincing crackle, the same glowing colour palette of the now-celebrated *Supper at Emmaus*, the painting which had been hailed by critics as Vermeer's finest work.

It is surprising that when Strijbis appeared on his doorstep two months later bearing *The Last Supper* – the 'major work' for which the *Head of Christ* was but a preliminary study and which Hoogendijk had predicted must exist – the dealer was not in the least suspicious. 'My first impression,' he later confessed, 'was that this was the most extraordinary work.' A canny dealer – Hoogendijk never purchased a canvas without first assuring himself of a buyer – he accepted *The Last Supper* on consignment. He took the monumental work to van Beuningen, suggesting a price of two million guilders – some ten million dollars today. Despite his considerable wealth, this was more than van Beuningen could afford. But, taken by the beauty of the painting, he offered to pay for it in kind, giving

Hoogendijk a dozen pictures – among them the *Head of Christ* (valued at some 1,600,000 guilders) which he had bought only two months earlier. Overjoyed with his purchase, van Beuningen set about building a country house in Vierhouten with a private gallery in which to display the work.

In November 1941, Han organised an exhibition of his own work at the Hotel Hampdorf in Laren to which the very critics and dealers who were appraising his Vermeers were invited. The paintings and watercolours in the exhibition were then collected and published at Han's expense as *Tekening 1*. But there were more prestigious exhibitions too – in the Pulchri Studio and the Panorama Mesdag in The Hague, and in the august Boijmans Gallery itself (whose curator Dirk Hannema bought the van Meegeren drawing *Fighting Peacocks*). It seems astonishing that no critic who saw van Meegeren's *Christ with Bread and Wine* noted the strikingly similarity to van Beuningen's *Head of Christ*; or that between Han's *A Farming Family at Supper* and the *Last Supper*.

In June, Strijbis turned up at Hoogendijk's gallery once more, this time carrying *Interior with Card Players*. Hoogendijk barely listened to the 'vague talk of an old Dutch family'. The painting was a classic de Hooch, beautifully signed in monogram PDH. It seemed to him a variant on the accepted *Card Players in a Sunlit Room* in the Royal Collection London. There seemed little point in offering the work to van Beuningen who already owned *Interior with Drinkers*, so Hoogendijk offered it – the third of Han's forgeries in less than six months – to the benighted van der Vorm whose patronage had secured *The Supper at Emmaus* for the Boijmans three years earlier.

Since he dealt only in cash, Han's embarrassment of riches was becoming difficult to manage. Though the villa in Laren

was furnished with every luxury, and though Han spent extravagantly on *genuine* old masters – among them a Holbein and a Frans Hals – to adorn the lavish rooms, it was impossible for him to spend it all. He began to invest in real estate. He confided to his friend Marie-Louise Doudart de la Grée that he owned fifteen country houses in Laren and fifty-two other properties including hotels and nightclubs. His clandestine game of Monopoly was quickly to make him one of the largest landowners in the Netherlands. Even this did not exhaust his extraordinary wealth. He could not deposit such vast sums in a bank, since he had not declared a penny of his illicit earnings. He was too fearful to keep his millions in the villa in Laren, so began to hide large sums of cash in the various properties he had acquired. He hid tens of thousands of guilders in central heating ducts, under floorboards and in dozens of cashboxes buried in gardens all over the country. The alcohol and morphine haze in which he now lived aggravated his mistrust: he feared the tax man, the bailiffs, the critics – a shadowy, amorphous 'they' who would come and take his money and his paintings and so in fits of paranoia, he criss-crossed the country unearthing his fortune only to hide it somewhere else. Often, he could not remember precisely where he had hidden his money and it was to lie undiscovered for decades.

At the height of the war, Han suffered a serious setback. Faced with crippling inflation, the Dutch government recalled all 1,000-guilder notes. Those with substantial sums were required to furnish details of how they had come by the money. Han panicked. Much of his fortune was distributed in chimney breasts, pipes and conduits in the dozens of properties he owned. For months, he scrabbled to find the rolls of bank-notes, mysteriously calling on his tenants to search for for-gotten hoards. He eventually amassed 1.9 million guilders in

1,000-guilder notes. When presenting them at the bank to be converted into smaller denominations, he meekly explained that he was an art dealer and the money was the profit from the sale of a number of old masters. It was truth of a sort. But since Han had no documentation to support these sales and was unwilling to furnish the bank with details of the buyers and dealers involved, the authories sequestered almost a million guilders pending further investigation. It mattered little. Han was still enormously wealthy; besides, he could 'discover' another Vermeer.

16

A CONFEDERACY OF DUNCES

When a true genius appears in the world, you may know him by this sign, that the dunces are all in confederacy against him.

Jonathan Swift

The swastika is not visible to the tourists who crowd the Richelieu Wing of the Louvre for a glimpse of two of the most exquisite paintings in Vermeer's *oeuvre*, *The Lacemaker* and *The Astronomer*, but it is there none the less. The plaque that accompanies *The Astronomer* explains that the painting, dating from 1667 or 1668, was bought by Baron Alphonse de Rothschild in London in 1886 and, passed down from father to son, donated to the Musée du Louvre in 1892. No mention is made of the years the painting spent, numbered among 'European works of the highest historical and artistic value', in the private collection of Adolf Hitler.

Hitler, who had twice failed to pass the entrance examinations to the Akademie der bildenden Künste in Vienna, would make art and aesthetics central to the Third Reich. As late as 1945, on the eve of his suicide and with Berlin under siege, his thoughts were of the art collection he had begun to amass almost twenty years earlier. His last will and testament states,

'The paintings in my collections, which I purchased over the course of the years, were not assembled for any personal gain, but for the creation of a museum in my native city of Linz on the Danube. It is my most sincere wish that this legacy be duly executed.'

It was Dr Hans Posse, appointed head of acquisitions for the Linz museum in June 1939, who had stressed the importance of obtaining a Vermeer. Reviewing the collection of nineteenth-century romantic realists which the Führer had already acquired, Posse rejected the sentimental paintings of artists such as Euard Grüntzer as unworthy of the museum he had been appointed to curate. The collection was swelled during the war through the work of the ERR – the Einsatzstab Reichsleiter Rosenberg – which organised the looting and confiscation of art works. *The Astronomer*, seized as part of the flawless Rothschild collection, was declared 'Property of the Third Reich', and a small black swastika was stamped on the reverse of the canvas. The director of the ERR wrote to Martin Bormann, 'I am pleased to inform the Führer that the painting by Jan Ver Meer of Delft, to which he made mention, has been found among the works confiscated from the Rothschilds.'

Hitler's collection was rivalled only by that of his second-in-command, Reichsmarschall Hermann Göring. The Reichsmarschall's collection, housed at his magnificent estate, Carinhall, was curated by Walter Andreas Hofer, who scoured Europe for important works of art. Göring, who regularly visited the ERR warehouse at the Jeu de Paume, hand-picking the finest works for his collection, boasted to Albert Rosenberg, 'At the current moment, thanks to acquisitions and exchanges, I possess perhaps the most important private collection in Germany, if not all of Europe.' Göring, however, did not yet own a Vermeer.

Of Han's last three Vermeers, his biographer Maurice Moiseiwitsch would later write:

> It is true that the Emmaus, the first inspired expression of homage to the Master, is more exquisite of detail, more intense of feeling than most of the others; but the others remain first rate technically and tremendously authoritative, all excellent examples of mature talent . . . By the standard of Vermeers these were good Vermeers; by the standard of seventeenth-century paintings, these were great paintings.

In fact, even Han, in a rare moment of sobriety, confessed that he was 'not as proud' of his later forgeries: 'They were neither conceived nor executed with the same care (Why should I make the effort? They sold just as well!)' But even this is to understate the sheer wretchedness of *Isaac Blessing Jacob*, *The Adulteress* and *The Washing of Christ's Feet*, which were painted and sold in a single year, earning Han the equivalent of twenty million dollars.

Isaac Blessing Jacob is a stilted, clumsy piece whose only allusion to the seventeenth century is the ubiquitous tableware Han routinely used as props. Nevertheless, when the steadfast Strijbis took the canvas to Hoogendijk, the dealer immediately accepted it as a Vermeer and sold it for 1,250,000 guilders to the hapless W. Van der Vorm, now the unwitting owner of three van Meegeren forgeries.

It might be charitably assumed that it was alcohol and morphine, hypochondria and paranoia that caused Han's talent to plummet, for his next work, *Christ with the Woman Taken in Adultery* – which would one day take pride of place in Göring's collection in Carinhall – is an ugly, poorly crafted work. None of the poetry and serenity that Han hoped to bring

to his biblical Vermeers is in evidence. The space, as in all of Han's biblical Vermeers, is cramped and the composition unwieldy. Two Pharisees loom menacingly over the young Christ's shoulders as he placidly absolves the remorseful reprobate. Only the face of the sinner, copied once again from Vermeer's *Lady in Blue Writing a Letter*, gives even the slightest hint that this might be the work of the master on a supremely bad day. Han's later claim that he continued with his forgeries because he had grown to love the technique he had discovered is belied by the careless way in which the painting was created. He made only a desultory attempt to remove the scene of *Horses and Riders* from the canvas and the resulting *craquelure* is therefore poor and inconsistent. Though he lavished a king's ransom in ultramarine on Christ's robe, which takes up almost half the surface area of the canvas, when the painting was later examined it was discovered that the ultramarine was adulterated with cobalt blue. Even his technical skill, until then the one fixed point in his waning talent, failed him here. He carelessly left *The Adulteress* too long in the oven and the resin blistered, leaving a patchwork of craters like acne scars over the surface of the painting. Han so disliked the finished painting that he considered discarding it. In the end, he salvaged the piece, restoring the damage as best he could and unleashing his monster on an unsuspecting world.

Han had previously relied on friends and acquaintances ignorant of the art world to act at his intermediaries, making it possible for him to control the sale. This time, however, he took the risk of offering *Christ with the Woman Taken in Adultery* to a genuine dealer, P.J. Rienstra van Strijvesande, who had a small gallery south of the Vondelpark. Han would later claim that he had been adamant that the painting should

not be allowed to fall into German hands. If this is true, then Strijvesande ignored his instructions, immediately taking the painting to Alois Miedl, a scout for Walter Hofer, who had acquired the art dealership N.V. Kunsthandel J. Goudstikker on the Herengracht with money obtained directly from Hermann Göring.

Alois Miedl immediately recognised in *The Adulteress* something of the qualities of the celebrated *Supper at Emmaus* in the Boijmans Gallery. If the painting was a Vermeer, then it was a rare and valuable find and one that he knew would be of interest to his superiors. He brought the painting to the attention of Hofer.

Rienstra van Strijvesande, however, had been suspicious of the tale Han had spun, and began to investigate van Meergeren's background. It did not take long before someone in the close-knit circle of the Haagsche Kunstring eagerly related the rumour that van Meergeren had somehow been involved with the forger Theo van Wijngaarden in the sale of a forged Frans Hals in 1923. Concerned, Strijvesande withdrew from the sale and passed Han's details directly to Alois Miedl. Han had no wish to deal with the occupying powers, but by now it was too late. Miedl had shipped the painting to Walter Hofer. It is easy to believe that Han was innocent of the charge of collaborating with the enemy: had he been a traitor, he would never have allowed a dubious Vermeer – let alone one adulterated with cobalt blue – to be offered to a high-ranking Nazi official, since even a cursory examination would have revealed it as a forgery. He had little to fear – Göring was in awe of the painting, and readily accepted Walter Hofer's opinion that it was a genuine Vermeer. As with all of his Vermeers, no X-rays were taken, no microchemical analysis performed.

* * *

Much has been made by critics and commentators of the fact that Han's forgeries were sold in secrecy to private collectors – only the *Emmaus* was publicly exhibited. Under the German occupation, they argue, it was impossible for experts truly to study the forgeries, comparing them to Vermeer's acknowledged work, thereby explaining how such truly terrible paintings came to be accepted as the work of Vermeer. The sale of *The Footwashing* is enough to refute such a simplistic theory.

Han's last forgery, *The Washing of Christ's Feet* (plate 21), completed in 1943, is by far the worst of his deteriorating efforts. He took as his inspiration Luke, Chapter 7, verses 37–38:

> And, behold, a woman in the city, which was a sinner, when she knew that Jesus sat at meat in the Pharisee's house, brought an alabaster box of ointment, and stood at his feet behind him weeping, and began to wash his feet with tears, and did wipe them with the hairs of her head, and kissed his feet, and anointed them with the ointment.

Two unidentifiable disciples lurk in the background, one gazing mawkishly at Christ, who is presumably blessing the kneeling figure of the unidentified sinner, often said to be Mary Magdalene. His gesture, however, is ambiguous, since the crude anatomy makes it seem as though he is waving away a plum pudding offered by a serving girl. The composition is improbable and the modelling shoddy and offhand – only Vermeer's signature, as perfectly executed as ever, demonstrates even a whisper of talent. Han approached a childhood friend to organise the sale. Jan Kok, a former civil servant in the Dutch East Indies, had never heard of Jan Vermeer. None the less, when Han offered him a sizeable commission, Kok agreed to negotiate. Han suggested he take

the painting to P. de Boer and offer it for sale for some two million guilders.

De Boer did not doubt for a moment that it was a Vermeer and wanted to ensure it was bought by the Dutch state as a national treasure, but before the state was prepared to make an offer for the painting a government committee was convened to examine and appraise the work. It numbered seven highly regarded experts: Dirk Hannema, the director of Boijmans Gallery, three representatives of the Rijksmuseum – the director general, the curator and the acting director – two distinguised professors and H.G. Luitweiler, the restorer who had refurbished *The Supper at Emmaus*. Six of the committee never doubted the painting's authenticity for a moment. Only J.Q. van Regteren-Altena a professor at the University of Amsterdam, suggested it was a forgery. Schendel, the acting director of the Rijksmuseum, later admitted: 'I thought it ugly, but none the less a genuine Vermeer.' Dirk Hannema would justify their decision, stating, 'None of us like it, but we were afraid the Nazis would get hold of it.' De Boer, concerned to rescue this 'work of national significance' for the Dutch state, selflessly offered to accept half his usual commission. Despite their reservations, the committee unanimously agreed that the painting was authentic and recommended that the state acquire it for the Rijksmuseum for 1.3 million guilders.

When Han had embarked on his career as a forger a decade earlier, his avowed aim was to expose the hypocrisy and venality of the art world. His towering achievement came not from proving himself the equal of the masters of the Golden Age in painting a masterpiece which deceived the experts, but in proving that regardless of how incompetent the painting, how crude his anatomy, how uncertain the provenance, the most erudite Vermeer critics were prepared to sanctify the monstrous daub.

ACCIDENTAL HERO

17

THE LINE OF LEAST RELUCTANCE

> There are terrible temptations which
> it requires strength, strength and
> courage to yield to. To stake all
> one's life on a single moment, to risk
> everything on one throw, whether
> the stake be power or pleasure.

Oscar Wilde, *An Ideal Husband*

Han was unjustifiably surprised and shocked when Joanna informed him that she wanted a divorce. There can be no doubt that she still loved Han. Her petition was the inevitable consequence of endless weary years watching Han drink and cheat and squander his talent. If Han relished the thought of the freedom he might lavish on younger, prettier girls, in his desultory way, he still loved his wife of almost twenty years. He had come to depend on her, she was his muse, his rock, his nurse, his confidante. He made a surprising proposal: he suggested to Jo that they rent the villa in Laren and move to Amsterdam, to a house on the Keizersgracht he had acquired some years before. He would not contest the divorce, he assured her – in fact, he was prepared to be

extravagantly generous, putting the deeds to the Keizers-gracht house in her name and agreeing to a settlement of almost a million guilders. But if they were no longer lovers, he implored, they were friends, so he asked if Jo would continue to live with him as his friend, his partner in their new house on the western canal belt. It is a testament to Han's charm that she agreed.

It took Han only a few short months to find the third woman who would share his life. Her name was Jacoba Henning, though everyone knew her as Cootje. More than twenty years his junior, she had radiant pale skin, auburn hair which spilled down her long, slender neck, a small, sensuous mouth daubed with a slash of red. She was perfect. Like his wife, his new mistress was a trophy. What had first drawn Han to Joanna was the fact that she was the wife of Karel de Boer, one of the most eminent art critics in The Hague. What in part drew him to Cootje was the fact that she was the wife of a celebrated young artist who had a garret on the Oudezijds Burgwal. It was here in her husband's studio that Han liked to make love to her.

Cootje was utterly unlike Jo and Anna before her. Han's wives had both been independent, intelligent women ever-ready to offer an opinion on art; in contrast Cootje deferred to Han and allowed him to live his life as he pleased. And in spite of the war, it was a perfect life. At home, he had Jo to support him, and Amsterdam offered him all the delights the fusty suburb of Laren lacked. Now he had found Cootje, a beautiful compliant mistress who was happy even to entertain the working girls Han brought back to her husband's atelier.

* * *

The two years Han spent in Amsterdam were perhaps the happiest of his life. His daughter Inez lived nearby, and for the first time in a decade he could spend time with her. Jacques, who still lived in Paris, somehow managed to visit his father in Amsterdam from time to time. He had all but given up painting, but there were regular exhibitions of his work in the Netherlands, in Belgium, in Germany, as far afield as Poland. He alternated his time with Cootje and his occasional carousing with a quiet life on the Keizersgracht with his devoted ex-wife, surrounded by his old masters. Even through the murderous 'Hunger Winter' which preceded the Allied liberation, Han and Jo suffered none of the privations of their countrymen. Han single-handedly supported a burgeoning black market in champagne and caviar, foie gras and fine wine which he served to the friends, followers and fawning sycophants who attended their frequent formal suppers.

He must have joined the solemn commemoration with his compatriots when on 5 May 1945 the Dutch prime minister, Pieter S. Gerbrandy, announced on Radio Orange, 'People of the Netherlands – you are free.' Amsterdam was finally liberated. Looking out of his studio window on Sunday morning, over the canal to the spire of Westerkerk, he would have heard the bells peal. He may have heard gunfire from Dam Square where a tragic gun battle was fought between former Dutch Resistance fighters and a pocket of German soldiers, which killed twenty-two of those who had gathered to celebrate the liberation. Even so, a semblance of normality was returning to the city and Han must have joined in the collective sigh of relief. The first legal edition of the Dutch underground newspaper *Het Parool* on 8 May described life returning to the city: 'Houses of worship are filled to the brim, there is an air of

excitement among the thousands who follow the religious services. Elsewhere people are feverishly at work, in the museums, preparing for new exhibitions and bringing the art treasures out of hiding . . .' One such art treasure, brought from its hiding place in the salt mines of Austria, would lead two officers of the Dutch Field Service to appear on his doorstep barely three weeks later.

Now, six weeks after his arrest, Han still skulked in the darkness of his prison cell, eking out the few cigarettes he managed to cadge from the warders, drawing in the sketchpad he had bribed the guards to allow Inez to bring him. It was here that Han drew his last self-portrait: the haggard face of the artist stares mournfully at the viewer, framed by the crude black lines of prison bars, and in a flash of self-pity bordering on cliché, the wall behind him is carved with notches counting off the days of his incarceration.

Joop Piller, the senior Dutch Field Officer who had arrested Han, was fascinated by his prisoner. Here was a respectable, perversely honourable man of considerable intellect and compassion. Piller was determined to discover what had motivated such a man to collaborate with the Nazis. Joop began to visit Han in his cell, admiring the biblical sketch *de Zalving*. Over the weeks, Han came to trust Piller. Here was a young Jewish man who, rather than go into hiding with his wife and young son who were harboured by *onderduikers* (passive resisters), had joined the Dutch Resistance. A section of British Military Intelligence, MI-9, was set up specifically to draw on such Resistance movements. In 1943, when Dick Kragt, an MI-9 agent, parachuted into the hinterland of the small town of Emst losing his equipment and his radio in the jump, it was Piller who discovered him and together the two men estab-

lished a network which was to hide and protect downed airmen and successfully smuggled many Allied soldiers out of the Netherlands.

Piller tried to probe Han about his motives, his beliefs. At first, Han would only guardedly repeat the story he had told a hundred times: an old Dutch family, a Fascist threat, a solemn promise of secrecy. He had never met Alois Miedl, he said, and had never heard of Walter Hofer. It was impossible to disprove Han's version of events since, after the liberation, Alois Miedl,* Walter Hofer and Rienstra van Strijvesande had fled. Piller could not understand why Han was so reticent. It was clear from the documents that van Strijvesande rather than Han had brought the Vermeer to the attention of Alois Miedl, so there was little reason to suspect him of treason. If Han truly had represented a Dutch family, they would surely vouch for his integrity. Why did he refuse to disclose the identity of the woman he called Mavroeke? Italy had been liberated, so she was no longer in any danger from the *fascisti*. Her identity, in any case, need not be made public – but his refusal made it impossible for the Allied Art Commission to return the painting to its rightful owner and made Han's role in the affair seem increasingly suspect.

The vitriol in the national press condemning 'this Dutch Nazi Artist' had not abated in the weeks of Han's incarceration. There were lurid tales of orgies at Han's Keizersgracht house during the war where, it was claimed, Han entertained senior Nazi officials. One newspaper printed a reproduction of the title page of *Tekening I*, a book of Han's watercolours and

* Miedl was later tracked down in Bilbao with a shipment of paintings and was interrogated there. After his release, he is thought to have plied his trade in Australia and South Africa.

drawings which the journalist claimed had been discovered among Hitler's possessions in Berchtesgaden, in which the title page was inscribed: *'Dem geliebten Führer in dankbaren Anerkennung'* – *To the beloved Führer in grateful recognition* and signed *Han van Meegeren*. Though the signature was genuine – one of a hundred and fifty copies signed by Han in 1941 – the inscription was later proved to be in another hand.

Han fiercely denied having any links with the Nazis, Alois Miedl, Walter Hofer or any of the occupying forces, but such protestations seem to be a convenient fig-leaf for his actual sympathies. There was considerable evidence that he had fascist leanings. Han's drawing 'Wolenzameling' had been commissioned by the Nazis and his symbolist watercolour *The Glorification of Work* had hung in the offices of the Fascist Dutch Workers Front, where it was discovered after the war. (It was sold for a carton of cigarettes to an American GI and now – aptly – hangs in a young offenders' institution in Connecticut.) Even more tellingly, Han's work had been widely exhibited in Germany during the war, and the artist had travelled to attend openings in Oldenburg, Stuttgart and Osnabrück. As late as 1944, while the Allies were firebombing the eastern front, Han still felt able to attend an exhibition of his work in occupied Poland – a journey he could only have made using documents and visas issued by the occupying forces.

Though Han had no direct ties to the Dutch and German Nazi parties, and in fact had often told friends that his painting was his 'act of resistance', Piller quickly discovered that, having been offered 1,650,000 guilders for *Christ with the Woman Taken in Adultery*, Han had insisted that Reichsmarschall Göring pay for the work by returning more than two

hundred paintings looted and stolen from public and private collections across the Netherlands. Han admitted that once he was aware of the sale, he had forced the Nazis to return hundreds of looted paintings – it was, Han told Piller, a profoundly patriotic act – but even this was to admit he was more deeply implicated than he had claimed.

The daily routine interrogation yielded little. Han would sit stonefaced as Piller and his colleagues asked the same questions over and over.

– How did you come by the painting?

– Why did you agree to allow a Vermeer to be sold to Reichsmarschall Hermann Göring?

– What contact did you have with the Nazi agent Walter Hofer?

– How many paintings did you sell to Alois Miedl?

After the first weeks of Han's imprisonment, Joop Piller began to take him out in his car, driving his suspect on day-trips through the countryside. It was an unusual and highly unorthodox practice for a senior officer to fraternise with a prisoner but perhaps Piller realised that prison was a special kind of torture for an artist for whom a glimpse of the outside world, a few hours of freedom, a breath of fresh air were life itself. It was on one such outing, on 12 July 1945, that the breakthrough came. Perhaps Piller admitted a sneaking admiration for Han's doggedness in forcing the Nazis to return two hundred looted paintings. It was an act of resistance. There was something heroic in rescuing so many works of art. Han, flattered, drew on the stub of his cigarette.

'It doesn't seem likely anyone will give me a medal . . .'

'It's hardly surprising,' Piller said abruptly. 'You may have saved two hundred minor works, but in exchange Göring

acquired one of only a handful of paintings by the great Vermeer.'

'Fool!' Han said almost inaudibly. His face clouded with frustration and anger. Joop glanced at the man to discover he was smiling bitterly.

'You're as much of a fool as the rest of them,' Han sighed. 'You think that I sold a Vermeer to that Nazi scum Göring. But there *was* no Vermeer, it was a van Meegeren. I painted it myself.'

Joop Piller stared at Han, astonished.

'It's easy enough to prove,' Han went on, 'I didn't take much trouble with it. If you X-ray the painting you'll find traces of an original seventeenth-century painting, *Horses and Riders* – I can't remember the artist, but it certainly was not by Vermeer. I bought the canvas from a dealer in Amsterdam. I'm sure he still has the bill of sale.'

When the two men returned to the prison, Piller took Han to an interview room where Han obligingly explained how he had painted the picture and the circumstances of the sale while Piller took notes. Joop Piller knew little about art, but he knew enough to realise that Han must be lying: even to the untrained eye the reproduction of *The Woman Taken in Adultery* was strikingly similar to Vermeer's celebrated *The Supper at Emmaus* in Rotterdam.

Han lit a fresh cigarette from the smouldering untipped stub, burning his fingers as he did so. He was weighing up the situation. He could prove that *The Adulteress* was his work – he clearly remembered the underpainting and could sketch its precise position with an overlay of his own, something investigators could easily confirm by X-ray. He had no desire to save the painting – it was an ugly piece, hardly worthy of his talent. If it were proved a forgery and destroyed he would not

regret it. He knew what Piller was thinking, but even now, he may have thought he could save the finest of his Vermeers for posterity. If he confessed to having forged *The Adulteress*, the curator of the Rijksmuseum might begin to look askance at *The Footwashing* – especially if he discovered that Jan Kok, who had acted as an agent for the painting, was a friend of Han's. But even if both paintings were exposed as forgeries, Han had enough ready cash to compensate his 'victims'. Without his confession it would be impossible to connect these two with *The Supper at Emmaus* and *The Last Supper*. G.A. Boon had disappeared without trace and Abraham Bredius was on his deathbed. Han could step into the limelight as the hero who had duped the Nazis and all the while his finest work might remain, admired and acclaimed by generations to come in the hushed halls of the finest galleries. After a long moment, he exhaled theatrically.

'I painted them all,' he said, in answer to Piller's unspoken question. '*Christ and the Disciples at Emmaus* in the Boijmans, *The Last Supper* and the de Hooch *Dutch Interior* in van Beuningen's collection, *The Footwashing* in the Rijksmuseum: I painted them all.'

Weary and shaking from lack of sleep and nauseous still from his withdrawal from morphine, Han launched into an impassioned confession lasting several hours, in which he carefully crafted a new identity for himself as a hero. Far from being a traitor who had sold a work of national importance, he declared, he was the equal of any man in the Resistance. Single-handedly, he had duped the highest echelons of the Third Reich, trading them a worthless van Meegeren in order to rescue hundreds of genuine Dutch old masters from oblivion. He reeled off dates and times, where and how he had acquired the canvases he had used. He harangued, he sermonised, he

lectured – offering impromptu lessons in the art of creating seventeenth-century pigments and the chemistry of modern plastics. He explained to the baffled Piller how he aged his canvases and produced a convincing *craquelure*. Now and then he would put down his cigarette, seize the pencil the officer was using to take notes and dash off a frantic sketch to illustrate the underpainting that might be found on *The Adulteress* or *The Footwashing* when they were X-rayed.

Realising they were ill-equipped to assess Han's outlandish claim, Piller and his colleagues contacted the Allied Art Commission which had taken over the premises at Herengracht 50, the very offices Alois Miedl had occupied during the war. Two members of the commission visited Han in his prison cell. Recalling the interview some fifty years later, Pieternella van Waning Heemskerk said that they simply refused to believe him. 'He claimed he was the maître of all those Vermeers and we couldn't believe him, absolutely, we said no that's impossible – and he said, "Believe me, I will give you the proof."'

Han was at a loss. He had explained his pigments and his plastics, he had offered detailed descriptions of the paintings he had defaced in order to create his Vermeers. He suggested that they X-ray *The Adulteress* and submit the other paintings for chemical analysis which would identify the phenol-formaldehyde he had used as a medium.

'We will, as you suggest, submit the paintings for examination. However, you must agree that your claim to have painted all of these masterpieces is far-fetched.'

'Never the less, it is true. I painted all the works I have named. Surely X-ray and chemical testing can confirm what I have told you?'

'Perhaps . . . they may confirm some of what you say. But they cannot tell us who painted these works.'

Han, frustrated and indignant, sighed and asked for another cigarette.

It seems to have been one of the officers who ingenuously proposed, 'Mijnheer van Meegeren, if you did indeed paint *The Adulteress* as you say, then surely it would be a reasonable test to ask you to paint a copy from memory.'

'A copy?' Han coughed on his life-giving smoke. 'To paint a copy is no proof of artistic talent. In all my career I have never painted a copy!' He quickly considered the proposal – it was too tempting to resist. 'I shall paint you an original. A new work in the Vermeer style, that should be proof enough for you.'

'There will have to be official witnesses . . .'

'Bring anyone you like, but I will not paint it here in this cell. I shall need access to my studio, pigments and canvas, and if I am to create then I must be allowed the morphine I need in order to be calm. But I shall paint you a masterpiece.'

18
GLORY'S SMALL CHANGE

A hero is born among a hundred,
a wise man is found among a
thousand, but an accomplished
one might not be found even
among a hundred thousand men.

Plato

On Friday 13 July, Joop Piller held a press conference at which he announced to a handful of incredulous reporters that the case against the suspected Nazi traitor Han van Meegeren was being reconsidered in the light of new information.

The suspect, Piller announced to the journalists, now claimed that *Christ with the Woman Taken in Adultery*, the Vermeer which had been sold to Reichsmarschall Hermann Göring, was in truth a forgery. In fact, he added, Mijnheer van Meegeren had confessed to forging a dozen works by Vermeer and other artists, many of them in prestigious public and private collections – chief among them *The Supper at Emmaus*, the pride of the Boijmans Gallery and the most visited painting in the Netherlands.

At a second press conference some days later, a junior officer

gave details of Han's confession which, he emphasised, were as yet uncorroborated. Asked whether the charges of treason had been dropped, the officer declined to comment, stating only that the case against van Meegeren was being reviewed. He did, however, confirm that Han had agreed to paint a new Vermeer under the watchful eyes of a rotating detail of prison officers. The press, he added, would be permitted to attend. Immediately, there was chaos. National newspapers dispatched journalists and photographers to cover this curious trial by ordeal. Stringers for foreign newspapers relayed the incredible story to their editors who sent correspondents from London and Paris. One of the Dutch tabloids gleefully ran the front-page headline: 'HIJ SCHILDERT VOOR ZIJN LE-VEN!': 'HE PAINTS FOR HIS LIFE!'

Han, who was still in custody, was not allowed to return to the studio in his home on the Keizersgracht, but an entire floor of the offices of the Allied Art Commission was provided for him to use as a studio. Pigments and ores were procured for him, phials of oil of lilac and canisters of phenol and formaldehyde. From the recently reopened artists' supplies shops a large canvas was obtained and sufficient quantities of gesso, umber, ochre and carmine. Some enterprising soul even succeeded in obtaining a few scant ounces of raw lapis lazuli with which Han could make ultramarine.

Recalling his arrival, flanked by the two officers who would invigilate at these unusual proceedings, van Waning Heemskerk was impressed by the forger: 'He was a most interesting man – just like an artist ought to be, with always a cigarette in one corner of his mouth, and that famous nice hair he had, grey, with a wave in it – he was a charming man to look at, let us say, but don't trust him . . .' Photographers and television crews arrived at the Herengracht studio, jour-

nalists barked questions to Han as he began preparing his pigments.

For his valedictory Vermeer, Han chose a subject he had painted for his disastrous second solo exhibition in 1922: *The Young Christ Teaching in the Temple*. For four or five hours each day, supplied with liberal quantities of Bols *jenever* and morphine, Han, incongruous in his prison overalls, stood beneath the glare of the photographers' arc lights and sketched out the huge canvas. Each time he stopped for a cigarette he chatted good-naturedly to the prison detail assigned to observe, eager for news of developments in his case. It was a prison officer who informed him that the paintings he had claimed to have forged had been seized by the police and were now being held at an undisclosed location. Neither journalists nor experts were allowed to view them while arrangements were being made for the director of the Central Laboratory of Belgian Museums, P.B. Coremans, to have them forensically examined.

As soon as the pentimento was complete and he began the modelling on the face of the androgynous Young Christ and the delicate folds of his ultramarine tunic, it was clear to everyone present that this was a man easily capable of painting *The Adulteress*, perhaps an artist talented enough to produce *The Supper at Emmaus*. There were hysterical reports in the press alleging that Han had painted *The View of Delft, Girl with the Pearl Earring*, every Vermeer in the Netherlands. Slowly, as the weeks passed, the painting began to take shape: the hooded eyes recalled the *Emmaus*, the faces of the jurisconsults kneeling rapt about the figure of the transfigured Christ were those of the disciples in *The Last Supper*. The painting took Han two months to complete, and while it is far

from being the consummate masterpiece Han had promised his captors, it is a significant improvement on *The Footwashing* and *The Adulteress*. Before it was complete, Han learned from his guards that the public prosecutor had dropped the charges of collaborating with the enemy and that, although new charges had yet to be filed, he was not to be charged with forgery – a crime which did not exist in the Dutch statute books – but with 'obtaining money by deception' and 'appending false names and signatures with the intent to deceive' in breach of articles 326 and 326b of the Dutch Penal Code. Immediately he heard the decision, Han, reluctant to offer evidence which the prosecutor might use against him, refused to age *The Young Christ Teaching in the Temple* or to forge Vermeer's signature.

Until a date could be set for his trial, and pending forensic examination of the paintings, Han was released on bail and returned to the Keizersgracht home he still shared with Jolanthe. He was weak from his spell in prison and regularly complained of chest pains. Jo attempted to persuade him to stay home and rest, but Han, who had longed for celebrity, could not forswear his audience. He would go out every evening in his sober suit, his florid cravat, and revel in his infamy in the little bars of the *negen straatjes*, the warren of tiny streets where the art and antique dealers liked to drink. He would sit sipping a *jenever* and wait to be recognised. Sometimes his son Jacques went with him. At last he had come into his kingdom.

On 5 November Han's determination to be found guilty of committing masterpieces took a blow. Jean Decoen, an eminent Belgian art historian and critic, wrote an article for the magazine *La Lanterne* expressing doubts about Han's confession: 'The arguments and proofs adduced have by no means

convinced me', Decoen wrote, offering to 'give at once . . . the reasons which lead me to doubt the veracity of the statements of van Meegeren'. It was strange that Decoen should have come to such a categorical verdict since he had not yet seen or examined *any* of the suspect Vermeers, nor had he visited the Boijmans during the exhibition at which *The Supper at Emmaus* was first displayed. Even so, he confidently wrote, 'of any forged Vermeers I have seen, none can be compared with *The Disciples at Emmaus*, and if van Meegeren is the author of it, I salute him. The case would be unique in the history of painting . . .' This much, at least, was true: no modern painter had ever attempted to conjure an old master from the ether. In the words of Decoen's contemporary Louis Hertig, 'A complete forgery is uncommon, with an old painting it is impossible. To paint a seventeenth-century canvas today can only result in a work that is not viable.'

In December 1945, though the charges against Han had not yet been filed, the Official Receiver began proceedings to recover the proceeds of Han's fraud, something which would rapidly result in Han being declared bankrupt. Though it was not yet admitted that all, or indeed *any* of the questionable paintings were forgeries, and the government commission to examine the forensic and aesthetic qualities of the paintings had not yet convened, claims for compensation were invited from van Meegeren's victims. D.G. Van Beuningen, W. van der Vorm and Dirk Hannema of the Boijmans Gallery petitioned the Official Receiver to recover a total of 4.35 million guilders. The Dutch state, on behalf of the Rijksmuseum, sued to recover the 1.3 million guilders paid for *The Washing of Christ's Feet*, and – since Reichsmarschall Göring was a war criminal now in Nuremberg awaiting trial – the 1.6 million paid by the Nazi administration for *Christ with the*

Woman Taken in Adultery. In addition, the Belastingdienst – the Dutch tax office – insisted that Han pay income and capital gains tax on his undeclared income for the previous decade, a claim they insisted should take precedence over all others.

The mathematics of the claims against Han's estate were absurd. Of the 7.25 million guilders paid for his forgeries, Han had received about 5 million – the balance had been paid in fees and commissions to G.A. Boon, Rens Strijbis, Jan Kok and Hoogendijk. The claimants, however, were insisting that Han reimburse the full purchase price of all the paintings. Had Han been able to repay this amount, his net earnings from the sale of the forgeries would be zero, yet he would still owe the state more than 5 million guilders in unpaid tax.

The matter, however, was academic: of the 5 million guilders Han had received, he had already frittered away 1.5 million (equivalent to an annual expenditure of $1.3 million a year). A further 900,000 guilders had been seized in 1943 when Han had attempted to convert his 1,000-guilder banknotes. In his divorce settlement Han had given Joanna another 800,000 guilders and almost half a million more was still scattered in metal boxes in heating ducts, radiator covers, gardens and attics in properties throughout the country, never to be found. Han's assets – the houses, hotels and nightclubs he owned – were valued at less than 2 million guilders. All of these, together with the house on the Keizersgracht – which was in Joanna's name – and their contents, including Han's collection of antiques and genuine old masters, would in time be auctioned off to cover his debts.

The statute of limitations on fraud, Han's lawyer Maître Helding advised him, is seven years, so it was a small comfort to realise that the money from *The Supper at Emmaus* – bought on behalf of the Boijmans eight years earlier – would

not have to be refunded. For Han's day-to-day expenses the Official Receiver allowed him a small monthly stipend. For the rest, he depended on handouts from Joanna, whose divorce settlement could not be sequestered. 'Jo asks nothing for herself,' he told Cootje, 'she just gives and gives. It's rather foolish of her from a financial standpoint, considering the millions I gave away.'

Jo's handouts financed his riotous lifestyle. Far from being chastened by his brush with the law, Han was determined to drink life down to the lees. He spent long evenings with Cootje in her studio, which he ensured was always well stocked with food, wine and fine cigars – a difficult task given the continued rationing. He clearly loved this tender, timid creature and was worried that having destroyed her marriage, she would be left with nothing when everything he owned was sold off. Carefully, he began to put together a 'shoebox' for Cootje, smuggling jewellery, gemstones and valuable old coins and even a number of genuine old masters out of the Keizersgracht house and the clutches of the bailiffs. But even the comforts afforded him by the creature he called 'this sweet irruption in my life', did not allay his obsession with *die meisjes van het Plein*, 'the girls on the square'. Cootje allowed him to invite them back to the studio on the Oudezijds Burgwal where they warmed themselves and feasted on fine food and *jenever*. They danced naked around the wood stove as Han sketched their lithe bodies, gaunt from the hardships of the 'Hunger Winter'. By now, the bacchanal was mostly in his head, he was paying the girls – with trinkets and jewellery – simply for their company.

In the wider world Han's popularity was still soaring. A 1946 newspaper poll ranked him second only to Louis Beel, an archetypal patriot who was to become prime minister of the first postwar Dutch government. Publishers wrote suggesting

Han write his memoirs, television stations wanted to make documentary films. An American tycoon made an astounding proposition – he would buy back all of Han's forged Vermeers *at their original purchase price*, thereby allowing Han to repay his creditors, and fly the famous forger to America where he would spend a year touring with an exhibition of his works and offering masterclasses in painting new 'old masters'. Han declined all offers, though he collaborated with his close friend Marie-Louise Doudart de la Grée on *Emmaus: A Novel*, a fictionalised account of his path to glory, which became a bestseller.

In the meantime, infinitely slowly, the cogs of criminal investigation ground steadily on, led by an intrepid inspector named Wooning. Han proved a supremely co-operative felon, giving Wooning a tour of his Amsterdam studio and handing over the keys to his villas in Laren and Nice. He offered the gruff, plain-speaking officer directions as to where evidence might be found. In Amsterdam and in De Wijdte in Laren, Wooning found raw materials for pigments, canisters of phenol and formaldehyde, brushes and canvases, but in the Villa Estate he found a wealth of incriminating evidence. Although the villa had been abandoned for years, it was remarkably as Han and Jo had left it. Wooning began his search in the basement which had served as Han's 'laboratory'. There he found four finished forgeries: two in the style of Vermeer – *A Woman Reading Music* and *A Woman Playing Music* – an unfinished *Portrait of a Man* in the style of Gerard Ter Borch and a sketch for a variation of Frans Hals's *Malle Babbe* which P.B. Coremans would later comment 'was as good as any of the works of Hals's pupil Judith Lyster'. Propped on an easel was a canvas with a preliminary sketch for a new Pieter de Hooch and nearby a 'blank' canvas from which the original

had been painstakingly removed and a priming layer added. A
convincing age crackle had been induced across the entire
surface. There was, however, no sign of the large oven which
Han claimed he had used to 'bake' his forgeries, though,
following Han's instruction, he found a spar – the twenty-
inch section of wood which Han had cut from the *Emmaus*
stretcher, but the strip of canvas which Han claimed to have
cut from *The Raising of Lazarus* before painting the *Emmaus*
was not to be found.

Despite the abundance of circumstantial evidence corrobor-
ating Han's confession, the Belgian critic Jean Decoen re-
mained convinced that the *Emmaus* and *The Last Supper*
were genuine Vermeers. He accepted that *The Woman Taken
in Adultery*, *The Footwashing* and *Isaac Blessing Jacob* were
crude imitations by a second-rate artist suffering a *folie de
grandeur*. As an amateur art dealer, he alleged, Han had
discovered two genuine Vermeers, the *Emmausgängers* and
Het Laatste Avondmaal, exactly as he had first claimed, and,
flushed by his success in selling them, had contrived and sold
the later forgeries, relying on their similarity to Vermeer's
masterworks. Decoen was finally issued a visa to travel from
Brussels to Amsterdam, where he asked if he might examine
the Vermeers Han claimed to have painted. Embarrassed by
the press coverage of the van Meegeren affair, the authorities
declined but, when the critic persisted, permitted Decoen to
examine *The Supper at Emmaus* and *The Young Christ
Teaching in the Temple*. Having studied the works, Decoen
wrote a second article for *La Lanterne* in which he stated: 'The
least that can be said of this affair is that we are dealing with a
disturbing hoax. The painting in the Boijmans is a genuine
work of the seventeenth century and is by Jan Vermeer of
Delft. In painting *The Young Christ Teaching in the Temple*,

van Meegeren has proved beyond doubt that he *could not* have executed the *Emmaus*.'

In the spring of 1946, Han learned that his trial, scheduled for May, was to be postponed. The case against him had not been made. Meanwhile, on 13 March in the crowded courtroom in Nuremberg, his unwitting nemesis Hermann Göring, wearing a grey uniform and yellow boots, took his seat in the witness chair. He had little time to think of art, which only a year before had been his passion. According to Jonathan Petropoulos's *Art as Politics in the Third Reich*:

> Göring filled all of his homes with artworks, though Carinhall, a huge, Norse-style structure, was his showpiece and therefore the repository of his most valuable pieces. By mid-1944 a visitor would enter the great atrium of Carinhall and witness a stunning array of artworks, with the center of the room dominated by four huge canvasses: two Hans Memling portrayals of the Madonna and child, a Madonna and child by Lochner, and Han van Meegeren's *Christ and the Adulteress*.

The former Reichsmarschall learned that Han van Meegeren had forged his treasured 'Vermeer' while a prisoner in Nuremberg.

According to a contemporary account: 'he looked as if for the first time he had discovered there was evil in the world.'

19

A DIRIGIBLE ARBITRAMENT

I forgot to ask you first what
sort of acquittal you want.
There are three possibilities,
that is, definite acquittal,
ostensible acquittal, and
indefinite postponement . . .

Franz Kafka, *The Trial*

On 29 October 1947, Han van Meegeren stepped from his house at 321 Keizersgracht to face the mob of waiting journalists. Tastefully dressed in an ultramarine suit, a teal shirt and a cobalt blue tie, his hair like hoarfrost slicked back from his proud high forehead, his moustaches clipped and waxed, he looked every inch the aesthete. Chatting and joking with the press, he ambled south along the Keizersgracht, parrying questions as he went. The reporters could not know that his leisurely pace owed more to the minor heart-attack he had suffered during the summer which had required him to spend a month convalescing from acute angina in the soothing gothic halls of the Valeriuskliniek.

The motley troupe crossed the canal at Huidenstraat, Han

pausing for a moment to gaze south towards the Leidseplein, where his 'little girls' plied their trade by night. He smiled, turning back to answer a reporter from the London *Times*. Traders from the antique shops on the Runstraat stood in their doorways to watch this curious procession as it passed. In a burst of late summer sun, the cortège turned left on to the Prinsengracht. Someone sitting on the terrace of Het Molenpad called out '*Veel geluk*, Maître' as he passed. Han shook his head – he was not hoping for good luck; he, more than his enemies, more than the prosecuting counsel, more than his victims wanted a guilty verdict.

More than two years had passed since Han's momentous confession, eighteen months since the first scheduled date for the trial. The law's delay was not the result of Han's proud contumely, but of the dissent among expert voices about just which and how many forgeries Han had painted. About six of the eight pictures there was no dispute: the de Hooch genre paintings, it was agreed, were forgeries – accomplished but derivative; of the Vermeers, it was universally accepted that Han had painted the *Head of Christ*, *Isaac Blessing Jacob*, *The Woman Taken in Adultery* and *The Washing of Christ's Feet*, but *The Supper at Emmaus* was still enthusiastically acclaimed a Vermeer by the art historian Jean Decoen and the director of the Boijmans, Dirk Hannema. As to *The Last Supper*, Daniël van Beuningen had at first refused to accept that his Vermeer was anything other than a masterpiece, but being a pragmatic businessman, when claims were filed against Han's estate, van Beuningen sued for the full purchase price of both *The Last Supper* and *Interior with Drinkers*. In the two years that followed, persuaded in part by the certainty of Decoen and Hannema and in part by his own instinct, he had begun to waver.

Such matters should have been settled beyond question by the Coremans Commission, which had been established by the Dutch state to examine all the paintings. Judge G.J. Wiarda, the titular head of the commission, was ignorant of the arts so the driving force had been P.B. Coremans. It was Coremans who appointed the members of the commission: W. Froentjes, official adviser on matters of chemistry to the Department of Justice, J-Q. van Regteren Altena, professor at the University of Amsterdam and Dr H. Schneider, who had been director of the Department for the History of Art. Lastly, A.M. de Wild, whose publications had proved such a boon to van Meegeren in his art crimes, and who had enthusiastically acclaimed each new forgery as genuine, was belatedly asked to join the commission which was to denounce them all. The results of their extensive forensic and aesthetic deliberations had postponed Han's day in court.

As Han rounded the bow of the Prinsengracht, the Gerechtshof – the Palace of Justice – hove into view, the reflections of its neoclassical pilasters and Corinthian capitals iridescent in the waters of the canal. The first stone of what had once been an almshouse was laid in the year in which Vermeer painted *Woman in Blue Reading a Letter*, the model for Han's first forgery, *A Woman Reading Music*. Crossing the canal a thrill of excitement mingled with dread surged through him to see the hundreds of journalists and onlookers, admirers and adversaries who had been queuing since before sunrise hoping to squeeze into the Fourth Chamber of the District Assize Court. Han was a national hero, a pricker of pomposity, a slayer of dragons. A small troupe of the glitterati – poets, painters and authors – had rallied to the cause. Among them, Simon Vestdijk, the most popular Dutch writer of his generation, Lodewijk van Deyssel, a legendary figure on the Dutch

literary scene and Kees Verwey, a respected Haarlem-born artist. The unofficial ringleader of this merry band was his biographer, Marie-Louise Doudart de la Grée, but his most vocal advocate was the immensely popular humorist, journalist and author Godfried Bomans, who declared in his daily column, 'It is not the Vermeers, but the experts who authenticated them that are fakes!' Bomans proposed that a statue be erected to Han van Meegeren, and set up a foundation to raise money. No statue was ever built.

International interest in the trial might have faded in the years since Han's confession, had it not been for Irving Wallace, whose story *The Man Who Swindled Goering* for the *Saturday Evening Post* had catapulted Han to worldwide fame. Perhaps Wallace saw in Han a vindication of his own personal maxim: 'To be one's self, and unafraid whether right or wrong, is more admirable than the easy cowardice of surrender to conformity.' Perhaps, as a bestselling novelist and screenwriter, he simply recognised a good story. Whatever his motives, he fashioned a version of events which could have been written by the forger himself. Weaving fragments of Han's confession with a dash of derring-do, Wallace airbrushed Han's questionable politics and decadent lifestyle to craft a tale of one man's wiles and talent pitted against international Fascism. It was so sensational, so partisan, so irresistible that journalists around the world clamoured to attend the trial. It was a story Wallace would tell again and again, adapting it for radio (where Han was played by the Oscar-winning Paul Muni) and later for television.

Han stood for a moment, gazing up at the Latin inscription carved above the entrance: 'Under your guiding light, Willem, this almshouse has been rebuilt, sacred to Justice and to the Law.' His lawyer, Maître E. Heldring, was waiting for him on the steps, and together they walked into the still shadows of the

courthouse, leaving the hum of spectators outside.

Maître Heldring's advice was simple: say nothing. In a bid to expedite justice (and minimise the embarrassment of all) Han's trial, which had been two and a half years in preparation, would last less than six hours, the seventeen witnesses for the prosecution averaging less than seven minutes in the witness box. With the exception of his closing argument, Maître Heldring would barely speak. He would call no witnesses in Han's defence and though he may have wished to venomously grill the experts ranged for the prosecution, he realised that it was pointless. The prosecution could argue either that Han was exceptionally talented or the experts exceptionally stupid. Either amounted to a victory for the defence.

As the two men entered the empty Fourth Chamber, Han whistled softly. The dark oak-panelled walls of the central court were hung with a retrospective of his finest work. The judge's bench was flanked on the right by the *Emmaus* and on the left by *The Last Supper*, utterly dwarfing the portrait of Queen Wilhelmina. *Isaac Blessing Jacob* hung above the dock where he now took his seat. The remainder of his Vermeers and de Hoochs stared down from the prosecutor's side. In the brief minutes while H.A. Wassenbergh, the public prosecutor, and his team filed into the room, Han gazed in awe at what he had achieved. The *Head of Christ* to the left of the magistrate's bench seemed faded now, the colours less brilliant, *The Footwashing* and *The Adulteress* were faintly embarrassing, but his first forgery, which had made him rich and made Vermeer a household name, still seemed to him to be timeless. He half-believed he had discovered rather than created them.

Shortly before 10 a.m., the public were admitted. Jacques and Inez sat behind him with Joanna. Cootje sat on his right,

smiling at him. The paparazzi called out to him, and he dutifully posed like a man born to it: with his glasses and without, against the backdrop of the *Emmaus* and framed by the royal ensign of the judge's bench. He waved to his supporters, chatted to the journalists: few self-confessed criminals can have looked so relaxed at their own trial.

At 10 a.m. precisely, the court rose for Judge W.G.A. Boll. The court was called to order and the judge asked that a summary of the charges be read – the full charge sheet, running to eight foolscap pages, was dispensed with.

'Are you Henricus Antonius van Meegeren?' asked the judge.

'I am.'

'Do you admit the charges brought against you?'

'I do.'

The trial might have ended there were it not for the doubts of Decoen and Hannema. The burden of proof, therefore, fell on the prosecution to prove the inveterate liar's confession true. Han was charged with multiple counts of obtaining money by deception by falsely representing his own works as those of Johannes Vermeer van Delft and Pieter de Hooch; he was further charged with adding false signatures to paintings with the intent to deceive.

The evidence presented was interesting for what was left unsaid: since the statute of limitations on the *Emmaus* had been reached, witnesses would not be questioned about its authentication and sale. The Boijmans Gallery would be spared the public ignominy heaped on those who were called to testify. More curious still was the fact that the circumstances surrounding the sale to Reichsmarschall Göring of *Christ with the Woman Taken in Adultery*, the incident which had first sparked the investigation, would not be discussed. In part, was

because those involved in the sale could not be called: Hermann Göring was dead, having cheated his executioners, committing suicide hours before he was to be executed, and his ambassadors Rienstra van Strijvesande, Alois Miedl and Walter Hofer had long since fled. Even so, the questionable nature of the sale and the accusations of collaborating with the enemy were not mentioned. A lone Dutch newspaper would lament that 'the political nature of the case was not publicly mentioned'. Everything about the trial was arranged to cause as little embarrassment as possible to the experts who had authenticated the works, the dealers who had sold them and the art world which had acclaimed them.

In concert, like a choir rising for a chorale, the seven members of the Coremans Commission rose as one to be sworn in. To each, in turn, the prosecutor put two questions:

'Are the paintings you have examined, in your considered opinion, contemporary?'

Each dutifully agreed that they were.

'Do you believe that these works could have been painted by Han van Meegeren?'

Again, the members of the commission assented.

Then the judge ordered that the blackout drapes be drawn so that P.B. Coremans could present the findings of the commission. A blaze of white illuminated an enormous screen positioned at an angle to the left of the bench. There was a second of darkness, then the *Emmaus* appeared, larger than life, luminous, shimmering, and Coremans began to speak.

'I must confess, sir, that we find your *oeuvre* excellent, indeed it is phenomenal.'

From the dock, Han smiled in the half-light: 'Thank you.'

'It is not easy to admit you have made fools of us, but your

work was so carefully conceived to bridge the chasm between two important phases in Vermeer's career – a period about which we know nothing. Furthermore, for some of us, your work satisfied a personal, secret ambition to discover once in our lifetime a truly great masterpiece. Knowing our desires, you laid a trap; some of us walked in eagerly, others less quickly, but in the end we were all caught out. It was our devotion, our enthusiasm which allowed us to be taken in, our search for truth and beauty blinded and betrayed us.'

In a lecture lasting half an hour, Coremans used slides and X-rays of the paintings to illustrate the committee's findings. Han, he stated, had co-operated fully with the commission's investigation – in fact, without his help, much that was found would never have come to light. As Coremans flashed up X-rays of the paintings, he referred to the detailed sketches Han had provided of the paintings over which he had created his forgeries. On the *Emmaus*, X-ray examination had identified the troublesome head of Martha which Han had been unable to remove 'in the position and of the dimensions indicated by the defendant' and the patch of lead white Han had tried to incorporate into the tablecloth. Though the underpaintings of the other forgeries generally corresponded with Han's sketches, Han had claimed that the underpainting of *The Last Supper* was a depiction of two children in a cart being drawn by a goat. X-rays had, however, revealed sections of a painting of *Horses and Riders* by an unknown artist. Coremans did not dwell on the discrepancy.

Showing the magistrates a close-up of the *Emmaus*, he explained that although the age crackle in the forgeries was superficially similar to that of a genuine old master, X-rays had shown that it was too homogeneous to have occurred naturally and must, therefore, have been artificially induced. Indicating

the magnified crackle, he testified that a blackish substance, later identified as Indian ink, had been used to simulate the presence of dirt and dust. On more than one of the paintings, ink had leached into areas of lead white paint, creating a bluish nimbus.

As to Han's claim that he had cut down the canvas and stretcher of *The Raising of Lazarus* before painting the *Emmaus*, Coremans demonstrated that the left-hand side of the *Emmaus* canvas was markedly different from the others. On three sides of the canvas, the threads were curved and warped from centuries of tension, on the left-hand edge, the fibres were straight. In addition, the original stretcher had been cut down by 49.5 cm. The rings denoting the age of the fragment of wood found at the Villa Estate in Nice were identical to those in the stretcher (which Luitweiler had had the foresight to preserve for the Boijmans for historical purposes); furthermore, the fragment discovered in Nice showed marks of woodworm which precisely matched the stretcher.

Coremans summarised the chemical tests performed on the paintings. Traces of cobalt blue – a pigment which had not been invented in Vermeer's time – had been found in the surface layer of *A Woman Reading Music*, a painting which had never been offered for sale, and in *The Adulteress*. Further, the surface of the paintings, unlike a genuine old master, was lustreless and porous. Testing had revealed that the paintings were impervious not only to alcohol, but to caustic potash, a substance which would normally cause even centuries-old paint to desaponify. Traces of phenol and formaldehyde, which the accused claimed to have used as a medium, were found in the surface layers of all the paintings.

In the commission's conclusions, only one artistic inconsistency emerged: radiography indicated that Vermeer created

the characteristic luminosity of his faces by slowly building a series of thin layers of translucent lakes and glaze over a white lead ground; the paintings examined by the commission displayed no such technique.

For half an hour, Coremans offered an erudite dissection of Han's technique, the composition of each paint layer, the details of each underpainting, the impetus and heft of each brushstroke. The import of this analysis was lost on the journalists and observers who heaved a collective sigh of relief when the projector was switched off and sunlight flooded back into the courtroom. Judge Boll asked the defendant if he had any comment to make on the presentation.

'I find this work excellent,' Han, gently mocking, echoed Coremans's compliment. 'Indeed it is phenomenal. In fact, to me this work seems much more ingenious than – say – painting *The Supper at Emmaus*.'

There was a ripple of laughter.

The prosecution called A.M. de Wild, a man in the unenviable position of having enthusiastically advised the Dutch state to purchase *The Footwashing* only to serve on the commission which denounced it as a forgery. Far from being chastened by his errors, de Wild proved an arrogant witness, eager to claim some shred of glory from the debacle.

'The test required to identify the defendant's pigments I found rather easy,' he testified, 'since it soon became clear that in order to create his quasi-old paints, the accused had borrowed a formula from my treatise on the methods of Vermeer and de Hooch.'

The judge rapped his gavel to keep the court in check.

'Indeed certain impurities that I mention as being found in Vermeer's paint are also to be found in van Meegeren's.'

'And yet you were a member of the committee which

recommended that the Dutch state purchase the painting known as *The Footwashing*? Why did such tests not reveal it to be a forgery?'

'Because de Boer, the art dealer, twice refused to allow X-rays of the van Meegerens in his possession. Such a test would have certainly shown that the paintings were not genuine. Later I would [X-ray the paintings], and it was this which brought me to a different conclusion.'

The prosecutor did not ask why de Wild and the members of the committee did not think de Boer's refusal suspicious, nor did he challenge de Wild's implication that *The Footwashing* had been X-rayed shortly after it was purchased (at which point the committee were free to conduct any test they thought appropriate). In fact the painting, painstakingly 'restored' and elegantly framed, had hung in the Rijksmuseum as a Vermeer for two years before de Wild was moved to have it X-rayed, and then only after Han had confessed to the forgery.

The other members of the commission filed into the witness box to corroborate the forensic evidence as to the chemical composition of the paintings. Wisely, they said little that might undermine their judgement, cloaking their testimony in jargon and science. During a particularly tedious homily by Professor van Regteren Altena, proud that he alone had dismissed *The Footwashing* as a forgery (though unable to explain why he had none the less recommended that the Dutch state spend 1.3 million guilders on the work), Judge Boll intervened to ask Han at what point he added the signature.

'I did that last of all and it was much the most difficult task.' The court stenographer records that Han sighed heavily. 'It had to be done all in one stroke. Once I had begun there was no going back.'

Rens Strijbis, who had earned more than half a million

guilders in commission from the sale of four of Han's forgeries, money he had failed to declare to the tax office, pleaded ignorance:

'I was already acquainted with the accused when, in 1941, he asked if I would sell a painting on his behalf,' Strijbis testified; 'I knew nothing about art, but he offered me a handsome commission – one-sixth of the eventual purchase price. I took the work, a *Head of Christ*, to Hoogendijk.'

'Did you realise it was a forgery?'

'Of course not. The defendant claimed it was a Vermeer. He never told me where he had obtained it. Myself, I would not have given the painting houseroom. Later I sold three others for him, all to Hoogendijk: *The Last Supper*, a Pieter de Hooch and *Isaac Blessing Jacob*. He claimed they all came from the same collection.'

'How much was paid for these paintings?' the prosecutor asked.

'I don't remember,' Strijbis said prudently, 'I did not keep records.'

A case for conspiracy might have been brought against the next witness, D.G. Hoogendijk, the dealer who had sold five of Han's eight forgeries. Hoogendijk had always firmly denied that he knew any of the paintings were doubtful, and it is likely that the prosecution accepted his word since, after Han's confession, the *Head of Christ* – which Hoogendijk had received from van Beuningen in part-payment for *The Last Supper* – was still in the inventory of his gallery. Had he known it to be a forgery, Hoogendijk would certainly have disposed of it; that he kept it was taken as evidence that he believed it to be genuine and had not yet been able to find a buyer for the painting.

The prosecutor asked what had persuaded him that the *Head of Christ* was genuine.

'I walked into a trap,' Hoogendijk admitted, shamefaced. 'When I saw the painting, I immediately thought of the *Emmausgängers*. Without the *Emmaus*, I would never have seen Vermeer's hand in it, but the most prominent Dutch experts had acclaimed the *Emmaus* as an extraordinary work; as a simple art dealer, what was I supposed to think . . .?'

'And it did not strike you as strange that so many Vermeers were suddenly coming to light?'

'Not at all. Most art historians agree that there should be more. I sold the *Head of Christ* to Mr van Beuningen. That was in 1941, in Rotterdam. It was a much finer painting then than it is now.'

Judge Boll turned to look at the painting and asked Han if he agreed that it had deteriorated in the six years since it had been sold.

Han nodded. 'I'm afraid the dull, lack-lustre appearance of the painting now gives little indication of how it looked when I put it on the market in Vermeer's name.'

'You have to remember,' Hoogendijk explained, 'that the *Emmaus* had been authenticated by world-renowned experts. The subsequent forgeries were links in the same chain. That's why they were more easily sold. Besides, there was a war on, the buyers were in a hurry. No one wanted these paintings to fall into the hands of the Germans.'

For the first time in the trial, Han's lawyer, Maître Helding, rose to his feet.

'What about the supposed provenance of these paintings?' he asked. 'Was it not said that they were the property of a countess who had inherited them as a family heirloom?'

'No, there was no mention of a countess, only some old Dutch family. I inquired about the provenance but I got no answer, or at least the answer I got did not seem to me to be

suspicious. In my profession, such things are not uncommon.'

'Not even . . .' Heldring asked, ' . . . when there are millions of guilders at stake?'

'When I sold *The Last Supper* to van Beuningen, my first impression was that it was an extraordinary painting, and my first impression is often the best.' He paused and smiled feebly. 'But again I was allowing myself to be influenced by the *Emmausgängers*. It seems inconceivable now, but at the time it was completely logical. After the *Supper*, I sold two more, including the strange one.' He nodded to *Isaac Blessing Jacob* which hung above van Meegeren's head.

'And yet you accepted it as genuine?'

'It's hard to explain.' Hoogendijk shrugged. 'It's unbelievable that it fooled me. But we all slid downward – from the *Emmaus* to *Isaac*, from *Isaac* to *The Footwashing*: a psychologist could explain it better than I.'

Doctor van der Horst, the psychologist who concluded the morning session, was not asked to explain the credulity of the victims, merely to offer his analysis of the accused based on his interviews.

'The defendant's character leads him to be sensitive to criticism, which in turn fuels a revenge complex that explains his anti-social attitudes. I would describe him as disturbed, certainly, but fully responsible for his actions. A man of his personality would be greatly hurt by isolation; I would strongly advise against a custodial sentence.'

After the lunch recess, Han seemed tired and weak, but he gamely quipped with the media as the seven remaining witnesses filed in, waiting for their hour of mortification. Most were spared embarrassment, the prosecution rattling through their evidence in less than an hour. The dealer

who had sold *The Footwashing*, P. de Boer, was first to take the stand.

Asked how he had come by the painting, he replied: 'In 1943, he [Jan Kok] came to offer me an old painting, *The Washing of Christ's Feet*, asking for more than a million guilders.'

'Did he say who painted it?' the prosecutor prompted.

'He did not, but he told me I would know who had painted it the moment I set eyes on it. As soon as he showed it to me I said it was by the same master who had painted the *Emmaus*. I added that it was probably not signed, but when I examined the painting closely, I discovered Vermeer's signature.'

'Did you ever doubt for a moment that the painting was genuine?'

'Absolutely not,' the dealer replied emphatically.

Perhaps fearing that the prosecutor was about to challenge the witness with A.M. de Wild's testimony that he had refused the purchasing committee's request to X-ray the painting, Han spoke from the dock: 'If I may, Your Honour, I know the witness well and I can vouch for the fact that he is an honest man. I believe he acted in good faith.'

'Very well,' Judge Boll nodded, 'though it is highly unusual to find a defendant coming to the aid of a prosecution witness.'

Han intervened again on behalf of the next witness, his childhood friend Jan Kok. Though the former civil servant limited himself to a short, factual account of his role in the selling of *The Footwashing*, Han was clearly moved by his testimony, especially when Kok was forced to admit that, before the sale, he had never heard of Vermeer. His voice quavering, Han said, 'This is the most honourable man of those who have been called to give evidence.'

The remaining witnesses said as little as possible. Dirk

Hannema, the director of the Boijmans, sought to justify his errors. Daniël van Beuningen, the proud owner of three of Han's forgeries, seemed dumbfounded, unable to believe even now that the paintings for which he had built a gallery in his country home were fakes. He even intimated that perhaps the *Emmaus* and *The Last Supper* were genuine. When the prosecution brusquely challenged the suggestion, he turned desperately to Judge Boll and cried, 'But, just look at them, my Lord!'

The only entertainment to be had in the afternoon's proceedings came from Dr J.G. van Gelder, the university professor who had argued so forcefully for the state to purchase *The Footwashing*. Though he offered the opinion that it was 'ugly', he confessed he had thought the painting genuine, before launching into a tale of duplicity and conspiracy worthy of Han himself.

'During the war,' he confided almost in a whisper, 'I was visited by two men claiming to be tax consultants. I had never met these men before, but they claimed to represent a client, an artist, who wished to sell a number of old masters.'

The prosecutor, blindsided, murmured something.

'Somehow,' van Gelder continued, 'I had the presentiment that these supposed old masters were the work of the accused. In fact I told these tax consultants that I suspected they were acting for Han van Meegeren and invited them to return the following day. I never saw them again. After that, I had the gut feeling that Mijnheer van Meegeren was not quite trustworthy.'

Han struggled unsteadily to his feet. 'You had a feeling?'

'I did,' van Gelder glared at Han, 'and it seems my misgivings were entirely justified.'

A ripple of laughter spread through the court.

'And when did you first have this *feeling*?'

'In 1942.'

Han smiled, turning to Judge Boll. 'Might I remind the court that *The Footwashing* had not been offered for sale in 1942 – in fact I had not even painted it.' He turned back to van Gelder. 'And yet in spite of your *feeling*, a year later you would accept it as a genuine Vermeer?'

When the public prosecutor rested his case, Judge Boll, as is the procedure in the inquisitorial system, questioned van Meegeren himself.

'You still claim to have created all of these forgeries?'

'Yes, Your Honour.'

'And sold them for exorbitant prices?'

'What choice did I have?' van Meegeren sighed. 'If I had sold them cheaply, that in itself would have been proof that they were forgeries.'

'Why did you continue to forge paintings after the *Emmaus*?'

'I found the process I had devised so satisfying, that it was as if I was no longer in control of myself. I had no willpower, I was helpless, forced to continue.'

'That's as may be,' the judge harrumphed, 'but you made a tidy little profit from your work.'

'I had no choice, Your Honour, I had been so slandered by the critics that I couldn't exhibit my own work any longer. Critics who didn't know the first thing about art had systematically, spitefully destroyed me.'

'But perhaps money had *some* bearing on your decision to continue?'

'It made no difference,' Han said quietly. 'The millions I earned from the later forgeries piled up with the millions I already had. I didn't do it for the money – money brought me nothing but worry and misery.'

'So you acted entirely without thought for financial gain?' Judge Boll's voice scoured the depths of incredulity.

'I did what I did only out of a desire to go on painting,' Han replied. 'I decided to carry on, not because I wanted to paint forgeries, but simply to make the best use of the technique I had discovered. I hope to use it again, it's a very fine technique, but I will never again age my paintings or present them as old masters.'

'Thank you, Mijnheer. Is the prosecution ready to offer closing arguments?'

Maître Wassenbergh moved to the podium and, gripping the handrail, gestured theatrically around the courtroom.

'Court Number Four, which is normally so dreary, is rather more colourful this afternoon. These paintings were once thought to be "old masters". Now it seems clear that they are anything but. Even *The Supper at Emmaus*, the oldest of them, is barely ten years old.

'The defendant hoped to prove to the world that he was an artist of genius, but by resorting to forgery, he has proved himself a lesser artist. The art world is reeling, and experts are beginning to doubt the very basis of artistic attribution. This was precisely what the defendant was trying to achieve.

'The primary function of art is to rouse emotion in the viewer,' the prosecutor stepped back to his bench and grasped a sheaf of papers, 'such emotion as may be attested in these reviews of the *Emmaus* when it was first exhibited in 1937.' Wassenbergh read excerpts from the glowing reviews. 'The greatest proof of which is that he has failed to achieve that aim, the reverence accorded his work has faded – though I admit the false signatures are excellent, indeed almost indistinguishable from Vermeer's own – and he is left only with the money.

'Whether or not he is a genius,' Wassenbergh mocked, 'this court has yet to decide.

'I maintain,' he concluded finally, 'that both charges have been proven. The maximum sentence set down by the Penal Code is four years' imprisonment; however, taking into consideration the defendant's ill-health and the report made by the psychologist, I ask that the court sentence him to no more than half the maximum term. In addition, I propose that the forgeries be returned to their owners, even though it is entirely within the purview of this court to have them destroyed.'

Maître Heldring took the speaker's podium, scanning the faces of magistrates and spectators. In a summation that was erudite, witty and persuasive he regaled his audience with tales of his client, whom he cast in the role of a jester, 'a man of considerable intelligence and great charm who can be childishly generous, often naïve, and putty in the hands of parasites.' He brought down the house with his account of Han's visit to the Boijmans where a security guard was forced to restrain him from getting too close to the priceless *Emmaus*. The substance of his argument, however, was that Han had perpetrated no fraud.

'The defendant never claimed that he was offering a genuine Vermeer or Pieter de Hooch. It was the *experts* who declared that these were Vermeers and de Hoochs – where is the fraud in that?

'It seems strange,' Heldring went on, 'that so far, none of the "victims" has been willing to sell their forgeries – this is hardly what one would expect of a person who feels deceived. One of the victims has even admitted to me that he was offered the full purchase price, and refused. So where is the injured party?'

As to the second charge, that of appending false signatures to paintings with intent to deceive in contravention of article

326b of the Dutch Penal Code, Heldring maintained this was a trifling matter.

'Whether or not a painting has a forged signature means very little. There are thousands, probably tens of thousands of paintings in galleries with forged signatures. It is commonplace in the art world. Even Rembrandt's *The Syndics of the Cloth-makers' Guild* bears a forged signature next to the real one – although the Rijksmuseum does not know which is which. If paintings are to be bought and sold purely on whether or not they bear a false signature, then the entire art world is done for.'

Han was asked if he had anything further to add and, after a long moment's thought, declined the opportunity. Suddenly, it was all over. Judge Boll reserved judgement until a later date and the proceedings were adjourned. Han, with Jo on his arm and his children by his side, stepped out into the chill autumnal afternoon sun. Around the curve of the Prinsengracht, the distant spire of the Westerkerk towered over the skeletal trees. Together, they walked home, steering a course through the dizzying eddies of the world's media.

On 12 November, Judge W.G.A. Boll found Henricus Antonius van Meegeren guilty of obtaining money by deception and of appending false names and signatures with the intent to deceive in breach of articles 326 and 326b of the Dutch Penal Code. The sentence was the most lenient it was within his power to impose – one year's imprisonment.

In accordance with the prosecutor's recommendation, the forgeries were not destroyed, but returned to their owners. *Christ with the Woman Taken in Adultery* became the property of the Dutch state and was later sold to the Nederlands Kunstbezit. The four unsold forgeries found in Nice, together with *The Young*

*Christ Teaching in the Temple** were deemed to be the property
of van Meegeren and were returned to his estate while the long
slow process of bankruptcy was played out.

The judge offered the defendant two weeks to appeal the
verdict and once more released Han on bail, though, having
conferred with Heldring, Han made no application for an
appeal. Unbeknownst to Han, but with the support of Judge
Boll, a petition was prepared seeking a royal pardon. Wassen-
bergh indicated that he would not contest this. It is doubtful that
with the concerted backing of defence, prosecution and the
judiciary, Queen Wilhelmina would have refused a pardon to
one of the most admired rogues in the Netherlands. As it
happened, it would not be necessary. On Wednesday 26 No-
vember, the last day on which Han might lodge an appeal, he
collapsed and was admitted to the Valeriuskliniek, where he
rallied briefly. On 29 December, having not served a day of his
sentence, he suffered a massive cardiac arrest and died.

Almost half a century later, in *The Democratic Muse*,
Edward C. Banfield, professor emeritus at Harvard, would
write: '. . . had van Meegeren not seen fit to confess, thereby
bringing great numbers of works into the laboratories, the
paintings of this supremely gifted forger would still be giving
pleasure to countless museum-goers all over the world.'

But perhaps all is not lost. There are ghosts that haunt the
catalogue still. Six works known to have been painted by Jan
Vermeer of Delft and described in detail in the seventeenth and
eighteenth centuries have never been found and are waiting
only for the keen eye of the critic or the forger's brush to
resurrect them.

* Bought by the chairman of De Beers, Sir Ernest Oppenheimer, it now
hangs in a church in South Africa.

EPILOGUE
LONDON, 7 JULY 2004

Any fool can paint a
picture, but it takes
a wise man to be
able to sell it.

Samuel Butler

From the media scrum milling on the pavement of London's
elegant New Bond Street, it is impossible to tell whether a glitzy
première or a serious crime is in progress. Some might claim
that it is both.

In the confusion of boom microphones and hand-held
cameras, reporters frantically search for a spot to stand and
give their first grave bulletin of the evening. An eighth TV crew
arrives late, frustrated and angry, delayed not by the usual
snarl of traffic, but by another publicity stunt. Tonight, the
customary London soundtrack – the honking of black cabs
and the farting of old Routemaster buses – has been silenced.
The city has been closed off to allow eight Formula 1 drivers –
among them David Coulthard and Nigel Mansell – to careen
through the city streets, the powerful throb of their engines
echoing through John Nash's elegant Regent Street arcades.

English summer, ever fickle, has lurched from the glorious sunshine and sweltering heat of yesterday to torrential rain. Lowering clouds frame the graceful eighteenth-century buildings and the ominous rattle of thunder adds a little drama to the first night of Sotheby's old masters sale. The last TV crew, somewhat bedraggled, press inside. Tonight, in the world's oldest and most venerable auction house, Lot number eight, the world's most famous 'forgery', is to go under the hammer.

Inside, platoons of dour security guards flank the crowds that spill out of the auction room into the hallways. Shortly after 7 p.m. the auctioneer begins.

'Lot number one: *A village scene with figures shooting the popinjay and dancing around a maypole* by Pieter Gysels. Property from the estate of the late Mrs Patricia Rosamund Landon Lee' . . .

Only the serious bidders are paying any attention. This is the first of three nights of Sotheby's auction of old masters, but the usually hushed atmosphere has given way to a whispered clamour. The halls are thronged with media pundits, sightseers and cultural tourists: they are not here to bid, they are here to gawp. In one corner of the auction room, the international press corps, a knot of eighteen journalists, is taking bets on how much Lot number eight will fetch; because it is no ordinary old master, it is the rarest of rare objects: a painting by Johannes Vermeer van Delft.

Only thirty-five paintings are generally attributed to Vermeer, two of which are disputed. Only two Vermeer paintings are in private hands – one because it is owned by Her Majesty the Queen, the other because it was stolen from the Isabella Stewart Gardner Museum in 1990. It is unlikely that a Vermeer will ever come to auction again. The painting to be sold tonight is listed in the catalogue as *A Young Woman Seated at*

a Virginal, but the press have dubbed it *Girl with a Yellow Shawl*, a deliberate echo of the master's most famous painting, *Girl with a Pearl Earring*.

The problem with Lot number eight is one of attribution. Baron Frédéric (Freddie) Rolin fell in love with it when he first saw it in a London gallery window in 1960. Previously, it had been the property of Sir Albert Beit, inherited from his father, the distinguished Irish collector who bequeathed Vermeer's famous *Lady Writing a Letter* to the National Gallery in Ireland. It has been impossible to trace its provenance before that date. Yet Sotheby's seems content to assert that 'The whereabouts of the present picture has, however, been securely documented since 1904.' When Baron Rolin first saw the painting, it was no longer thought to be by Vermeer, having been dropped from the second edition of A.B. de Vries's *catalogue raisonné* of Vermeer's work in 1948 as part of an extensive purge. The painting was omitted from the first major Vermeer retrospective in 1996, and two years later the Vermeer scholar Benjamin Broos rejected it as a 'tasteless mishmash' of two Vermeers in the National Gallery and argued that its advocate 'Christopher Wright cannot be taken seriously with his continuing presentation of this and other pseudo-Vermeers as the genuine article'. The painting was hastily included in 'Vermeer and the Delft School' at the National Gallery in London in 2001, though Axel Ruger, the curator, made no claims for its authenticity, and it did not appear in the catalogue.

Sotheby's catalogue glosses over the murky history of the painting, focusing instead on the fact that the painting has recently been *re-attributed*. Re-attribution, like a magical incantation, can turn a worthless forgery into a priceless old master.

Sotheby's has set a 'conservative' reserve price of £3 million, but if the committee's attribution is to be believed the reserve is not conservative but laughable, since even insignificant works by Vermeer are considered 'almost like minor relics of a saint'. 'In making an attribution,' the art historian John Conkin observes, 'a critic or dealer is not only adding a footnote to the history of art, he or she is also adding or subtracting zeros from the eventual price that will be paid for it.' Sotheby's chairman, A. Alfred Taubman, when he took over the august institution, commented: 'Selling art has much in common with selling root beer . . . People don't need root beer and they don't need a painting, either.' The observation is somewhat disingenuous since root beer routinely sells for a dollar a can, but collectors will pay more – much more – for genius. 'Art,' in the words of the critic Robert Hughes, 'is no longer priceless, it is priceful.'

There is an unexpected flurry of bidding for Lot number seven, *Study of the Head And Shoulders of an Old Man*, a dark, brooding portrait in which the artist has masterfully captured the human frailty, the intimation of mortality in his subject. Even the onlookers are caught up in the excitement, bidding quickly tripling its estimate to top £1 million and finally selling to the respected London dealer Johnny Van Haeften for £1.8 million, setting a record price for a work by the artist Jan Lievens. Though those in the hall are probably unaware of the irony, Lievens's portrait has also been *re-attributed*. And attribution – which is no more than an expert opinion – can cause the value of a painting to go down as well as up. Until the mid-nineteenth century, the painting was attributed to Rembrandt Harmenszoon van Rijn, Lieven's mentor and teacher. It was a Rembrandt when last exhibited at the National Gallery. If the portrait were still attributed to

Rembrandt, the auctioneer would not have countenanced £1.8 million as an opening bid. In a more cruel irony still, *Study of the Head and Shoulders of an Old Man* is listed as 'The Property Of The Late D.G. Van Beuningen'.

In art, then, attribution is everything. This is why we are here, craning to get a look at the tiny painting now being held aloft by a handsome blond Sotheby's official wearing regulation white gloves. There is a theatrical hush, and the auctioneer clears his throat and invites bids.

'Lot number eight: *A Young Woman Seated at a Virginal*, by Johannes Vermeer, oil on canvas, in a fine French Louis XV carved and gilt wood frame, property of the heirs of the late Baron Frédéric Rolin.'

It is an unprepossessing painting. Barely ten inches by eight – hardly bigger than a family photograph – and utterly dwarfed by the ornate gilt frame. The subject is a rather plain girl, awkwardly posed at the virginals, wrapped in a huge, graceless yellow shawl. She gazes wanly at the viewer. Somewhere, off the canvas to the left, an unseen window lights the featureless, almost monochrome interior of greys and flesh tones; only the yellow of the girl's shawl provides a visual focus. There is nothing else, none of the signature shadow-play on the wall, no maps or linens or brocade, no foreground furnishings – a *repoussoir* – to frame the scene. This is unusual in a Vermeer, even more so in one which is dated around 1670, the period of his mature style, in which he painted *The Lacemaker*, *A Young Woman Seated at a Virginal* which hangs in the Royal Collection, in that his paintings are never simply portraits, he uses the details of a room to tell us silent, intricate stories about his subjects.

None of this, however, makes any difference to the bidding, which from the outset is brisk but discreet. The bidders present

eschew what is called 'lighthouse bidding', where a bidder
sticks his paddle in the air and leaves it there, indicating s/he is
in it for the long haul. Instead, once the bidders are established,
a simple nod of the head suffices to add another hundred
thousand pounds, another half-million. Incongruous in the
elegant eighteenth-century splendour of the auction room is
the customary bank of telephones manned by some two dozen
Sotheby's officials taking bids from those who wish to remain
anonymous. Among the onlookers there is feverish speculation
as to the identity of these 'anonymous bidders'. Steve Wynn,
Las Vegas millionaire and owner of the Bellagio, may be keen
to add an old master to the twenty-five Picassos which give one
of the hotel's seven restaurants its name; billionaire collector
Ken Thomson is surely a strong possibility, and the leviathan
of all bidders – at whose name public galleries and private
collectors tremble – the J. Paul Getty Museum, is unlikely to
miss this unique opportunity. The officials manning the phones
nod, pushing the bidding higher and there is an almost audible
sigh of relief when the painting quickly breaks the ten-million-
pound barrier.

An inexperienced bidder might trust to the reputation of the
auction house in such matters. Such a person would be wise to
read the general terms and conditions common to every
auction house: 'All property is sold "as is" and Sotheby's
makes no representations or warranties of any kind or nature,
expressed or implied, with respect to the property . . . nor be
deemed to have made any representations or warranties of
physical condition, size, quality, rarity, importance, genuine-
ness, attribution, authenticity, provenance or historical rele-
vance of the property.' An additional clause is pertinent to the
case of *A Young Woman Seated at a Virginal*. 'In addition to
other exclusions described in the catalogue, we cannot guar-

antee the authorship of paintings, drawings and sculpture created before 1870.'

But those bidding this evening, all but one of whom are anonymous, are experienced in the ways of the auction house. They know that in art there are no guarantees, only hunches. Of the remaining bidders, only one is present in the hall: Robert Noortman, a respected Dutch dealer, finally concedes defeat when the bidding reaches £14.5 million. Some minutes later, George Gordon, a Sotheby's Old Master expert who has been manning one of the phones, takes the winning bid, £16,245,600 ($27 million) including commission. At the back of the hall, a Spanish journalist collects his winnings: eighteen pounds for guessing the price paid for the painting.

Though there are more than fifty lots remaining to be sold this evening, the onlookers, reporters and media pundits begin to file out. Journalists rush to file their copy. The bidders and the auctioneers resume their earnest work. Later that evening a striking *Night Scene* by Rubens (listed simply as 'The Property of a Lady of Title') will fetch £2.4 million. *Saint John Preaching in the Wilderness* by Jan Breughel the Elder will sell for less than £350,000 and a fine Tintoretto, *The Deposition*, for a trifling £151,200. The media care only that the world is officially one Vermeer richer.

Two days later, Brian Sewell, the august art critic of the London *Evening Standard*, challenges Sotheby's assertion that A *Young Woman Seated at a Virginal* is 'an extremely important addition to our understanding of Vermeer's artistic development', preferring to suggest that 'this nasty little picture' is a forgery. 'The history of Vermeer in the twentieth century,' he writes, 'is littered with false attributions and downright forgeries enthusiastically attested by the experts of the day, and I confidently predict that the Sotheby picture

will join them as an object of derision – £16.2 million is monumental proof of folly, not authenticity.'

Coincidentally, Sewell's article appears on the very day that Sotheby's is forced to admit it withdrew the star item in its Russian sale, having been informed that the work is a forgery. The painting, attributed to Ivan Shishkin, had been estimated at between £550,000 and £700,000. In truth, it was a crude hack-job. The forger had purchased a minor painting by an obscure Dutchman, Marinus Koekkoek, only a few months earlier in Stockholm and, making no attempt to imitate Shishkin's style, simply contented himself with overpainting some details and appending Shishkin's signature. When the catalogue was published, Sotheby's was fulsome in its praise for this profoundly atypical 'Shishkin': '*Landscape with Brook* is a rare example of an important piece by a major artist'. Citing a Shiskin specialist that the artist was a 'delicate and profound chronicler' of pastoral life, Sotheby's added, 'Looking at *Landscape with Brook* it is difficult to disagree.' Faced with photographic evidence of two almost identical paintings, Sotheby's withdrew the picture from the sale, blustering that it was 'not yet convinced that its authentication was wrong'.

Matthew Bown of the Izo gallery in Mayfair commented to the *Guardian*: 'Hopeful attributions are common in the art world and are not confined to Russian painting. However, it is startling to see a misattribution estimated at over $1m in a Sotheby's catalogue. Most of the people who buy at Sotheby's Russian auctions are not professionals but collectors who rely implicitly on the accuracy of Sotheby's statements.'

Meanwhile, the head of Sotheby's Russian department, Joanna Vickery, insisted that she had not yet seen evidence to prove that the Shishkin was a forgery. In her words, 'The jury is still out.'

A shudder of panic rippled through the art world, but quickly dissipated. The Shishkin returned to deserved oblivion, and no voices came to join Sewell's attack on the Vermeer. On the latter, Sotheby's stood by its attribution. The painting had, after all, been authenticated by a committee which included luminaries from the Mauritshuis and the Rijksmuseum, although to those who know how to read an auctioneer's catalogue, the attribution seems full of caveats: the experts are 'Almost certain . . .' the work is by Vermeer, although they admit that the painting was 'to some extent reworked by another hand . . .' More damagingly, they suggest that 'part of the picture was brought to completion after the rest of the composition, perhaps as much as a few years later'. They are certain, however, that the picture is 'unquestionably seventeenth-century'. It has taken them ten years to reach even this, qualified, certainty.

The canvas, the committee concluded, matched that on which Vermeer painted *The Lacemaker* so exactly that it 'made it likely that the two pieces of canvas had been cut from the very same bolt of cloth'. But this is a specious argument – *The Lacemaker* is barely eighty square inches and *A Young Woman Seated at a Virginal* smaller still. A bolt of canvas would measure some two yards wide by fifteen to twenty yards in length and could accommodate Vermeer's life's work ten times over. As Brian Sewell notes, 'If Vermeer's lifetime's work on canvas were measured against a single bolt, I suspect that 90 per cent of it would not have to be unrolled.'

The pigments in A *Young Woman Seated at a Virginal* were analysed and found to correspond with the 'unusual, expensive, and often extremely rare' pigments typical of Vermeer's work. Of these, the committee focused on three pigments: lead-tin yellow, green earth and the most expensive colour available

to seventeenth-century Dutch artists, ultramarine, the colour quintessential to Vermeer. None of these have been in use since the mid-nineteenth century, when cheaper, factory-produced colours supplanted them. The committee, however, seem to have forgotten the simple advice set out fifty years ago in a small pamphlet published by the Museum of Modern Art in New York: 'Valuable as chemical analysis is, the check which it offers must not be considered as foolproof, because forgers also know the correct dating of pigments and prepare their frauds accordingly.'

Furthermore, the lead-tin yellow in the painting is principally to be found in the shawl, which even the experts admit may be a later addition; and though there is ultramarine in the shadows, there is a curious absence of *visible* full-strength ultramarine compared to contemporaneous paintings by Vermeer.

It is precisely because there are so few Vermeers that we do not get to see the master on a bad day, but what is most striking is how curiously defensive the arguments for the painting's authenticity sound. As John Haber points out, 'They stake an artist's signature on his materials, as if he held the Dutch monopoly on paint supplies.' No one – not the experts, nor even Sotheby's – suggests that this is a beautiful painting; certainly not a great Vermeer. Instead, in an attempt to date the painting, a cultural historian asserts that the hairstyle worn by the girl was in fashion 'only between 1669 and 1671'. Art historians comment on the striking similarity between the young woman's pose and that of the lady in Vermeer's *A Young Woman Seated at a Virginal* in London's National Gallery. But the paintings, which according to the committee's findings would have been painted at much the same time, have nothing else in common. The painting in the National Gallery

has the subtle cues and restrained narrative of a mature Vermeer. While the young girl's innocence is emphasised by the name of the instrument favoured by young ladies, behind her on the wall, Baburen's *The Procuress* reminds the viewer that all is not courtly love. The instrument itself is beautifully rendered, as is the abandoned cello (another sexual symbol, critics maintain) and the scene is framed in classic Vermeer style. By contrast, this new Vermeer is all but monochrome. It has no space to breathe and little light, the instrument is dark and muddy, the wall behind the sitter bare and the anatomy unsophisticated. It is a painting unworthy of Vermeer, unworthy even of the man to whom it was attributed for the past half-century: Han van Meegeren.

APPENDIX I
THE DWINDLING VERMEERS

Han van Meegeren's true legacy to the world of art is doubt. More than that of any other forger, his work rocked the foundations of an art world reliant on the authentication of experts. The work of Jan Vermeer of Delft has never been so discussed, so admired, so fêted as in the aftermath of Han's trial. Newspapers and magazines published feature articles extolling this modest, unassuming artist so long unsung, whose serene interiors and minimalist narratives seemed extraordinarily modern compared to the theatre and bombast of the Romantics. But if the downfall of the man who made Vermeers brought a new audience to the work of his beloved Sphinx of Delft, his skill as a forger made it even more difficult to assess the authenticity of works attributed to Vermeer. Within months of Han's trial, Arie Bob de Vries hurriedly published a revised edition of his catalogue of Vermeer's *oeuvre*. The first edition, published in 1939, had proudly included *The Supper at Emmaus*. Now, de Vries took a scythe to the mediocre and the insipid. 'It was only after the war that this bewildering forgery business came to light,' he wrote. 'It opened my eyes completely. I now feel that I have to remove every doubtful

work from the artist's *oeuvre*.' Together with the *Emmaus*, he downgraded Dutch interiors and crude copies by unknown hands, many bearing the elegant signature of Vermeer, whittling the number of genuine Vermeers from forty-three to the thirty-five canvases most scholars acknowledge today.

Two years later, the number of genuine Vermeers seemed once more under threat when the critic P.T.A. Swillens dismissed *Christ in the House of Martha and Mary*, which had been attributed by Abraham Bredius, and *Diana and her Companions* as unlikely Vermeers, though other Vermeer experts have not agreed with his censure.

In January 1951, Jacques van Meegeren further muddied artistic waters when, at a press conference in Paris, he announced that his father had forged four further paintings:

- *The Laughing Cavalier* (Frans Hals), in the collection of Cornelis Hofstede de Groot.
- *Young Girl with a Flute* (Vermeer), in the National Gallery, Washington.
- *Head of a Young Woman* (Vermeer), in the Mauritshuis.
- *Young Man with a Pipe* (Vermeer), Musée des Beaux-Arts, Lille.

However, Jacques was unable to provide any evidence – sketches or writings by his father – to support these allegations and when quizzed by journalists at the press conference he quickly became confused and began to contradict himself. Consequently his allegations were not believed. Significantly, however, of the four paintings, *Head of a Young Woman* is now considered a forgery, possibly the work of Han van Meegeren's erstwhile colleague Theo van Wijngaarden. *Young Man with a Pipe*, though a seventeenth-century Dutch paint-

ing, was never a secure addition to Vermeer's work. *Young Girl with a Flute*, though still exhibited in Washington as 'attributed to Vermeer' is not accepted by all Vermeer scholars.

A legacy, advertising executives assure us, is a gift that goes on giving. Han's legacy goes on taking. In 1974, John Walsh, curator of the Metropolitan Museum of Art, reclassified Vermeer's *A Young Woman Reading* as a forgery. The attribution now reads 'Style of Johannes Vermeer (first quarter 20th century)'. It may very well be the work of Han van Meegeren, and was sold to Jules Bache by Georges Wildenstein, who would later dismiss the *Emmaus* as a fake.

Joseph Duveen, who had also been contemptuous of *The Supper at Emmaus*, accepted two further Vermeer paintings, *Laughing Girl* and a variation on *The Lacemaker*, which he sold to the National Gallery of Art in Washington. Both are now declassified and exhibited as 'Imitator of Johannes Vermeer *c.* 1925'. They are thought to be the work of Theo van Wijngaarden.

In 1975, the eminent Vermeer scholar Albert Blankert, in his book *Johannes Vermeer van Delft 1632–1675*, proposed purging four further Vermeers:

- *Girl with a Red Hat*, National Gallery, Washington.
- *Girl Interrupted at her Music*, Frick Collection, New York.
- *Woman with a Lute*, Metropolitan Museum of Art, New York.
- *Young Girl with a Flute*, National Gallery, Washington.

All but the last are still considered by most scholars to be genuine.

Since 1949, only two works have been proposed as new attributions to Vermeer: *Saint Praxedis*, a copy of a Florentine

painting by Felice Ficherelli, known as 'Il Riposo', which was first tentatively attributed to Vermeer in 1969, and 'definitively' attributed in 1986 by Arthur Wheelock, a senior curator of the National Gallery of Art in Washington, who included it in a major Vermeer retrospective. It remains disputed, with few scholars sharing Wheelock's enthusiasm.

In 2004, after ten years of scholarly research, *A Young Woman Seated at a Virginal* rejoined the canon of Vermeer's *oeuvre*. Sold at auction at Sotheby's in 2004, it is now in the collection of Las Vegas mogul Steve Wynn. Despite the categorical attribution made by a host of respected Vermeer scholars following this decade, the authenticity of the painting is still disputed.

APPENDIX II
THE TWO LAST SUPPERS

At Han's sentencing, the greatest joy, the most profound relief was felt not by defence or prosecution, but by the Belgian art historian, critic and collector Jean Decoen:

The moment of greatest anguish for me was when the verdict was being considered. The court might, in accordance with ancient Dutch law, have ordered that *all* the paintings be destroyed. One shudders at the thought that two of the most moving works which Vermeer created might have been destroyed. During his summing up, the public prosecutor stated that there was in the court a man who claimed that a number of the paintings were not by van Meegeren. He made this statement because, since 1945, he must have realised that my perseverance had not faltered, that my conviction was deep and that I have never changed my original statements in any respect whatsoever. Perhaps my words may have influenced the decision of the Court with regard to the application of the law. If this be so, I should consider myself amply repaid for my efforts and pains, for my tenacity may possibly have ultimately rescued

two capital works of the Dutch school of the seventeenth century.

Decoen approached D.G. van Beuningen, who owned *The Last Supper*, asking to examine the painting and explaining to van Beuningen that the prosecution's case conflicted with Han's account of how the painting came to be created: Han claimed to have painted over a large canvas depicting two children in an ornate carriage being drawn by a goat, whereas X-rays indicated fragments of a hunting scene under *The Last Supper*.

With van Beuningen's financial support, Decoen set about systematically refuting each of the major findings of the Coremans Commission. On a forensic level, it seemed a powerful case. At the trial Coremans testified that traces of phenol-formaldehyde had been found in each successive layer of the forgeries. Trials carried out at Decoen's request by the director of the Meurice Institute of Chemistry in Brussels proved such tests elicited numerous 'false positives' on genuine old masters.

The Commission's conclusion that the canvases were painted with synthetic resin by van Meegeren is a hasty one since

(a) a large number of old paintings produce a similar reaction and

(b) the reaction is not specific to phenolic resins, which prove nothing under these conditions, but of products mixed with phenolic resins, which divests the test of every value

Coremans further testified that tests carried out by the commission had found that caustic potash, known to desaponify centuries-old paint, had no effect on Han's creations. Decoen's

tests performed at the Institut Meurice, however, proved that 'while the greater number of old masters do not withstand the action of hydroxide of potassium, the fact is far from general.'

He offered as evidence that the paint structures of undisputed paintings by Rubens and Fabritius were completely impervious to caustic potash.

The conclusions of the Coremans Commission accepted Han's account of how he had cut down *The Raising of Lazarus* before painting the *Emmaus*. The evidence, they testified, was that years of strain exerted by the tacks holding the fabric causes canvas fibres to acquire a slight but distinct wave of between five and twenty centimetres. While three of the edges of the *Emmaus* exhibited such characteristic warping, the fibres of the left-hand edge were straight.

Decoen disagreed. 'Being a chemist,' he scoffed, 'Mr Coremans has probably never mounted a canvas on a stretcher.' The *Emmaus*, Decoen insisted, had never been cut. New tests seemed to bear him out:

On December 15, 1949 Monsieur Jean Decoen gave a demonstration in the presence of the restorers H.G. Luitweiler, M. van Grunsven, H.J. Schrender, C.J. Snoeijerbosch and Charles Meurice of the Institut Meurice in Brussels.

Mr Decoen's presentation was limited solely to showing unequivocally that the canvas of *The Supper at Emmaus* had never been cut down.

The aforementioned restorers concurred with his assessment, with Monsieur Meurice vouching for the accuracy, from a chemical viewpoint, of the arguments used by M Decoen in support of his thesis.

In witness whereof, the four restorers, the chemist and M Decoen have signed this attestation.

Increasingly convinced by the work of Jean Decoen, a few short months after Han's death D.G. van Beuningen contacted the Boijmans and offered to buy *The Supper at Emmaus* for 520,000 guilders – the price originally paid by the gallery in 1937. The Boijmans declined the offer.

P.B. Coremans addressed Decoen's concerns on 27 September 1948, when he presented 'a most important document': a black and white photograph of a hunting scene by Jodocus Hondius, sent to him by Dr van Schendel, the curator of the Rijksmuseum, a painting which Douwes Brothers, an Amsterdam art dealership, claimed they had sold to Han van Meegeren in May 1940. The painting was intriguingly similar to the underpainting of *The Last Supper*. Furious, Jean Decoen, publicly accused Coremans of hiring an unknown artist to paint a scene which would coincide with the underpainting of *The Last Supper*. It was a serious accusation, charging both Coremans and Douwes Brothers with a criminal conspiracy. Coremans, however, did not seek legal redress to clear his name.

Decoen further argued that even if the canvas had been sold to Han, the sale took place in May 1940, while Han's letter to Boon offering a detailed description of *The Last Supper* had been written in 1939. Coremans blithely suggested that Han had painted two versions of *The Last Supper* – one in Nice in 1939 and the second in Laren in 1940–41. There was little to support such a far-fetched hypothesis: Han's villa in Nice had been painstakingly searched and four unsold forgeries found. It seemed unlikely that officers would have missed a canvas measuring nine feet by six.

In the spring of 1949, van Beuningen asserted that he had heard rumours that another version of *The Last Supper* was being fashioned to the specifications of P.B. Coremans; in fact

he claimed to know the identity of the artist working on it. He confided this to Jean Decoen, who visited the villa in September 1949 and searched the basement on two separate occasions during which he saw no sign of an unknown masterpiece.

Two days later, on 26 September, Coremans arrived to search the derelict property again. It was a quixotic venture. More than a decade had elapsed since Han and Jo abandoned the Villa Estate and in addition to the searches made by French and Dutch authorities, Coremans himself had twice before searched the villa.

> During the whole morning and part of the afternoon, I turned over and over the objects in the two basement kitchens and the corridor leading to them. This was where the gardener had stored most of van Meegeren's paraphernalia after his departure. I was beginning to despair when, all at once, the miracle occurred and I suddenly noticed two sheets of plywood stuck together, measuring no less than 146 × 267 cms. On separating them I found – not the piece of canvas I was seeking – but another version of the *Last Supper*.

Decoen immediately dismissed this 'first' *Last Supper* as a forgery masterminded by Coremans himself and planted in the villa. What other explanation could there be for the fact that repeated searches had failed to turn up a canvas the size of a small car? There is one further oddity: if, as he claimed, van Beuningen had heard of Coremans's plan to plant evidence, why send Decoen to search the villa when, as Lord Kilbracken suggests, a private eye might have been hired to keep the villa under surveillance. A heavyset man lumbering towards it with a huge sheet of plywood would have made a perfect photo opportunity.

Decoen's theory was that Han had discovered *The Last Supper* in a château in the Midi, just as he had recounted in his 1939 letter to G.A. Boon and set about tracing the shipment to Han from Nice later that year. On 6 June 1950, Decoen finally tracked the shipment to Tailleur et Fils in Paris who issued an attestation to this effect:

> Tailleur et Fils, 6 June 1950
>
> By this document we hereby certify that we received four crates from Monsieur van Meegeren in Nice, two of which contained one painting each measuring 261 × 190 cm and 155 × 95 cm. The two others contained porcelain and earthenware. These four crates were taken away by a German lorry on May 22 1941 for transfer to Holland.

This, Decoen believed, was proof that *The Last Supper* had been shipped from Nice in 1939 and taken by the German occupying forces to the Netherlands in 1941. In his book *Terug naar de waarheid: Vermeer-van Meegeren*,* published in Rotterdam a year later, he wrote: '[The affidavit] of June 6 1950 alone would have been enough to prove that the whole Hondius affair was a sham. In fact, the document makes it possible to prove beyond any doubt how *The Last Supper* arrived in Holland.'

Decoen ignored the fact that the painting Han described in his letter to Boon was approximately 150 × 270 cm – measurements which coincide with the canvas discovered by Coremans (146 × 267 cm), but are significantly different from *The Last Supper* bought by van Beuningen in 1941 (174 × 244 cm). He also conveniently disregarded the fact that the Nice consignment was shipped from Paris in May

* *Back to the Truth – Vermeer/van Meegeren.*

1941, while at the trial van Beuningen testified that he had bought *The Last Supper* in April 1941.

With his uncanny knack for belatedly discovering incontrovertible evidence to undermine Decoen's thesis, P.B. Coremans produced one further rabbit from his hat: a receipt dated 1938 from a Paris art dealer for a painting by Govert Flinck sold to Han van Meegeren. A photograph of the painting was attached, clearly showing two children in an ornate carriage drawn by a goat – the image Han had claimed of the underpainting. Han, Coremans argued, painted his first attempt at *The Last Supper* over the Flinck, the second over the Hondius he bought from Douwes Brothers. Decoen blustered that van Meegeren 'could not be so despicable nor show such little respect for a work of art that he would have deliberately destroyed a beautiful work', forgetting that Han had desecrated dozens of works of art in order to create his forgeries.

Frustrated, D.G van Beuningen hired the Krijnen Brothers, art dealers from nearby Utrecht, to find conclusive evidence that *The Last Supper* was genuine. In a three-year investigation which ranged as far afield as Canada and Italy, the brothers searched for some historical reference to the painting. They found not a whisper of the work before it emerged into the light in the hands of the greatest forger of the century.

Undeterred, van Beuningen, whose faith in his painting had taken on a totemic certainty, sued Professor P.B. Coremans seeking damages of £500,000 ($13,000,000 in 2005), alleging that Coremans's flawed judgement had harmed his reputation as a connoisseur and collector. A judicious magistrate would have thrown the case out, but in the hectic years after van Meegeren's trial, any claim had to be heard. But in June 1955, before he could have his day in court, Daniël van Beuningen died of a coronary.

Though advised against pursuing the claim, van Beuningen's heirs pressed to have the case heard. The judge found for the defendant; P.B. Coremans was exonerated and awarded costs and punitive damages.

Scientific testing performed in 1967* clearly proves that Han did indeed paint *The Last Supper* found by Coremans in Nice and a similar, rather better forgery two years later when he was quietly installed in his villa in Laren. But this does not explain what was contained in the huge crate which Han shipped from Nice in 1939. We can be certain that the shipment arrived, since the porcelain and other items contained in the smaller crates were later found among his effects. Han would only have shipped a forgery, since a painting signed in his own name would not even have recouped the cost of transport. There may be another biblical Vermeer waiting in the wings.

* See Appendix III.

APPENDIX III
THE APPLIANCE OF SCIENCE

In 1967, The Artists Material Centre at the Carnegie Mellon University, Pittsburgh, was asked to examine the evidence of the Coremans Commission. A team of researchers under the direction of Dr Robert Feller and Dr Bernard Keisch examined *The Supper at Emmaus* and a number of other paintings to test whether they were products of the twentieth century. The dating of objects was to be done based on radioactive decay; specifically that of the lead contained in lead white.

In genuine seventeenth-century paintings, white is invariably lead white. Han knew this, and so oxidised lead, grinding the resulting white powder to create his paint. However, while the Dutch lead in Vermeer's time was acquired from mines in Central Europe, from the mid-nineteenth century, lead was imported from Australia and the United States. It was this which Han used to make lead white for his paintings. Seventeenth-century Dutch lead was unique in containing quantities of silver and antimony, whereas in twentieth-century lead such elements are separated during the smelting process.

In addition, the paintings themselves can be dated using the

Lead 210 method. Lead oxide is not pure but also contains elements which are unstable:

- 210 Pb: (Radioactive lead-210) which decays rapidly into polonium 210. Half-life: twenty-two years, that is, in twenty-two years half the initial quantity of lead 210 will decay to polonium 210.
- 226 Ra: (Radioactive radium-226) which decays slowly to become lead-210. Half-life: 1,600 years

When lead oxide is formed, most of the radium is removed, with the remainder beginning to decay very rapidly. The process of decay continues until the lead 210 in the white lead is once more in equilibrium with the small amount of radium then present.

If a painting is a genuine seventeenth-century Vermeer then the time span of 300 years is considerable compared to the twenty-two-year half-life of lead 210, and the amount of radioactivity from lead 210 will almost equal the amount of radioactivity from the radium 226. On the other hand, if the painting is a twentieth-century forgery, the amount of radioactivity from the lead 210 will be much greater than the amount from the radium 226.

By calculating the imbalance between these, researchers at the Carnegie Mellon University were able to determine categorically that the *Emmaus* and *The Last Supper* had been painted with lead white manufactured in the twentieth century and could not therefore be genuine Vermeers.

The role of chemistry in determining the authenticity of van Meegeren's forgeries and the Shroud of Turin is now taught as part of courses such as *The Chemistry of Art: Teaching Science in a Liberal Arts Context* at Huntingdon University, Pennsylvania.

APPENDIX IV
VAN MEEGEREN'S FORGERIES

Title	Date	Artist	Price Guilders	Equivalent*	Current Location
The Laughing Cavalier	1923	Frans Hals	Unsold		Rijksbureau voor Kunsthistorische Documentarie (RKD)
The Satisfied Smoker	1923	Frans Hals	Unsold		Groninger Musuem
Lady and Gentleman at the Spinet	1936	Jan Vermeer	50,000	$225,000	Institut Collectie Nederland (ICN) Rijswink
A Woman Reading Music	1936?	Jan Vermeer	Unsold		Rijksmuseum (Atelier), Amsterdam
A Woman Playing Music	1936?	Jan Vermeer	Unsold		Rijksmuseum (Atelier), Amsterdam
The Supper at Emmaus	1937	Jan Vermeer	520,000	$4,700,000	Boijmans/van Beuningen Gallery, Rotterdam

* Genuine equivalence is difficult to estimate, in part because during the war there was no exchange rate for the Dutch florin. More importantly, relative values may be calculated against the Consumer Price Index or against the average unskilled wage. These figures favour the more conservative estimate, CPI; calculated against the unskilled wage, they would be almost doubled.

Title	Date	Artist	Price Guilders	Equivalent	Current Location
The Last Supper (1)	1938?	Jan Vermeer	Unsold		Private Collection
Interior with Card Players	1938	Pieter de Hooch	220,000	$1,900,000	Boijmans/van Beuningen Gallery, Rotterdam
Interior with Drinkers	1938	Pieter de Hooch	220,000	$1.900,000	Kunsthal, Rotterdam
Head of a Man	1938?	Gerard Ter Borch	Unsold		Rijksmuseum (Atelier), Amsterdam
Malle Babbe	1939?	Frans Hals	Unsold		Rijksmuseum (Atelier), Amsterdam
Head of Christ	1940	Jan Vermeer	475,000	$4,200,000	Private Collection
The Last Supper (2)	1941	Jan Vermeer	1,600,000	$14,400,000	Boijmans/van Beuningen Gallery, Rotterdam
Isaac Blessing Jacob	1941	Jan Vermeer	1,250,000	$11,200,000	Boijmans/van Beuningen Gallery, Rotterdam
Christ with the Woman Taken in Adultery	1942	Jan Vermeer	1,650,000	$14,500,000	Rijksmuseum, Amsterdam
The Washing of Christ's Feet	1943	Jan Vermeer	1,300,000	$11,400,000	Rijksmuseum, Amsterdam
The Young Christ Teaching in the Temple	1946	Jan Vermeer	3,000	$20,000	Cape Town, South Africa

APPENDIX V
WHERE TO FIND YOUR NEAREST VERMEER [*]

In 1866 when Théophile Thoré published the first catalogue of Vermeer's work, he detailed sixty-six paintings, including works now attributed to Jan Vermeer of Haarlem, and the cityscapes of Jacobus Vrel. By the beginning of the twentieth century, their number had dwindled steadily to about forty-three. To this *A Young Woman Seated at a Virginal* was added in 1904, and Abraham Bredius added *Christ in the House of Martha and Mary* in 1907. The catalogue ballooned in the 1940s to include van Meegeren's forgeries but in 1948, de Vries, the curator of the Rijksmuseum, weeded out the forgeries and misattributions to leave only thirty-five undisputed Vermeers.

 * Challenged by one or more Vermeer experts
 ** No longer considered to be a Vermeer
*** Probable forgeries

<div align="center">*</div>

* Assuming it is still genuine.

Austria

The Art of Painting, Kunsthistorisches Museum, Vienna

France

The Astronomer, Louvre, Paris
The Lacemaker, Louvre, Paris

Germany

The Glass of Wine, Gemäldegalerie, Berlin
Woman with a Pearl Necklace, Gemäldegalerie, Berlin
Rustic Cottage,** Gemäldegalerie, Berlin (now attributed to Derk van der
 Laan)
Head of a Boy,** Kupferstichkabinett, Berlin
The Glass of Wine, Herzog Anton Ulrich Museum, Brunswick
A Girl Reading a Letter by an Open Window, Gemäldegalerie, Dresden
The Procuress, Gemäldegalerie, Dresden
The Geographer, Stadelsches Kunstinstitut, Frankfurt am Main
City View,** Kunsthalle, Hamburg (now attributed to Jacobus Vrel)

Ireland

Lady Writing a Letter with her Maid, National Gallery of Ireland, Dublin

The Netherlands

The Milkmaid, Rijksmuseum, Amsterdam
Woman in Blue Reading a Letter, Rijksmuseum, Amsterdam
City View,** Rijksmuseum, Amsterdam (now attributed to Jacobus Vrel)
The Little Street,** whereabouts unknown (now attributed to Derk van der
 Laan)
The Little Street, Rijksmuseum, Amsterdam
The Love Letter, Rijksmuseum, Amsterdam
Girl with a Pearl Earring, Mauritshuis, The Hague
The View of Delft, Mauritshuis, The Hague
Diana and her Companions, Mauritshuis, The Hague

United Kingdom

*Christ in the House of Martha and Mary,** National Gallery of Scotland, Edinburgh
The Music Lesson, The Royal Collection, Windsor Castle
A Young Woman Seated at a Virginal, National Gallery, London
A Young Woman Standing at a Virginal, National Gallery, London
The Guitar Player, Kenwood House, London

United States

The Concert (stolen from the Isabella Gardner Museum, Boston. A blank space is left on the wall where the painting used to hang.)
Officer and Laughing Girl, Frick Collection, New York
Mistress and Maid, Frick Collection, New York
*Girl Interrupted at her Music,** Frick Collection, New York
Study of a Young Woman, Metropolitan Museum of Art, New York
The Allegory of Faith, Metropolitan Museum of Art, New York
Young Woman with a Water Pitcher, Metropolitan Museum of Art, New York
*Woman with a Lute,*** Metropolitan Museum of Art, New York
A Maid Asleep, Metropolitan Museum of Art, New York
A Young Woman Reading, Metropolitan Museum of Art, New York
*The Girl with the Blue Bow,*** Glenn Falls, New York
*Saint Praxedis,** The Johnson Collection, Philadelphia
*A Woman Weighing Pearls,*** Joseph E. Widener, Philadelphia
Woman Holding a Balance, National Gallery of Art, Washington DC
A Lady Writing, National Gallery of Art, Washington DC
*Young Girl with a Flute,*** National Gallery of Art, Washington (Jacques van Meegeren claimed this had been painted by his father)
*The Lacemaker,**** National Gallery of Art, Washington (now thought to be a forgery by Theo van Wijngaarden)
*Laughing Girl,**** National Gallery of Art, Washington (now thought to be a forgery by Theo van Wijngaarden)
*Girl with a Red Hat,** National Gallery of Art, Washington DC
*A Young Woman Seated at a Virginal,** Collection of Steve Wynn, Las Vegas

BIBLIOGRAPHY

Aldrich, Virgil C.: *Philosophy of Art*, Prentice-Hall, 1963

Altabe, Joan: 'Airing "Stuffy" Art World's Dirty Laundry', *Sarasota Herald Tribune*, 4 February 2001

Arnau, Frank: *The Art of The Faker – 3,000 Years of Deception*, Little Brown & Company, Boston, 1959

Baesjou, Jan: *De Alchimist van Roquebrune*, Vink, Antwerpen/Tilburg, 1954

Banfield, Edward C.: *The Democratic Muse: Visual Arts and the Public Interest*, Basic Books, New York, 1984

Benjamin, Walter: '*Art in the Age of Mechanical Reproduction*', in *Illuminations*, Fontana, London, 1973

Berger, John: *Ways of Seeing* BBC/Penguin, Harmondsworth, 1972

Brandhof, Marijke van den: *Het geval-Van Meegeren, in Knoeien met het verleden*, Utrecht, 1984

Braum, Martin: 'The Van Meegeren Art Forgeries', *Applied Mathematical Sciences*, Vol. 15, Springer-Verlag, New York, 1975

Bredius, Abraham: 'An Unpublished Vermeer', *Burlington* magazine 61 (October 1932), pp. 144–5

Bredius, Abraham: 'A New Vermeer: Christ and the Disciples at Emmaus', *Burlington Magazine* 71 (November 1937), pp. 210–11

Bredius, Abraham: 'Nog een woord over Vermeer's Emmausgängers', *Oude Holland* 55 (1938), pp. 97–9

Broos, B.: *Vermeer, Malice and Misconception*, Vermeer Studies, 1998

Carr Howe, Thomas: *Salt Mines and Castles: The Discovery and Restitution of Looted European Art*, The Bobbs-Merrill Company, 1946

Cassou, Jean, Emil Langui and Nikolaus Pevsner: *Gateway to the Twentieth Century: Art and Culture in a Changing World*, McGraw-Hill, 1962

Cole, Herbert M.: *A Crisis in Connoisseurship?*, *African Arts*, Vol. 36, Issue 1, 2003

Conklin, John E.: *Art Crime*, Praeger Publishers, 1994

Coremans, P.B.: *Van Meegeren's Faked Vermeers and de Hooghs*, Cassell, 1949

Cullity, Garrett and Berys Gaut: *Ethics and Practical Reason*, Oxford University Presss, 1997

Danto, Arthur C.: 'Age of Innocence', *The Nation*, Vol. 274, 7 January 2002

Decoen, Jean: *Back to the Truth: Vermeer/Van Meegeren*, Donker, 1951

De Groot, C.H.: *Jan Vermeer von Delft und Carel Fabritius*, 1906

de Vries, A.B.: *Jan Vermeer van Delft*, London and New York, 1948

Doudart de la Grée, Marie-Louise: *Emmaüs*

Doudart de la Grée, Marie-Louise: *Het fenomeen: Gedramatiseerde documentaire over het leven van de kunstschilder Han van Meegeren*, Omniboek, 1946

Dutton, Denis (ed.): *The Forger's Art: Forgery and the Philosophy of Art*, University of California Press, 1983

Feliciano, Hector: *The Lost Museum: The Nazi Conspiracy to Steal the World's Greatest Works of Art*, Basic Books, 1997

Ford, Charles V.: *Lies!, Lies!!, Lies!!!: The Psychology of Deceit*, American Psychiatric Press, 1996

Froentjes, W. and A.M. de Wild: 'De natuurwetenschappelijke bewijsvoering in het proces van Meegeren', *Chemisch Weekblad* 45 (1949), 269–78

Gardner, Howard: *Art, Mind, and Brain: A Cognitive Approach to Creativity*, Basic Books, 1982

Godley, John (Lord Kilbracken): *Van Meegeren, Master Forger*, Nelson, 1967

Gombrich, E.H.: *Art and Illusion*, Princeton University Press, 1962

Goodman, Nelson: *The Languages of Art*, 1976

Goodrich, David L: *Art Fakes in America*, New York, The Viking Press, 1973

Groom, Nick: *The Forger's Shadow: How Forgery Changed the Course of Literature*, Picador, 2002

Guarnieri, Luigi: *La doppia vita di Vermeer*, Mondadori, Mailand, 2004

Haney, George W., Leonard Keeler, John A. Larson and August Vollmer: *Lying and Its Detection: A Study of Deception and Deception Tests*, University of Chicago Press, 1932

Hebborn, Eric: *Drawn to Trouble: Confessions of a Master Forger*, Mainstream, 1991

Hjort, Mette and Sue Laver: *Emotion and the Arts*, Oxford University Press, 1997

Hoving, Thomas: *False Impressions: The Hunt for Big-Time Art Fakes*, Touchstone, 1997

Howells, John G.: *A Reference Companion to the History of Abnormal Psychology* Vol. 2, M. Livia Osborn; Greenwood Press, 1984

Jansen, Geert Jan: *Magenta: Avonturen van een meestervervalser*, Prometheus, 1998

Kasof, Joseph: *Clarification, Refinement, and Extension of the Attributional Approach to Creativity*, 1995

Keck, C.K. and R.S. Eisendrath: *How to Take Care of Your Pictures*, Museum of Modern Art & the Brooklyn Museum, 1954

Kostelanetz, Richard: *Esthetics Contemporary*, Prometheus Books, 1978

Kreuger, Frederik: *Han van Meegeren, Meestervervalser*, Veen Magazines, Diemen, 2004

Leigh, David and Elena Borissova: 'How forgery turned £5,000 painting into £700,000 work of art', *Guardian*, Saturday 10 July 2004

Moiseiwitsch, Maurice: *The Van Meegeren Mystery*, Arthur Barker, 1964

Montias, John Michael: *Vermeer and His Milieu*, Princeton University Press, 1989

Moulyn, Adrian C.: *The Meaning of Suffering: An Interpretation of Human Existence from the Viewpoint of Time*, Greenwood Press, 1982

Murphy, Cullen: 'Knock It Off: The Art of the Unreal', *The Atlantic Monthly*, Vol. 294, Issue 5, December 2004

Nash, John: *Vermeer*, Scala, 2002

Petropoulos, Jonathan: *Art as Politics in the Third Reich*, University of North Carolina Press, 1996

Petropoulos, Jonathan: *The Faustian Bargain: The Art World in Nazi Germany*, Oxford University Press, 2000

Reitlinger, Gerald: *The Economics of Taste: The Rise and Fall of Picture Prices 1760–1960*, Barrie and Rockliff, London, 1961

Sparshott, F. E.: *The Structure of Aesthetics*, University of Toronto Press, 1970

Spencer, Ronald D.: *The Expert versus the Object: Judging Fakes and False Attributions in the Visual Arts*, Oxford University Press, 2004

Swillens, P.T.A.: *Johannes Vermeer: Painter of Delft 1632–1675*, Utrecht, 1950

van den Brandhof, Marieke: 'Een vroege Vermeer uit' 1937, *Het Spectrum*, 1979

Wallace, Irving: 'The Man Who Swindled Goering', *Saturday Evening Post*, Vol. 219, No. 28, 1947

Watson, Peter: *Sotheby's: The Inside Story*, Random House, 1997

West, Patrick: 'Faking it big in the 21st century', *New Statesman*, 2001

Wheelock, Arthur K.: *The Public and the Private in the Age of Vermeer*, Osaka, 2000

Websites

Jonathan Janson has created a dizzyingly comprehensive series of websites dedicated to Vermeer:

http://www.essentialvermeer.com
http://howtopaintavermeer.fws1.com/
http://newvermeers.20m.com
www.johannesvermeer.info

Other websites about Han van Meegeren

http://www.mystudios.com
http://www.tnunn.ndo.co.uk
http://www.rnw.nl/special/en/html/040122meeg.html

Websites about art forgery

http://www.invaluable.com
http://www.the-artists.org/tours/art-forgery
http://www.museum-security.org/forgeries.htm
http://www.ifar.org
http://www.artcult.com
http://yin.arts.uci.edu/-mof/index.html

PICTURE CREDITS

1. Van Meegeren: *Interior of the Laurenskerk*. (Private collection. Photo: Maarten Binnendijk, The Netherlands (www.binnendijk.com)
2. Van Meegeren: *Jo with Dove*. (*Libelle*, 1950)
3. Van Meegeren: *Hertje* (The Little Deer). (*Teekeningen* 1)
4. Van Meegeren: *Theo van der Pas*. (*Teekeningen* 1)
5. Van Meegeren: *A Woman Reading Music*. (© Rijksmuseum Amsterdam)
6. Van Meegeren: *Lady and Gentleman at the Spinet*. (Photo Tim Koster, I.C.N. Rijswijk / Amsterdam, The Netherlands)
7. Vermeer: *Woman in Blue*. (akg-images)
8. Van Meegeren: *Die Emmausgängers*. (Musuem Boijmans Van Beuningen, Rotterdam)
9. Vermeer: *The Astronomer*. (akg-images / Erich Lessing)
10. Van Meegeren: *Malle Babbe*. (© Rijksmuseum Amsterdam)
11. Frans Hals: *Malle Babbe*. (bpk / Gemäldegalerie, Staatliche Museen zu Berlin. Photo: Jörg P. Anders)
12. Van Meegeren: *A Woman Playing Music*. (© Rijksmuseum Amsterdam)
13. Van Meegeren: *The Drinking Party*. (No information available)
14. Pieter de Hooch: *The Visit*. (Metropolitan Museum of Art, H. O. Havemayer Collection, Bequest of Mrs H. O. Havemayer, 1929 (29.100.7). Photograph © 1992 The Metropolitan Museum of Art
15. Van Meegeren: *Interior with Card Players*. (Museum Boijmans Van Beuningen Rotterdam)
16. Pieter de Hooch: *Card Players in a Sunlit Room*. (The Royal Collection © 2006, Her Majesty Queen Elizabeth II)
17. Van Meegeren: *The Last Supper*. (Museum Boijmans Van Beuningen, Rotterdam)

INDEX

A NOTE ON THE AUTHOR

Frank Wynne is a journalist and award-winning literary translator and has written for, amongst other publications, the *Irish Times, Melody Maker, Time Out* and *Attitude*. Frank was born in Sligo and is now based in London.

A NOTE ON THE TYPE

The text of this book is set in Linotype Sabon, named after the type founder, Jacques Sabon. It was designed by Jan Tschichold and jointly developed by Linotype, Monotype and Stempel, in response to the need for a typeface to be available in identical form for mechanical hot metal composition and hand composition using foundry type.

Tschichold based his design for Sabon roman on a font engraved by Garamond, and Sabon italic on a font by Granjon. It was first used in 1966 and has proved an enduring modern classic.